IMAGES
of America

LONG ISLAND CITY

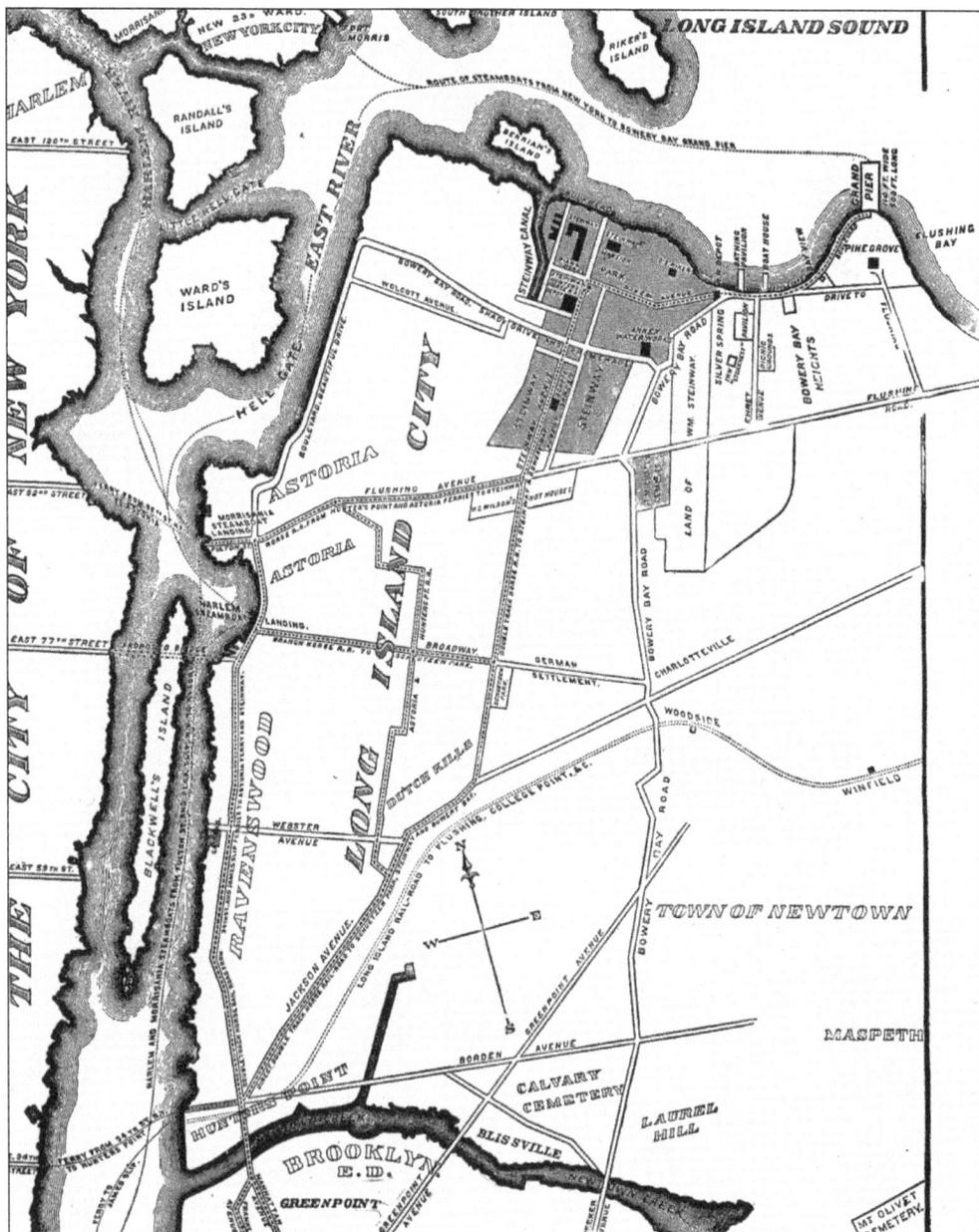

This map, from Kelsey's *History of Long Island City* (1896), shows Long Island City and the Steinway property. (Courtesy Greater Astoria Historical Society [GAHS].)

IMAGES
of America

LONG ISLAND CITY

Greater Astoria Historical Society with
Thomas Jackson and Richard Melnick

ARCADIA
PUBLISHING

Published by Arcadia Publishing
Charleston, South Carolina

Library of Congress Catalog Card Number: 2004108184

For all general information contact Arcadia Publishing at:
Telephone 843-853-2070
Fax 843-853-0044
E-mail sales@arcadiapublishing.com
For customer service and orders:
Toll-Free 1-888-313-2665

Visit us on the Internet at www.arcadiapublishing.com

On the cover: A parade is seen in a view looking west on Broadway at the corner of Steinway Street *c.* 1930.

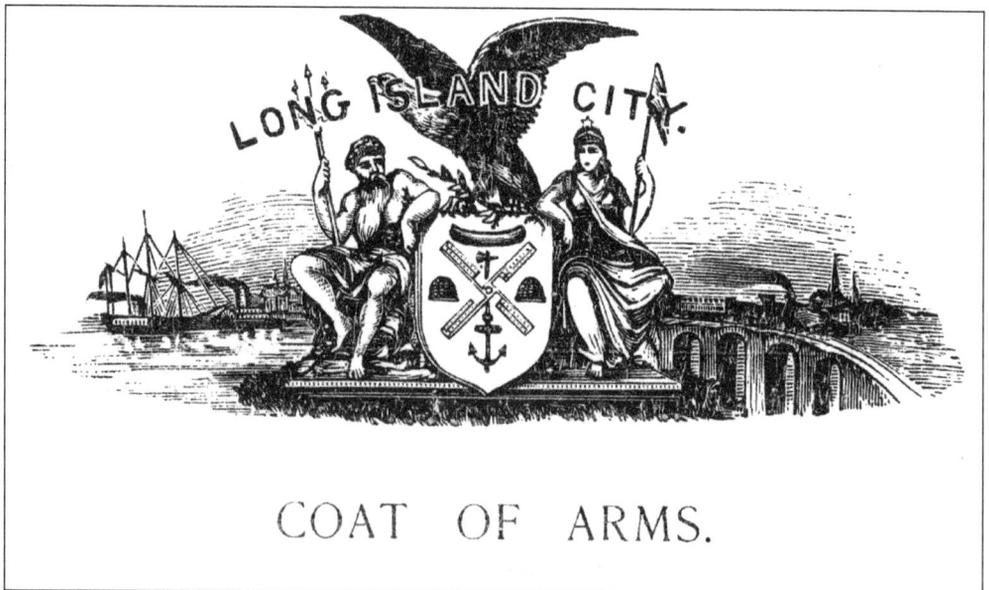

COAT OF ARMS.

In 1873, the Common Council adopted this coat of arms, emblematic of the varied interests represented by Long Island City. It was designed by alderman George H. Williams of Ravenswood. (Courtesy GAHS.)

CONTENTS

Acknowledgments 6

Introduction 7

1. The Birth of Long Island City 9

2. Architecture and Housing 33

3. Amusements and Entertainment 49

4. Industry and Commerce 61

5. Transportation 75

6. We the People 89

7. The Neighborhoods 107

ACKNOWLEDGMENTS

No book about the history of Long Island City would be possible without the generous assistance and insight of Vincent Seyfried. His classic book *300 Years of Long Island City* is the definitive resource for understanding the history of the area. Seyfried, our mentor, taught us the value of reading old newspapers, including the *Long Island Star Journal*. By doing so, we rediscovered our history long lost.

Many thanks to Robert Singleton and Debbie Van Cura, who are the primary historians, administrators, and archivists in this organization. They have made this all possible.

Thanks to the many people from the neighborhoods of Long Island City and around the country who answered the Greater Astoria Historical Society's call for images. They are as follows: Luke Adams and the Sunnyside Chamber of Commerce, George Andrew, Robert Biliski Jr., Robert Bitter and Scalamandré Silks, Marie Blanda, Bohemian Hall and Park, Jack Conway, Frank Carrado, Sydelle Diner, Patty Fagan, Charles Fertita, Edward "Whitey" Ford, Sherry Gamlin, Nick Kalis, Tim Kehoe, Mike Leahy, Stephen Leone, Kenneth Lewison, Louis Mancuso, the Mathews family, Steven Melnick, Ruth Meyerhoff, Dorothy Morehead and the Sunnyside Foundation, Chuck Noe, the Noguchi Foundation, the Queens Chamber of Commerce, William Quinn Sr., Tom Paino, Herb and Liz Reynolds and the Sunnyside Gardens Preservation Alliance, George Ribeling, Lawrence Rippere, Al Ronzoni, Jerry Rotondi, Hal Rosenbluth and the Kaufman-Astoria Studios, Maureen Sabo, the Sessa family, Robert Singleton, the Stein family, Henry Z. Steinway, Steinway & Sons, Bob Stonehill, Margaret Tietz, Bob Ulino, Debbie Van Cura, Julie Wager and the Central Astoria Local Development Coalition, and the Xerox Corporation.

While researching, the following resources were crucial: *The Encyclopedia of New York City*; *History of Long Island City*, by J. S. Kelsey; *A.I.A. Guide to New York City*; *Historic Preservation in Queens*, by Jeffrey Kroessler and Nina Rappaport; and *The Annals of Newtown*, by James Riker Jr.

Thanks go to our friends, colleagues, and family: Concetta and Joseph Cascio, Clare Doyle, Steven Greenfield, Dr. Jeffrey Kroessler, and Stefano Ranzini.

Thanks to Michael McDonald of ImageMaid for scanning and formatting the images in the book.

Thank you to all the present and former residents of Long Island City who visit or contact us and share stories with us. You always impress us with the affection and pride you have in this wondrous place called Long Island City. To you we dedicate this book.

INTRODUCTION

Long Island City is the largest community in Queens County. It was the earliest part of Queens to be recognized by the Dutch and was the scene of many British troop movements during the Revolution.

Astoria was the first hamlet in the county to organize itself as a village, in April 1839. In 1870, the hamlets of Hunters Point, Ravenswood, Astoria, Bowery Bay, and Middletown united to form Long Island City. The place grew rapidly due to its extensive waterfront, the commercial traffic on Newtown Creek, and its position as a railroad terminal.

The opening of the Queensboro Bridge in 1909 proved the making of Long Island City as many factories located here, and innumerable industries took advantage of the ample space and low land cost.

Long Island City today is a study in contrasts. Hunters Point is primarily factories and industry, but the Astoria, Steinway, and Ditmars areas are solidly residential with apartments and private houses accommodating thousands.

<div align="right">

—*Queens: Pictorial History*,
Vincent Seyfried, 1983

</div>

This photographic history of Long Island City touches upon many themes, including architecture, amusements, industry, people, and neighborhoods. Its pictures cannot do justice in so ambitious a subject but serve only as a hint of the wonderful depth found in our community. Long Island City retains the unique character and charms of a small town, yet it possesses the overwhelming advantages of a great city, as Manhattan is just a few minutes away.

Here, artisans and artists crossed paths, fertilizing each other's imagination and inspiring new dimensions of creativity. If F. Scott Fitzgerald drove down Northern Boulevard and through Queens Plaza and dreamed of writing *The Great Gatsby*, he undoubtedly would have listened to music played by Sunnyside's Bix Beiderbecke or heard Gershwin's latest compositions played on a Steinway piano. While Rudolph Valentino and the Marx brothers shaped their careers at the Paramount (today the Kaufman-Astoria) movie studios on film sets built by local talent, they wore costumes sewn by local needles. When inventor Chester Carlson borrowed a back room in his mother-in-law's beauty parlor for a laboratory and there duplicated the word "Astoria" on the first photocopy, our community's name appeared on the first page of the information age.

For 350 years, creative people flocked here in search of a better life. They laid out our streets; built our schools, bridges, and subway tunnels; and worked on our farms and in our factories. They patronized our beer gardens and our movie theaters. They lived out their lives, raised their children, and enjoyed the benefits of the American Dream.

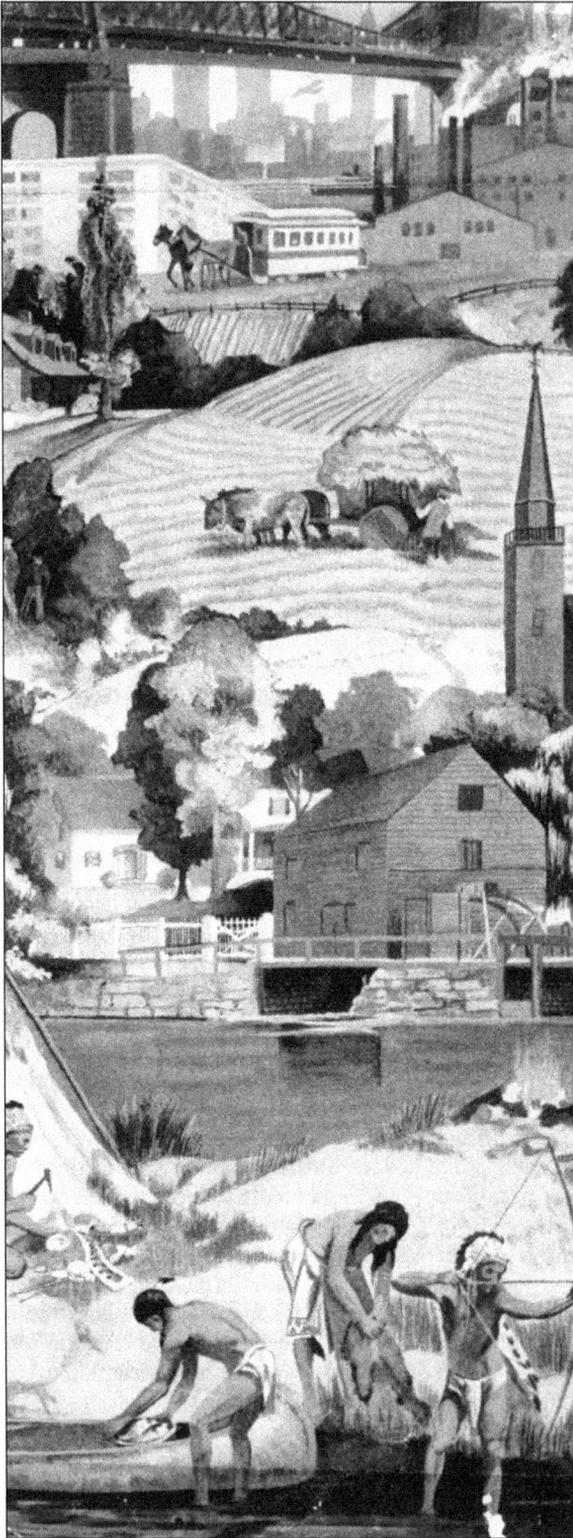

Long Island City, by Vincent Aderente, was commissioned in 1939 for the Long Island Savings Bank. The painting was later lost when the bank building was converted into a nightclub. Shown, from top to bottom, are the following: the subway, the Queensboro Bridge, an East River tugboat, an airplane, and Manhattan in the distance; a new factory of concrete and glass contrasting with the old factory belching smoke, dark and dingy; the horsecar line that ran from the 34th Street ferry to Astoria, passing Queens Plaza; the 1656 Lent Homestead (near LaGuardia Airport), the oldest private dwelling in Queens; redcoats in Newtown during the American Revolution; the 1654 Poor Bowery, kept under cultivation for the benefit of the poor; St. James Church (built in 1735 on Broadway in Elmhurst), the second-oldest structure in Newtown; the 1656 Jackson Homestead and Mill, located on Jackson Creek by the Grand Central Parkway at 94th Street; the Mespachtes Indians at Newtown Creek, the first people in Queens; a wampum worker making the first form of currency from a clamshell. (Courtesy GAHS.)

One

THE BIRTH OF
LONG ISLAND CITY

Long Island City emerged 12,000 years ago when the last glacier melted and left on Long Island a 150-foot-deep deposit of rocks and sand scraped from New England. The only solid bedrock on the island emerges in several outcroppings between 21st Street and the East River in Hunters Point, Ravenswood, and Astoria Park. Small ponds dotted the landscape, and marshes were at Hunters Point, Ravenswood, and Dutch Kills. An underground fault, starting at 35th Avenue and Crescent Street, ran northwest under the Harlem River. The remains of a mastodon were recovered when Anable Basin was dredged. The slight rise in Northern Boulevard at 50th Street was said to mark the site of a beaver dam.

Native Americans, leaving behind shell heaps as evidence, had summer camps on Newtown Creek, Sunswick Creek, Halletts Cove, Bowery Bay, and Pot Cove. The name Sunswick, given to a swamp that ran under 21st Street between Broadway and Queens Plaza, was a corruption of *Sunkisq*, a native word meaning "place of the chief's wife," perhaps because women gathered herbs and medicines at its banks for healing and religious activities. Indians called Newtown Creek *Mespaetches* and Dutch Kills *Canapaukah*. Their footpaths today are under Hazen Street, Woodside Avenue, and 20th Road.

In April 1614, the Dutch fur trader Adriaen Block was the first European to see what was to become Long Island City. His crew sailed the tiny *Onrust*, meaning "restless," the first vessel constructed in New York, from lower Manhattan up the East River. Perhaps spying the wide Long Island Sound in the distance, he called the treacherous tidal strait *Helle-gat*, meaning "bright passage," later distorted to Hell Gate because of its reefs, rocks, and currents.

In 1643, Dutch Kills was the first permanent European settlement in Queens. The Dutch set up a farm, the Poor Bowery on Bowery Bay, to sustain widows and orphans. On December 1, 1652, William Hallett received land on Halletts Cove in Astoria. The route of Newtown Road and Newtown Avenue was the lane to his farm.

In 1663, dissatisfied with Dutch rule, the area's predominately English settlers tried to become a part of Connecticut. English rule arrived in 1664. By 1683, the district became Queens County. Controversy surrounds the alleged namesake of Queens, Queen Catherine of Braganza. Her name is not mentioned in the first 200 years of the county's existence. No one has offered one historically verifiable fact supporting any connection between her and Queens.

In Dutch Kills and Sunswick Creek in Ravenswood, East River tides turned millstones grinding wheat and corn into flour and meal. After 1720, a hamlet, Middletown, grew up around one of the first schoolhouses in Queens at the corner of 46th Street and Newtown Road. In the mid-1800s, the school was moved and attached to one of the old houses that still dot the area. Whether it still remains or not is an open, and intriguing, question.

After the Battle of Long Island in August 1776, during the American Revolution, the British army encamped near 30th Avenue and Steinway Street, along Skillman Avenue, and at the head of Maspeth Kills. There were long artillery duels across the East River. For decades afterward, farmers pried old cannonballs out of stumps and rocks.

On September 15, 1776, thousands of troops swarmed out of Newtown Creek, across the East River and to Kips Bay, where they inflicted a terrible defeat on the Americans. New York fell and remained under British control until war's end in 1783.

All homes had billets of troops. The virgin forest in Queens vanished, as the army of occupation had an enormous need for fuel. Vandalism was widespread and crime was common, and more than one pot of gold coins was secreted and forgotten, only to be discovered years later.

Change came slowly after the war. A ferry ran between 86th Street, Manhattan, and Halletts Cove. Fort Stevens, at the Hell Gate, became a temporary fortification during the War of 1812.

Growth began during the 1830s. Neziah Bliss set up Blissville on Newtown Creek, and Col. George Gibbs developed Ravenswood along the East River. On April 12, 1839, Stephen Halsey created the first village in Queens County, Astoria. The area that was to become Long Island City, even with this development, was still a quiet suburb just across the East River from Manhattan.

A decade later, Hunters Point began to change dramatically. Quickly, a railroad from Flushing followed by the Long Island Railroad constructed terminals at the East River.

The construction and opening of Jackson Avenue in 1861 changed the flow of east–west traffic to the detriment of Old Astoria Village. People out east preferred to use the newer and more direct road to the 34th Street ferry rather than the older and poorly maintained turnpike to the uptown 92nd Street ferry (Astoria Boulevard). Hunters Point gained what Old Astoria Village lost.

This had a stunning effect on transforming a sleepy corner of Queens County into a dynamo. The community's paper, the *Long Island Star,* coined the name Long Island City and began to lobby for the people of Old Astoria Village, Dutch Kills, Hunters Point, Ravenswood, and Blissville (Sunnyside) to set aside their narrow parochial interests and create a unique identity that would set them apart from the rest of Queens County. The new municipality, Long Island City, was born on May 4, 1870.

A major coup came in the early 1870s, when Steinway & Sons moved to 400 acres on the East River at Bowery Bay, building not only manufacturing facilities but an infrastructure of transportation, cultural institutions, and housing for its workers. A German cabinetmakers union created a similar settlement on upper Broadway.

This is Dutch Kills, a typical tidal creek found in the harbors and rivers of the New York region. To those first, canny New Yorkers, these creeks were opportunities for the milling of grain into flour and for transportation to ship the flour by water. These advantages launched the colony onto its path of greatness. They are remembered as kegs of flour on New York City's coat of arms. (Courtesy GAHS.)

Dutch Kills, granted in 1643, is the first European community in Long Island City. The Debevoise family, who built this farmhouse in 1652 on Hunters Point Avenue, held land here until 1900. (Courtesy GAHS.)

Pot Cove was the site of a Native American settlement. Fresh water came from a small stream, later called Linden Brook, that flowed along Astoria Park South. Here, they cleared woodlands to grow corn, harvested oysters and clams, and caught fish. After Newtown Township purchased land from the Native Americans in 1666, most moved away, although some lingered at Maspeth Kills for a few years. (Courtesy GAHS.)

William Hallett received a grant for Halletts Cove from Gov. Peter Stuyvesant in 1652. In 1664, he ratified this by purchasing the land from the Native Americans for 58 fathoms of wampum, seven coats, one blanket, and four kettles. The tract embraced 2,200 acres, extending from Bowery Bay to Sunswick Creek. This deed, signed by four Native American chiefs and witnessed by three white men, still exists in the state archives in Albany. (Courtesy GAHS.)

This is one of two granite millstones that ground wheat and corn at Burger "Citizen" Jorissen's mill. When the mill was torn down c. 1860, the millstones were rescued by the Payntar family, who placed them before their home on Northern Boulevard. When the family's house was sold and torn down, the New York City government moved the stones to their present location in a traffic island at Queens Plaza North. They are the oldest European artifacts in Queens. (Courtesy Steven Melnick.)

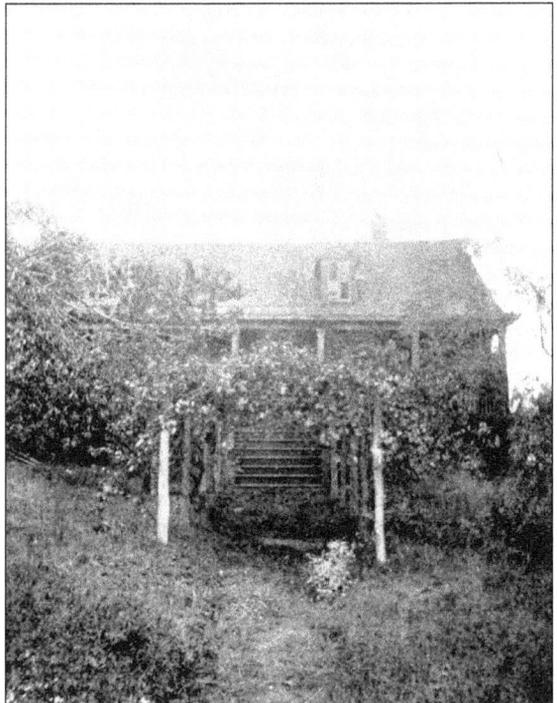

The Payntar house, which existed from the early 1700s to 1912, was on the east side of Northern Boulevard just beyond Queens Plaza. The Payntar family settled with the Debevoise, Van Alst, and Van Dam families at Dutch Kills. They owned most of the land that later became Queens Plaza. (Courtesy GAHS.)

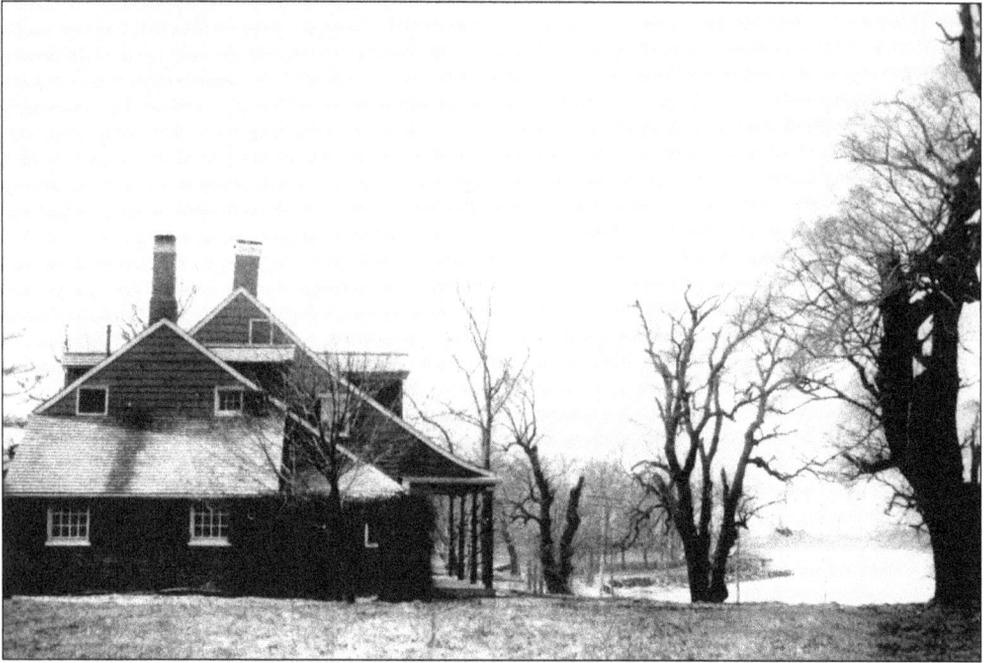

The Robertson-Trowbridge house was on a bluff overlooking Hell Gate between 20th and 21st Avenues just north of Astoria Park. James Robertson, the father of Mrs. George Trowbridge, built the house in the early 1700s. This was a typical grand estate that lined the East River. The mansion was sold in 1905 to the Astoria Gas, Heat & Power Company and destroyed. (Courtesy GAHS.)

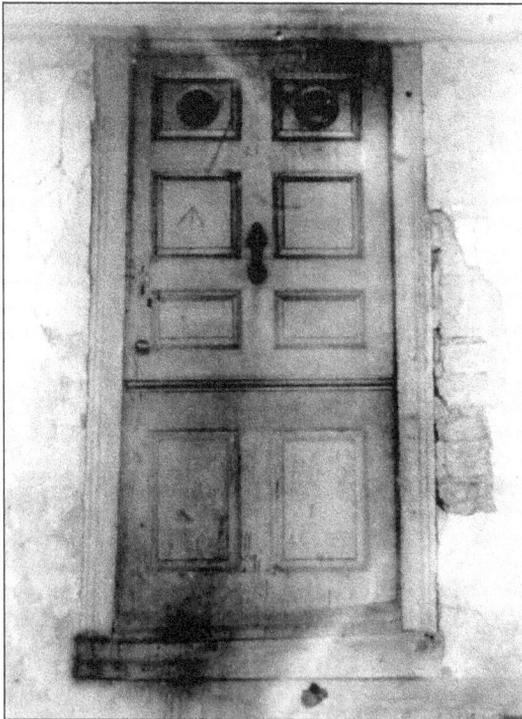

The Jacob Blackwell house, c. 1730, was at the foot of 37th Avenue in Ravenswood. British troops hacked an arrow into the door with their sabers, indicating that the Blackwells were rebels whose home could be confiscated. Lived in until 1893, the house was razed in 1901. Blackwell's (Roosevelt) Island was a portion of their estate (see page 20). (Courtesy GAHS.)

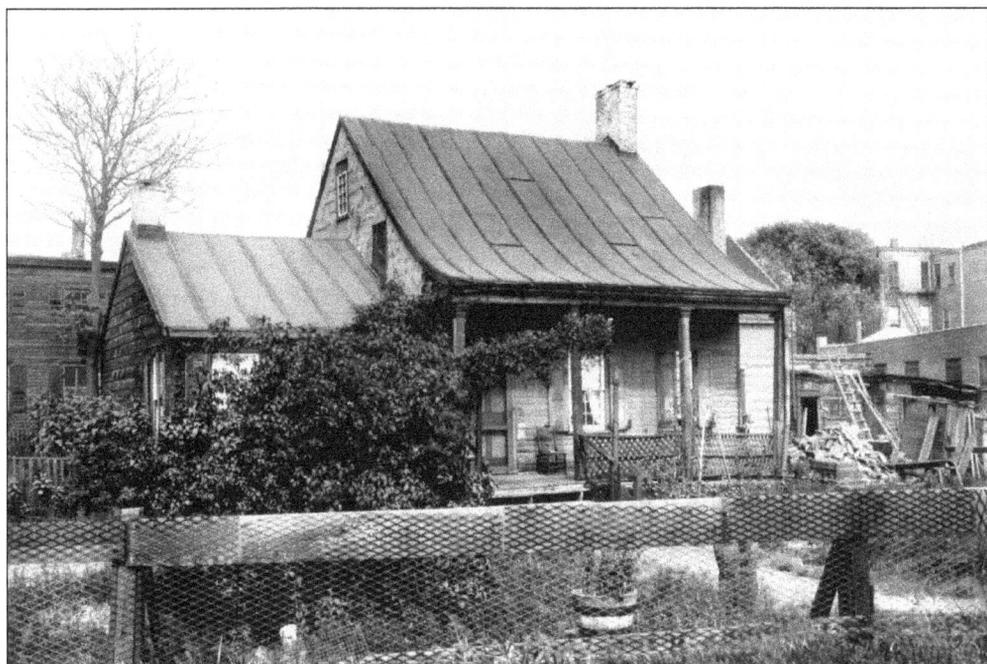

Owned by Isaac B. Strang, a box manufacturer during the Civil War, this humble home stood near Vernon Boulevard and Broadway and was a typical vernacular house. A pane of glass in one of its windows had the inscription "Libby Field, Jan. 1, 1806" scratched on its surface. The Fields, originally from Flushing, built this long-gone dwelling. (Courtesy GAHS.)

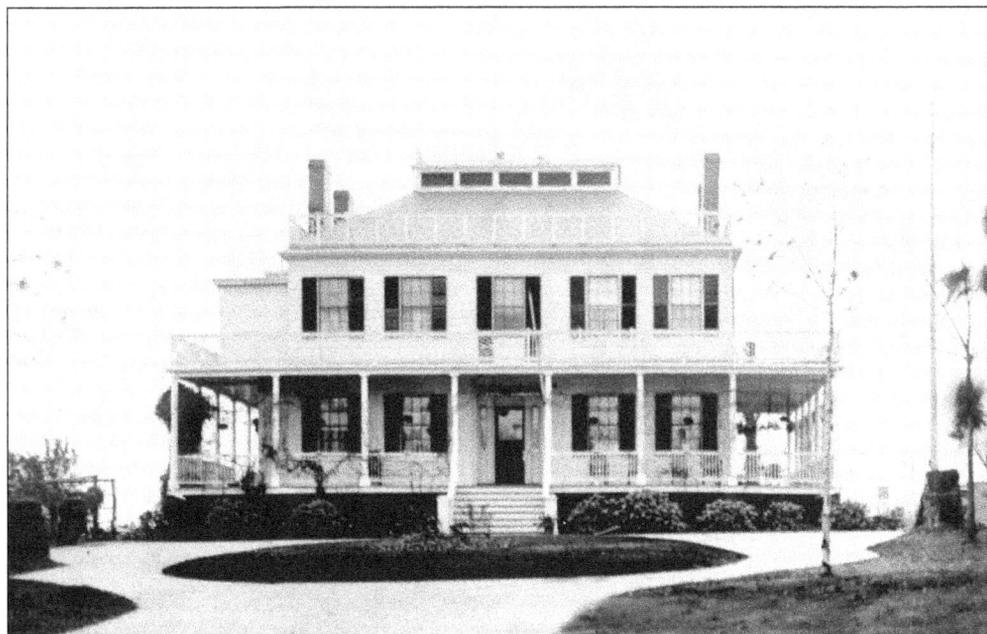

The Robert Tisdale house was a grand residence built during the 1820s in the style of a Southern planter's mansion. With a commanding view of the East River from Halletts Cove to Pot Cove, it stood at the summit of "the Hill" in Old Astoria Village. The community had wealth, taste, and refinement. (Courtesy Bob Stonehill.)

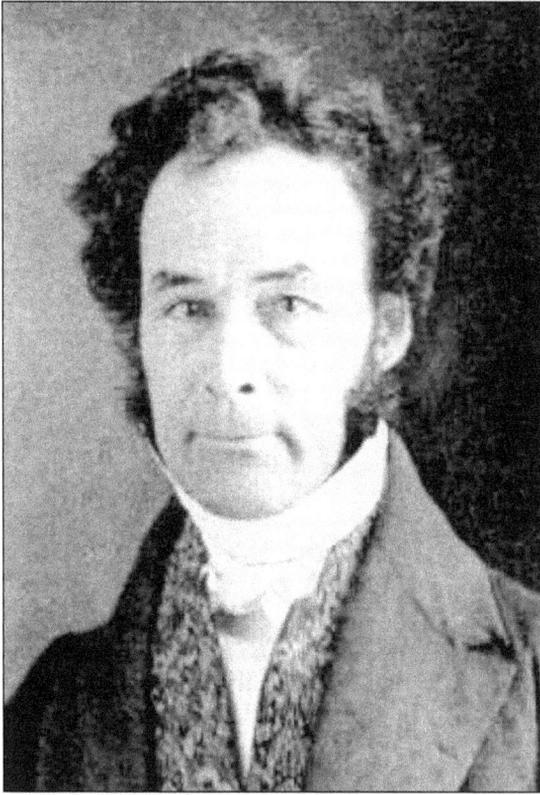

Called "the Father of Astoria," Stephen Halsey (1798–1875) moved to Halletts Cove in 1835 and conceived the idea of founding a new village with dwellings, stores, factories, schools, and churches. He obtained a village charter from Albany in 1839. He assumed responsibility for the ferry to Manhattan and created Astoria Boulevard and Vernon Boulevard. Imitating his older brother John, who was one of the founders of Astoria, Oregon, he named the village Astoria after John Jacob Astor. (Courtesy Lawrence Rippere.)

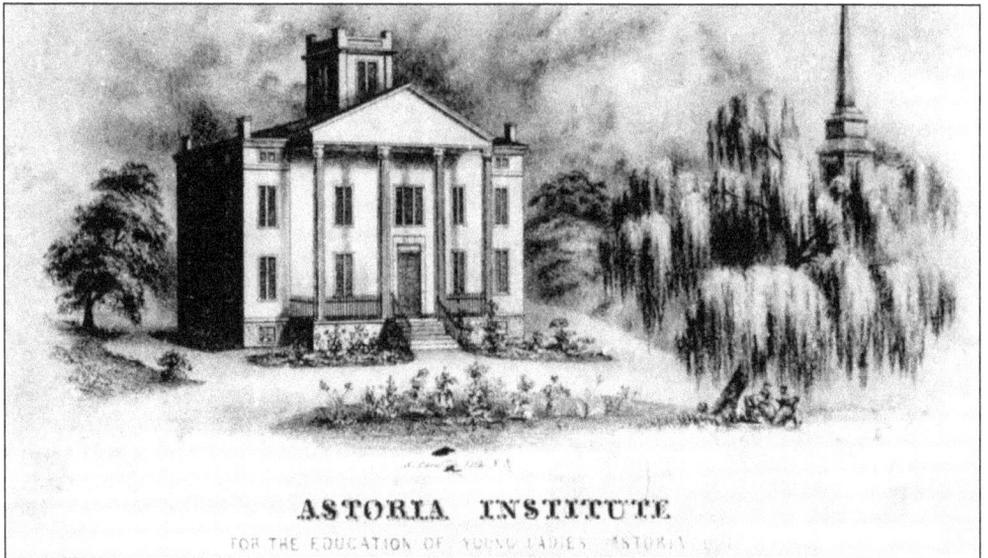

ASTORIA INSTITUTE
FOR THE EDUCATION OF YOUNG LADIES, ASTORIA

The Astoria Institute (1828) was the parsonage of St. George's Episcopal Church. Halsey suggested the name Astoria, hoping that John Jacob Astor, who lived across the East River in Yorkville, would give his namesake money. A delegation visited Astor and requested $2,000 for the institute, but they only got $500. The school was later the Astoria Female Seminary in 1844. Sadly, this structure was demolished in 2005. Many other sacred structures face development pressures and have an uncertain future. (Courtesy GAHS.)

16

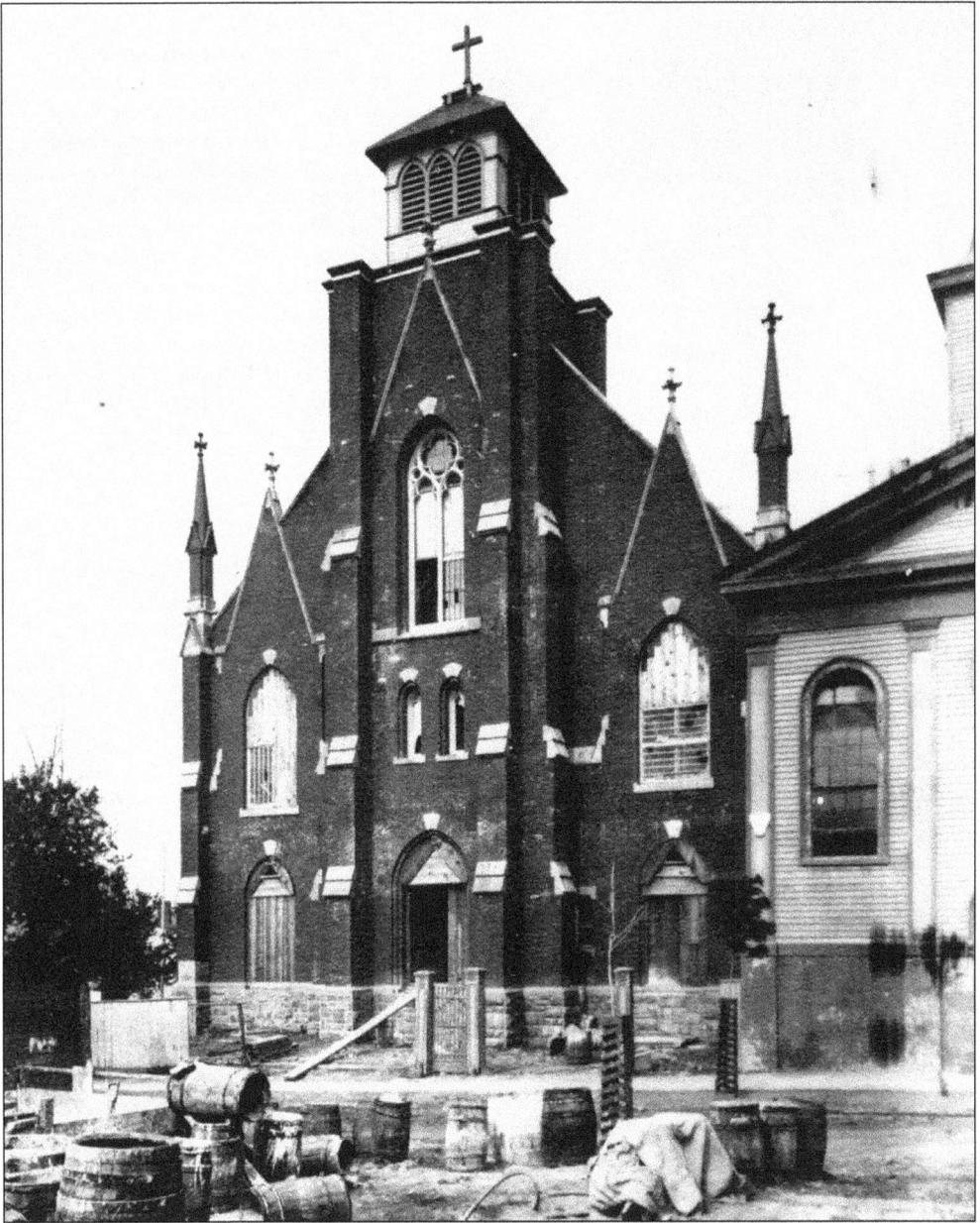

St. Mary's Roman Catholic Church (at 49–01 Vernon Boulevard), under the leadership of Fr. John Crimmins, was a driving force for the creation of Long Island City. Concerned that his working-class community was not getting its fair share of municipal services, Crimmins canvassed through Hunters Point and Dutch Kills to press for votes for the creation of Long Island City. The city received a charter on May 4, 1870. (Courtesy Bob Ulino.)

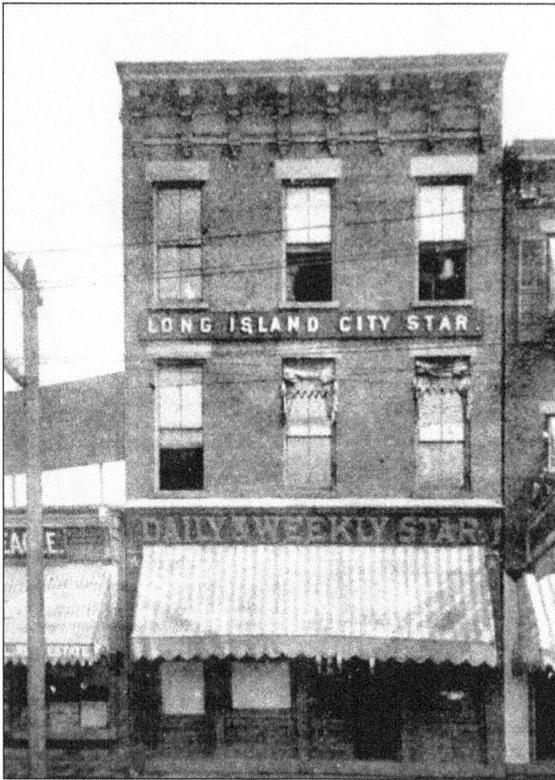

A "star" was born on October 20, 1865, with the first issue of the *Long Island City Star and Newtown Advertiser*. Before Long Island City was incorporated, and when the region was still part of Newtown Township, Thomas Todd, the newspaper's founder, believed that a thriving city was destined to spring up along the riverfront. This newspaper waged a ceaseless campaign through spirited editorials to define and improve the community. (Courtesy GAHS.)

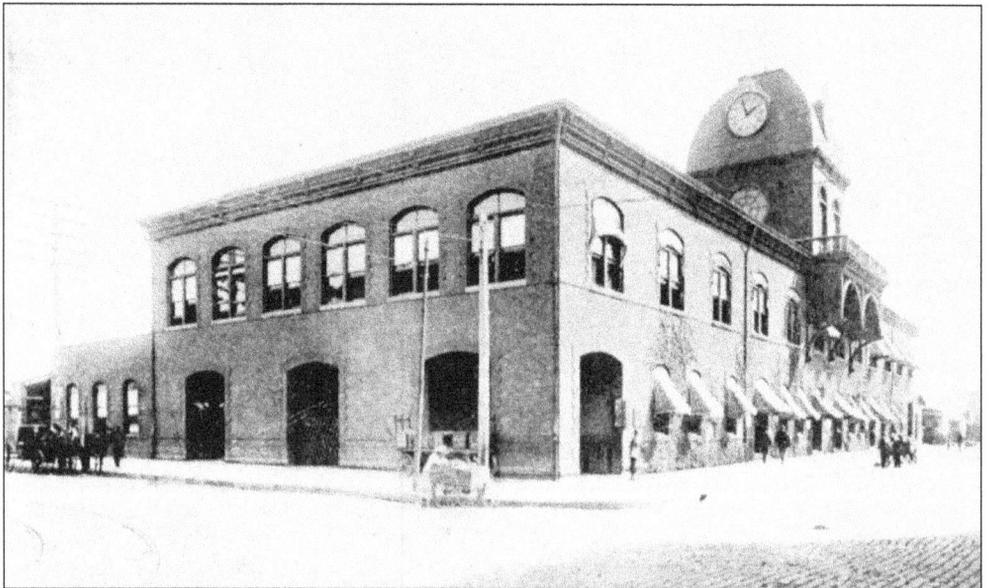

This is the 1891 Long Island Railroad terminal at Hunters Point on Borden Avenue and Second Street. Railroads set into motion unstoppable development pressures and accelerating social change, factors that sparked Long Island City's creation. This train depot burned in 1902, was rebuilt, and was finally torn down in the late 1930s to make way for the Queens-Midtown Tunnel. (Courtesy GAHS.)

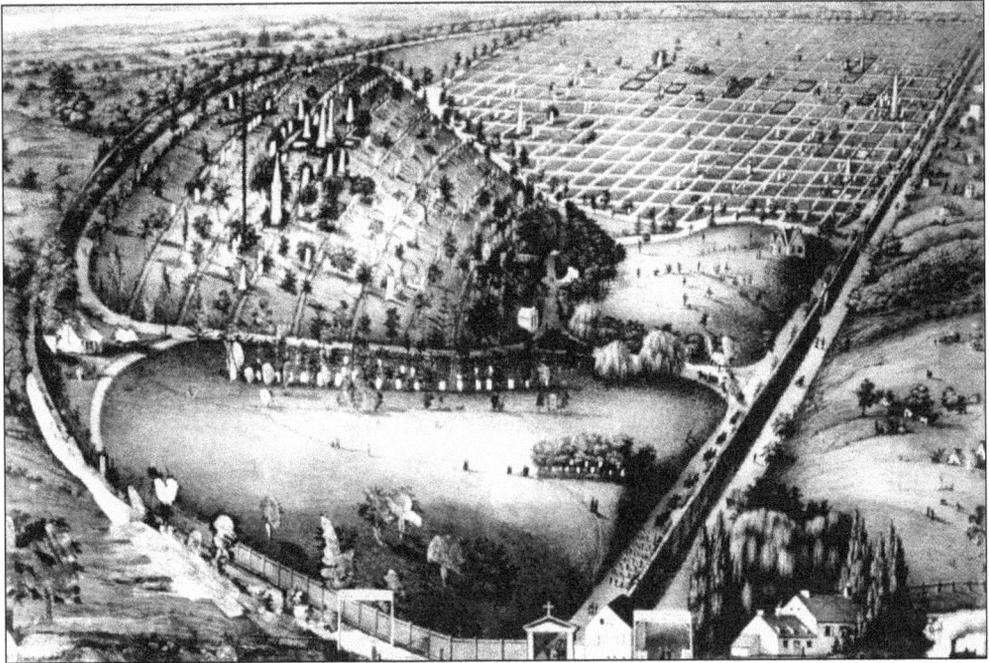

This 1865 panoramic view of Calvary Cemetery displays property acquired by the Roman Catholic archdiocese of New York after burials were forbidden in lower Manhattan. The largest cemetery within Long Island City was originally the Alsop family farm. The trustees of old St. Patrick's Cathedral purchased this 80-acre tract in 1846 for $18,000. The first body interred, Esther Ennis, was buried on July 31, 1848. (Courtesy GAHS.)

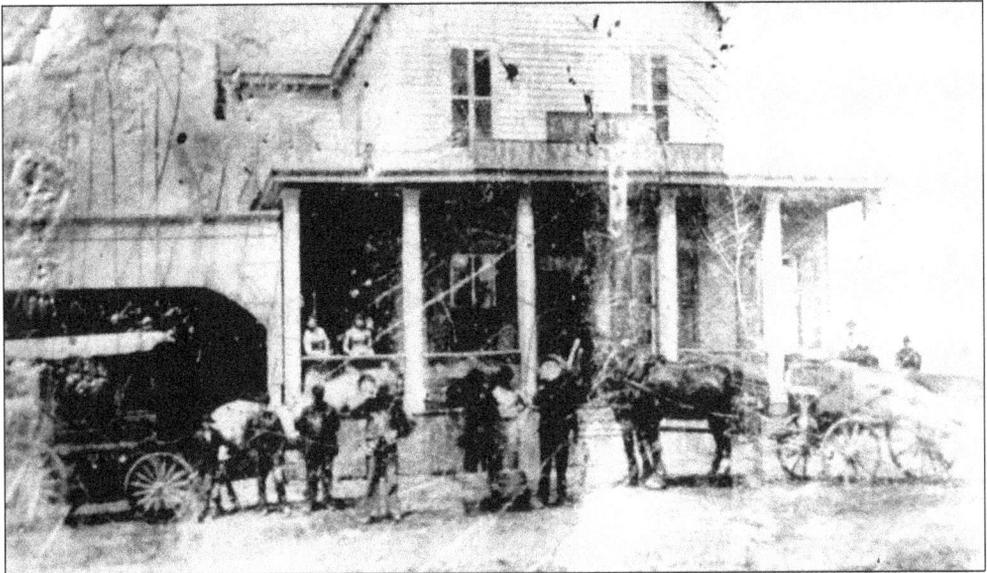

One of the earliest photographs of Sunnyside shows the Sunnyside Hotel, built by circus man Joseph Cook. The hotel was popular with crowds at Corona's Fashion Race Course in the 1850s and 1860s. It was bought in 1873 by Maria Nentwich, who owned it when this picture was taken. It later became a residence. This building, which gave its name to the Sunnyside community, was torn down for an automobile showroom. (Courtesy Sunnyside Chamber of Commerce.)

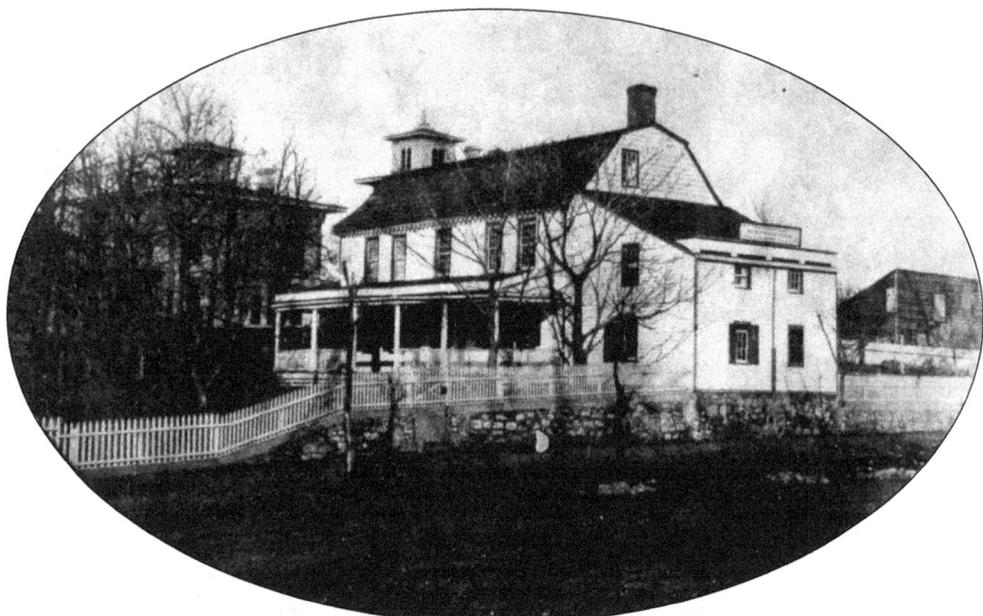

Jacob Blackwell built this residence at the foot of 37th Avenue on the East River c. 1730. It was confiscated by the British during the Revolution. The house later became a school and then a picnic grove before being destroyed in 1901 (see page 14). (Courtesy GAHS.)

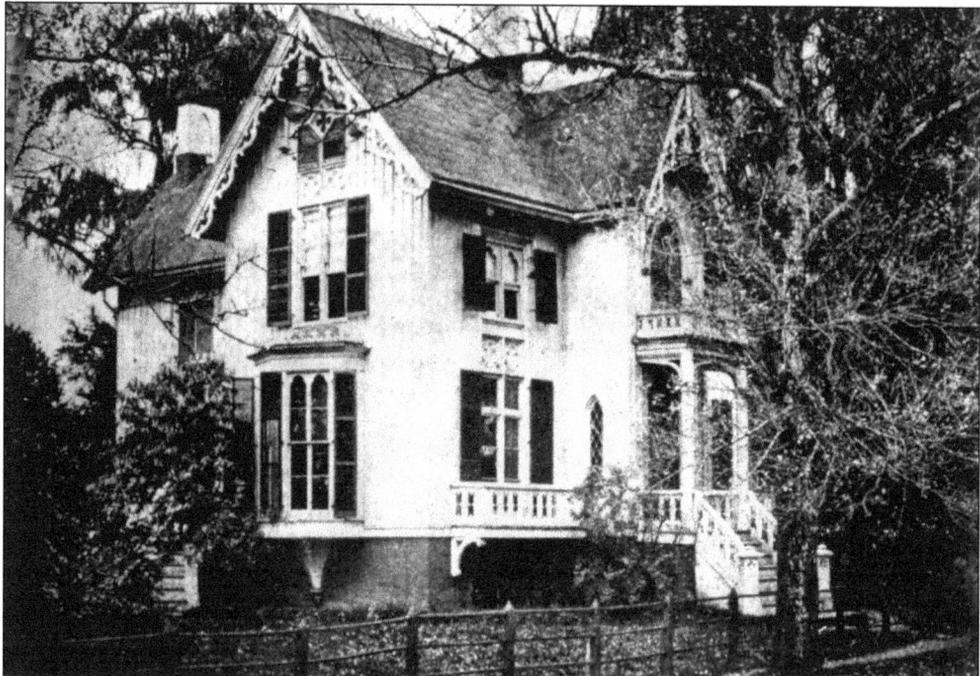

Intending to create a beautiful private residential park with an unmatched view of the East River, Col. George Gibbs purchased land along the shoreline in 1814. His group adopted the name Ravenswood. This delightful house, one of four on 38th Avenue built c. 1850, was a typical dwelling near Vernon Boulevard. Industrial development obliterated the community within a few generations. (Courtesy GAHS.)

St. Thomas's Protestant Episcopal, organized in 1849, was the fashionable church for the wealthy who lived in the mansions along the East River shore in Ravenswood. When the first building, on Vernon Boulevard and 38th Avenue, burned down, a new one opened in 1869. After the area became commercial in the 1870s, the congregation fled, and the parish could no longer support a minister. The church limped along until it burned down in 1922. (Courtesy Bob Stonehill.)

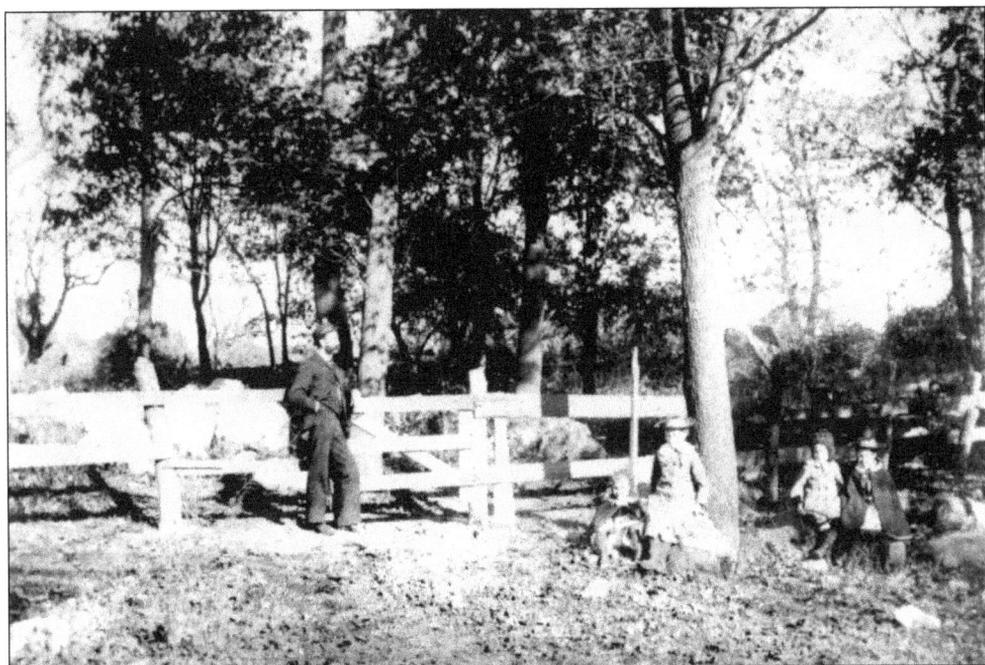

On the crisp, fall day of October 29, 1883, this family posed on a wayside picnic along Vernon Boulevard in Ravenswood. It is astonishing that even when industry had already started to intrude on this once fashionable community, a rural retreat was still possible. (Courtesy GAHS.)

21

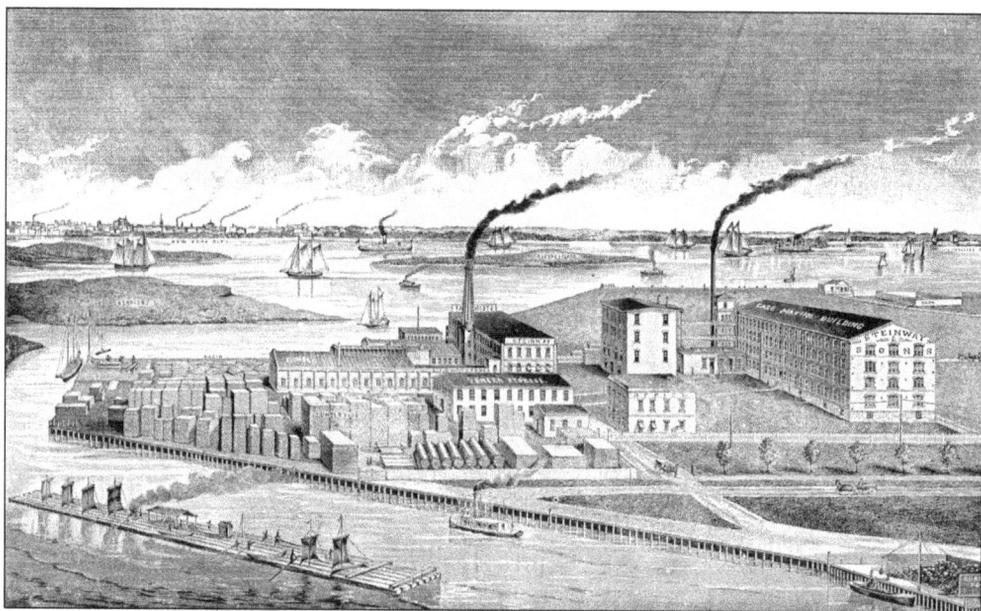

According to an 1882 advertisement, "Messrs. Steinway & Sons have erected and now have in active operation a large mill, iron & brass foundry, machine shops, metal works, wood carving and piano-forte key-making departments, extensive lumber yards storing 2,000,000 feet of lumber for open air drying, and during the summer of 1879, erected a new factory building, four stories high, 213 feet long, for the accommodation of 300 additional workingmen." (Courtesy Steinway & Sons.)

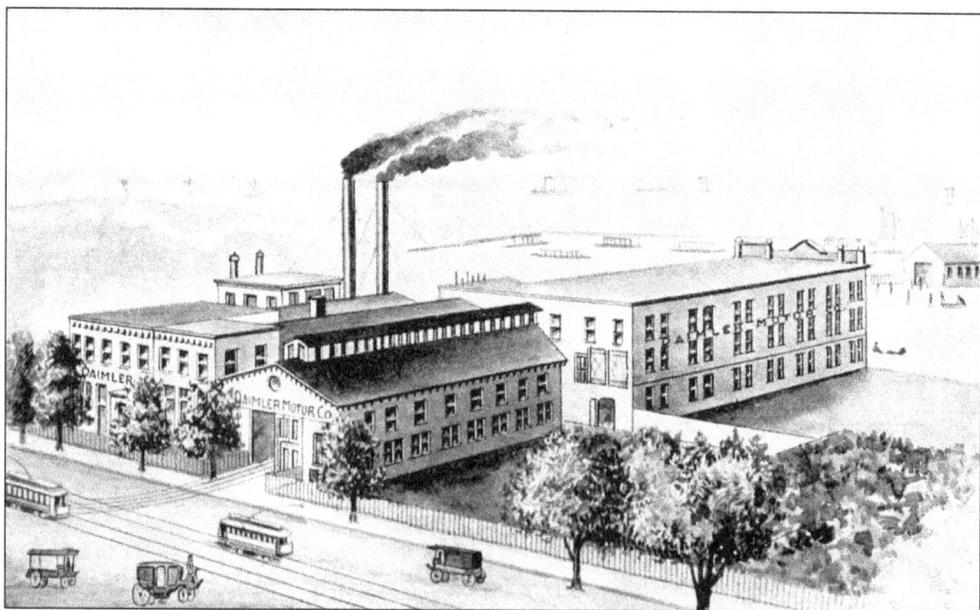

After Gottlieb Daimler perfected the internal-combustion engine, he leased the North American rights to friend William Steinway. This was one of the first automobile plants in the nation. The Daimler works on Steinway Street made Mercedes cars from 1898 to February 1907, when the factory burned down. The Steinway family decided to get out of the automobile business and concentrate on pianos. (Courtesy GAHS.)

This building housed the Steinway Library (as well as one of the first kindergartens in the country), a public-spirited and philanthropic endeavor of the family. Taken over by the Long Island City Public Library, and later absorbed into the Queens Borough Public Library, it is the largest circulating library in the country today. The portrait of William Steinway still looks down on the reading room of the library's Steinway branch. (Courtesy GAHS.)

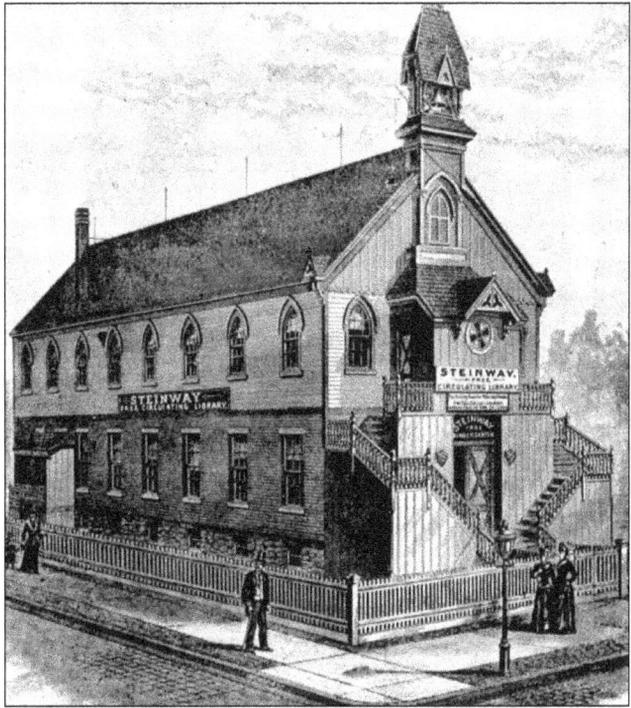

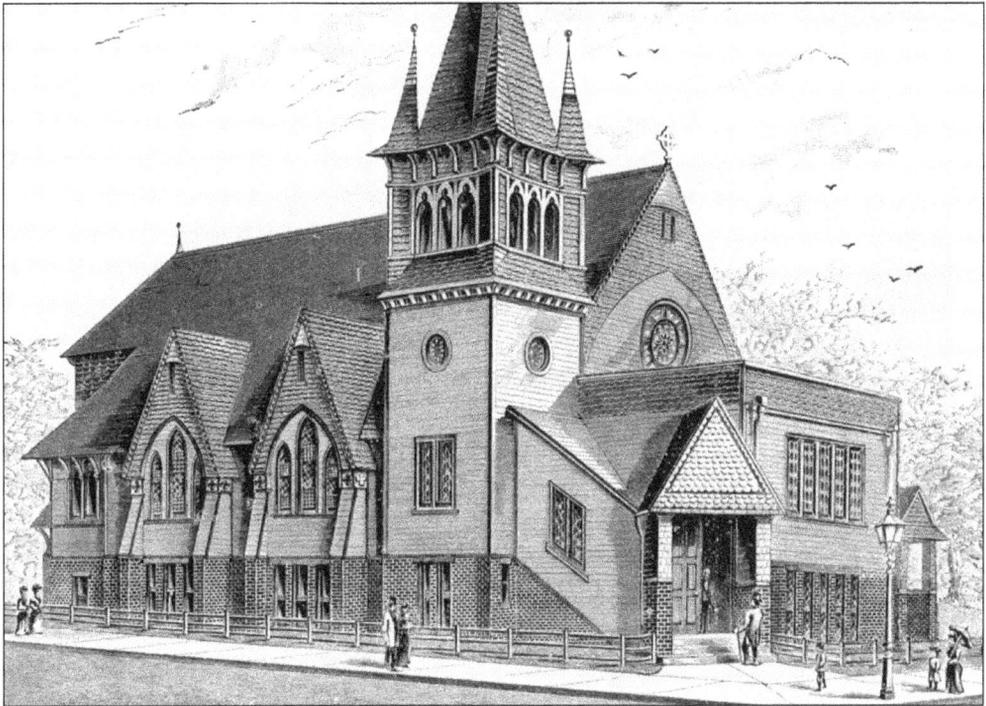

The Steinway Reformed Church began in 1879 and later expanded to a new location on the northeast corner of 41st Street and Ditmars Boulevard in 1891. William Steinway contributed a pipe organ from Steinway Hall in New York. This rural Gothic gem does not enjoy landmark protection. (Courtesy GAHS.)

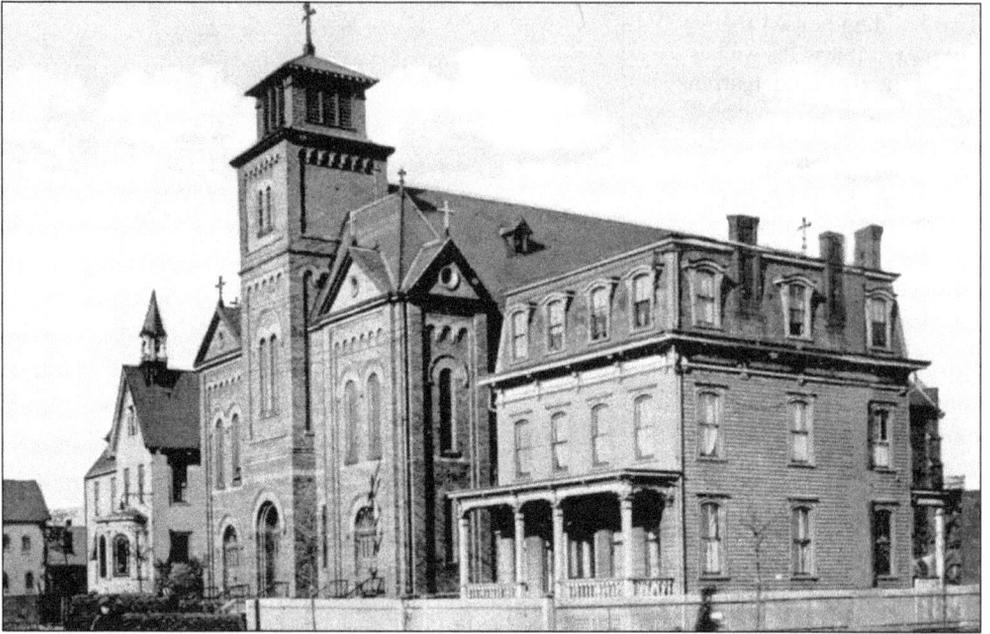

In 1880, German Catholics near the German Settlement opened St. Joseph's church on the north side of 30th Avenue between 43rd and 44th Streets. Later, the church was expanded, and a convent and school were built. The rectory, on the right, was moved to the northeast corner of 47th Street and Newtown Road in the 1920s. (Courtesy Bob Stonehill.)

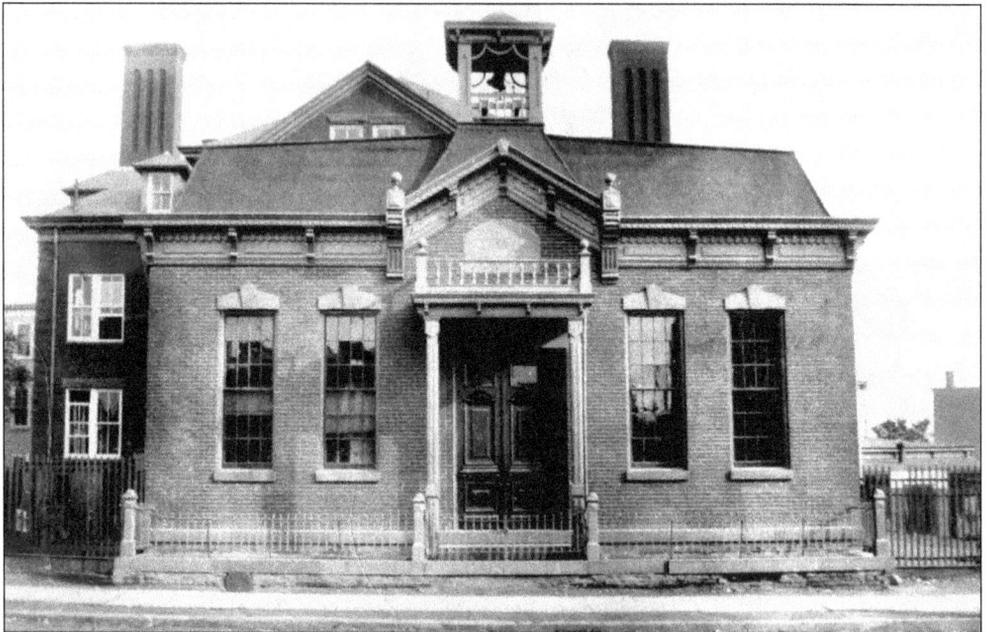

The 1885 Fourth Ward (Astoria) Primary School, on 38th Street between 31st Avenue and Broadway, was one of the first schools put up by Long Island City. This one-story brick building, with only 12 classrooms, was enlarged to Steinway Street in 1905. After the building was demolished in 1968, the Steinway Street portion became a parking lot and the rear portion, on 38th Street, became a park renamed Sean's Place during a 1998 renovation. (Courtesy GAHS.)

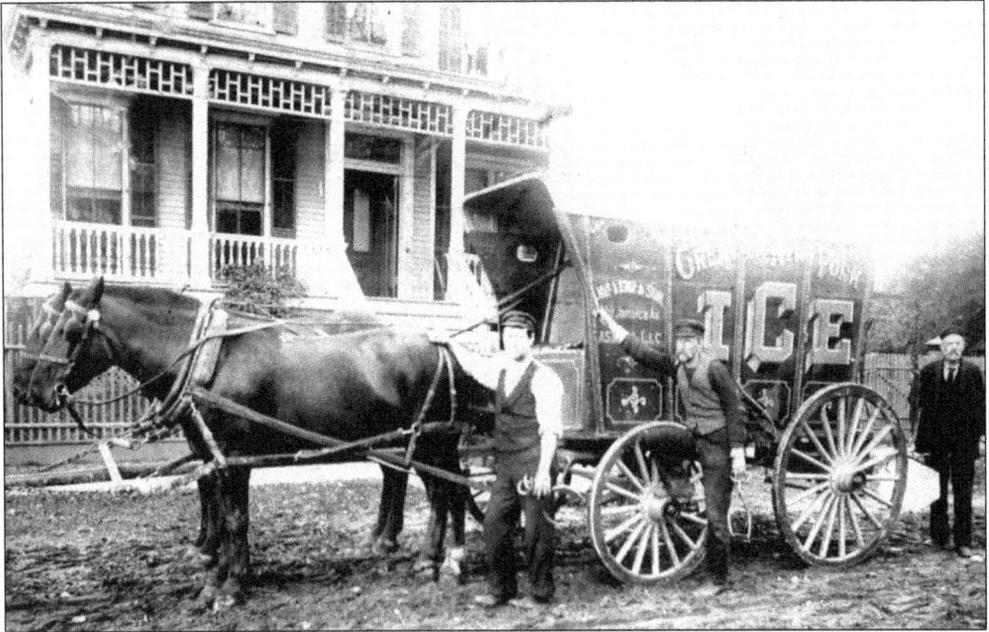

Employees of Joe Lenz & Son of the Great New York Ice Company from "Jamaica [31st] Avenue Astoria, L.I.C." pause on their rounds, ice blocks in hand and ice tongs at the ready. Before refrigeration, ice was harvested in the winter and stored for delivery to the icebox year round. Hideously muddy streets, a horse and wagon, and a meticulously maintained house complete this little gem. (Courtesy Robert Singleton.)

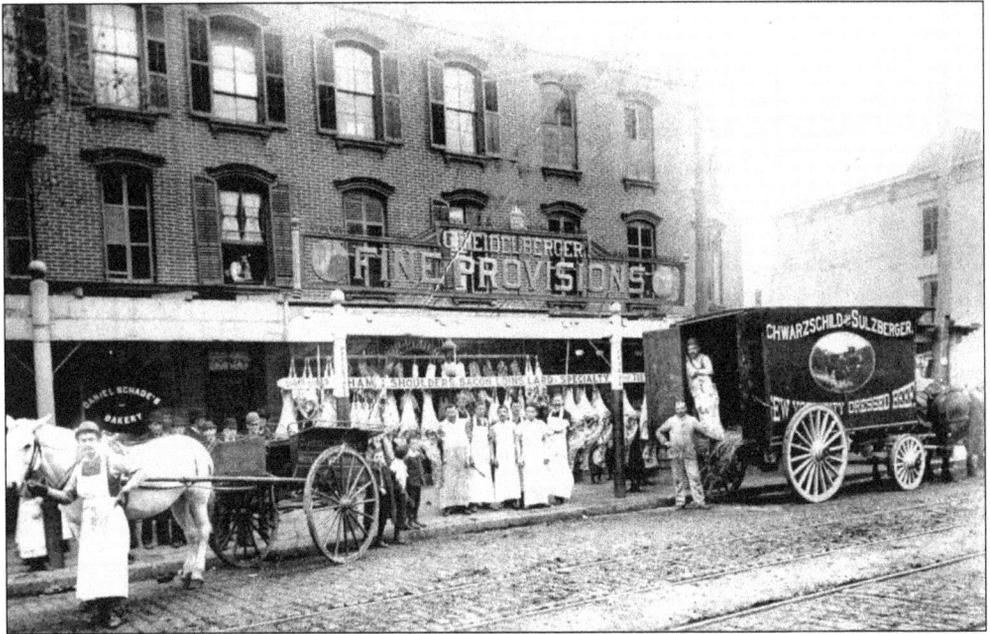

The butchers of C. Heidelberger Fine Provisions await a delivery of Schwarzschild & Sulzberger New York dressed beef. Butchers, bowler-hatted men, and the inevitable group of kids stand around for the photographer in this late-19th-century glimpse of Vernon Boulevard, probably in Hunters Point. (Courtesy GAHS.)

This *c.* 1900 photograph was taken at 27th Avenue and Fourth Street. With such solid institutions as "the Hill" and the 1848 First Presbyterian Church in the background, residents of Old Astoria Village confidently look to the future. When the village was founded, 70 years earlier, this was farmland. By 1950, everything was gone. The Astoria Houses replaced all the buildings on the right. (Courtesy Bob Stonehill.)

This rare 1884 portrait of St. George's Row (Welling Street) recently came to light. From left to right are Susan Dean Andrews, Florence Rainey, Minna ?, Bert ?, Dave ?, Ed Skidmore, Lucy Litchfield, and Andrew Litchfield. (Courtesy Robert Singleton.)

Francis Stein, purveyor of "Segars & Tobacco," stands next to a furniture store at approximately Astoria Boulevard and 18th Street. The vintage gaslight and tall pole, perhaps supporting a telegraph line, dates this scene from *c*. 1875, but the building may be much older. (Courtesy GAHS.)

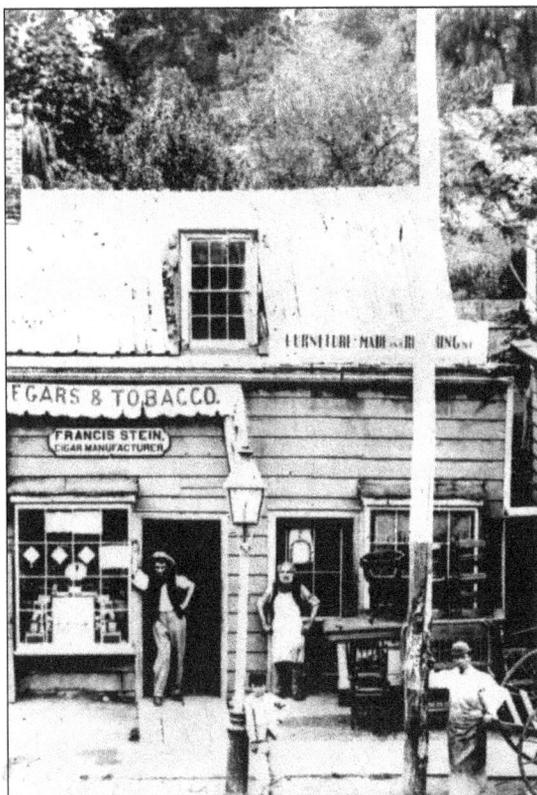

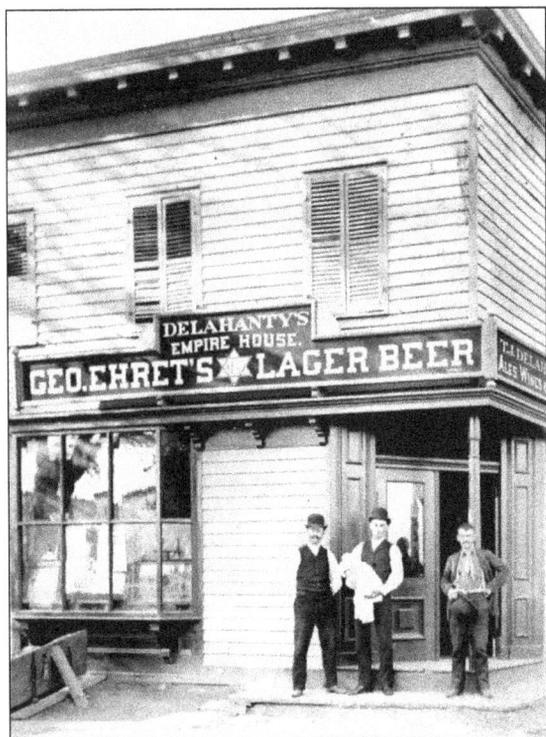

A proud father shows off his new baby to his drinking buddies at the northwest corner of 21st Street and Astoria Boulevard *c*. 1910. Except for postcards and pictures of churches or civic buildings, little vignettes from this time are rare. (Courtesy GAHS.)

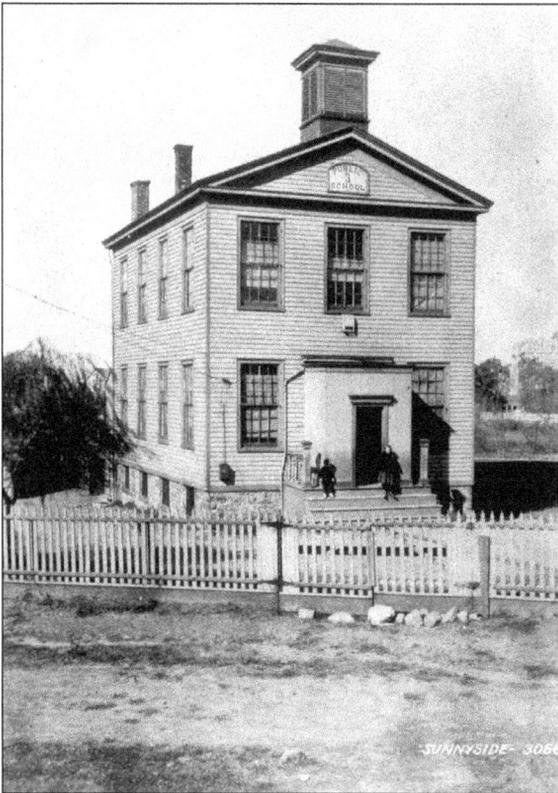

A school was built sometime before 1850 at approximately Skillman Avenue and 32nd Street in what is today the Sunnyside Railyards. It was the Hunter's Point–Dutch Kills School of Newtown Township. After it burned down, this building replaced it and continued as Primary School No. 3. After the Pennsylvania Railroad bought up the neighborhood and demolished the houses, the school was closed in March 1907. (Courtesy GAHS.)

After starting Greenpoint, Brooklyn, Neziah Bliss acquired land across Newtown Creek and formed the hamlet of Blissville, whose main street, Greenpoint Avenue, connected the two communities. Since the 1840s, Blissville was densely settled along Greenpoint Avenue from Newtown Creek up to Hunters Point Avenue. This c. 1910 view, looking east, shows the entrance to Calvary Cemetery on the right. St. Raphael's Church is in the distance. (Courtesy Bob Stonehill.)

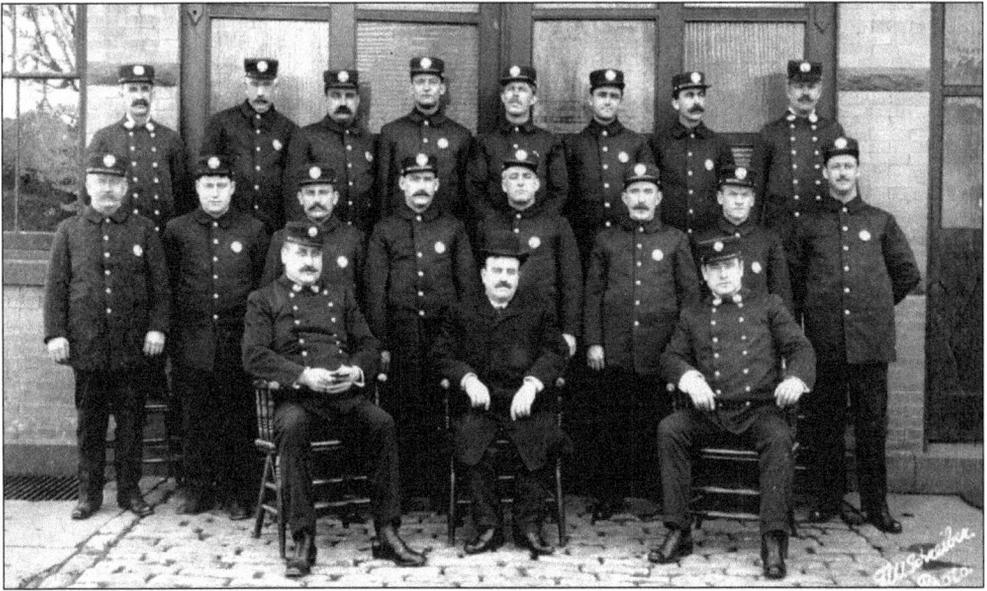

The classification of "exempt" for firemen indicated that as long as they remain volunteer fire personnel they were excused from certain civic obligations, including military service. For many years, there were three retired firemen's associations in Long Island City: the Exempt Firemen at 30th Avenue and Crescent Street, the Veteran Firemen at Astoria Boulevard and Main Avenue, and the Volunteer Firemen at 27–01 Jackson Avenue and 43rd Avenue. The last survivor died in 1961. (Courtesy GAHS.)

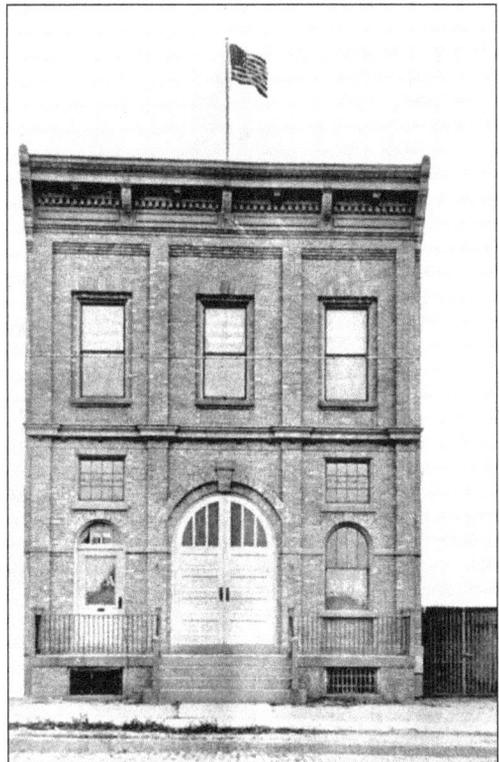

The first fire company was organized in Old Astoria Village in the 1840s. Long Island City's nine fire companies became professional in the 1890s. Equipment from Steinway, Astoria, and Long Island City units are preserved in the New York City Fire Department Museum in Manhattan. This building, home to the Exempt Firemen Association on 30th Avenue, was altered when taken over by a medical clinic a few years ago. (Courtesy GAHS.)

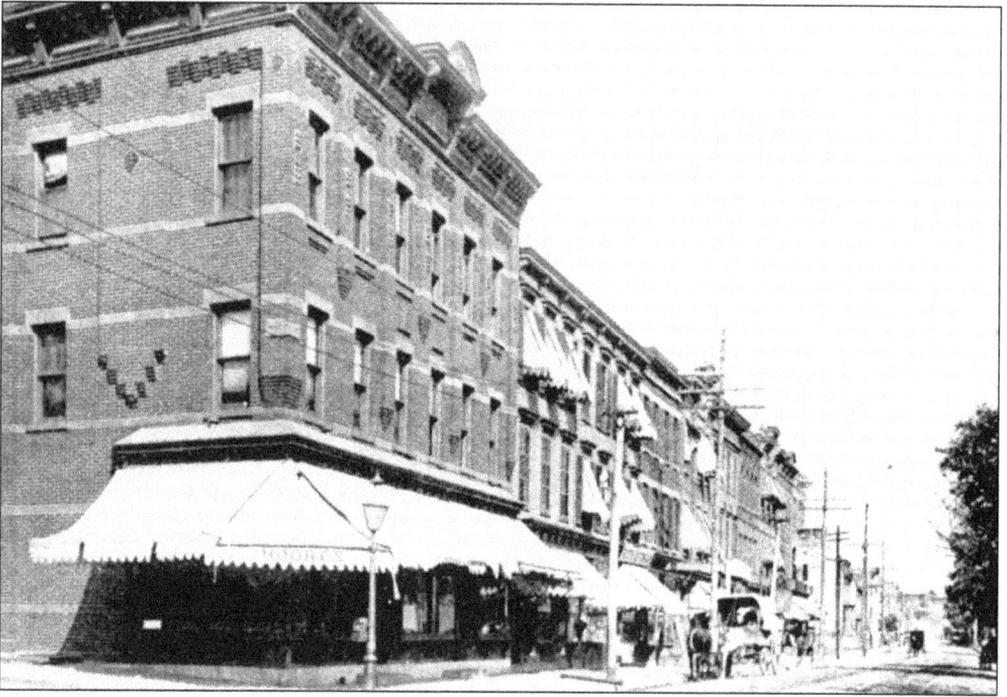

Main Avenue was the center of Old Astoria Village. A small remnant of this road still exists today. Stores and small houses occupied both sides of the street. The Kouvalenki watch and jewelry store stood at the corner of Main Street and Astoria Boulevard in 1867. (Courtesy GAHS.)

In July 1873, with the aid of steam shovels, Steinway Street was cut through from Astoria Boulevard to the river. By August, the Steinway brothers had a brick store built near 20th Road. By mid-August, Steinway Street was open to traffic, and the rest, as they say, is history. (Courtesy GAHS.)

Shown on perhaps a Sunday morning, the corner of Vernon and Jackson Avenues was not often this deserted. Rudely thrust into the spotlight, Hunters Point went from sleepy backwater to city center in the blink of an eye. From 1860 to 1920, it was perhaps the most important community on Long Island. (Courtesy GAHS.)

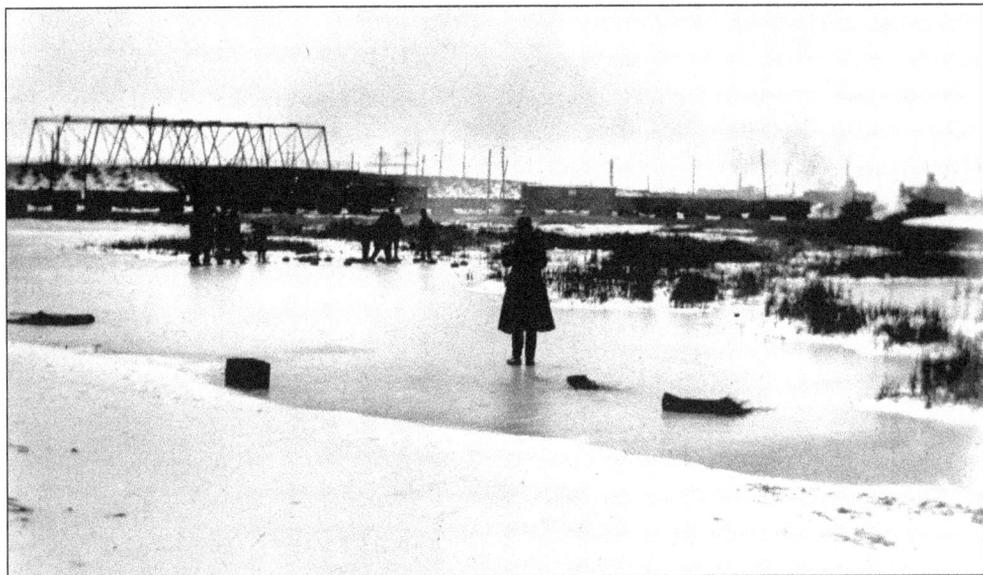

Since the first inhabitants came to Dutch Kills, the panorama of American history has played out along its banks, involving Native Americans, Dutch farmers, Hessian soldiers, and Yankee traders. Much water has flowed as it has grown from a remote hamlet to a settled township to an independent city to a part of the greatest metropolis on the planet. At the dawn of the 20th century, a person can ponder on a winter's day and wonder what the future will bring. (Courtesy GAHS.)

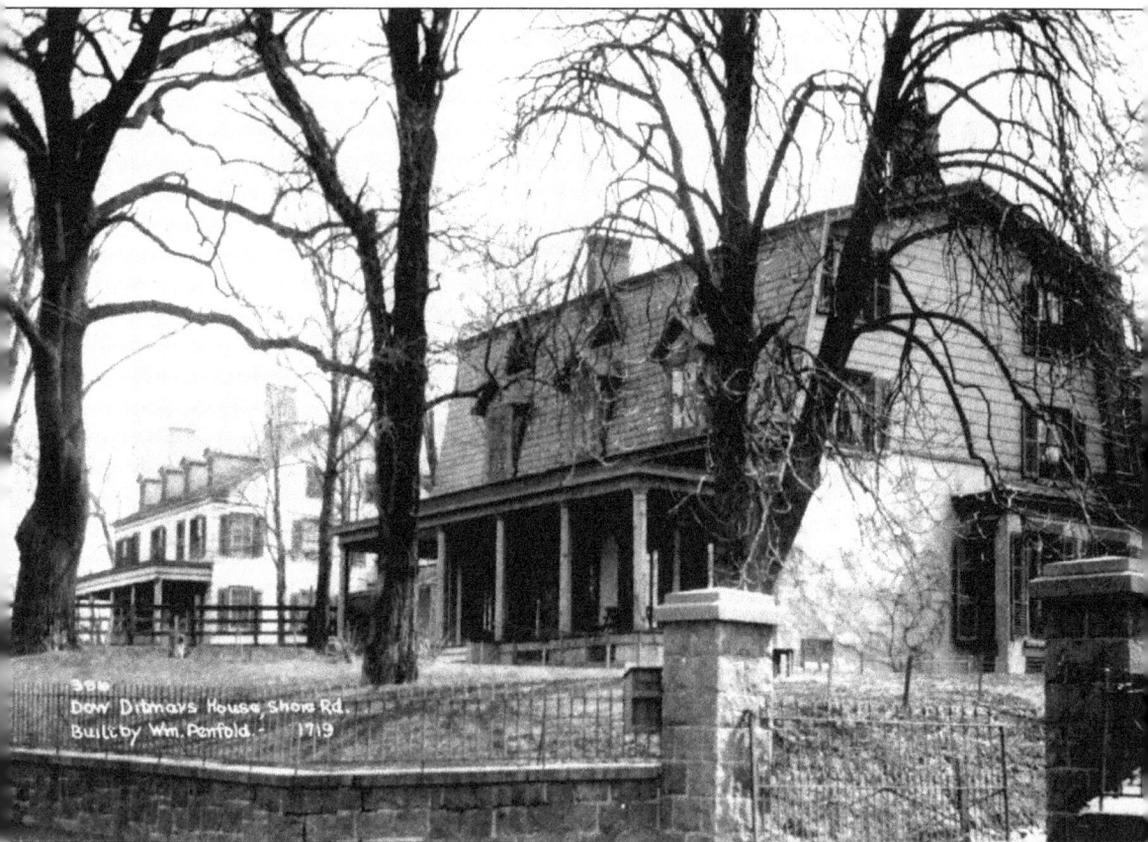

Built in 1719, this classic Dutch-style home was bought by Dr. Dow Ditmars in 1816. Located on the northeast corner of Ditmars Boulevard and Shore Boulevard, it was typical of the large estates that lined the Hell Gate shore in the vicinity of Astoria Park. The house was demolished in 1919. Dow Ditmars (1771–1860), one of the first physicians in the area, was the father of Long Island City's first mayor, Abram D. Ditmars. (Courtesy GAHS.)

Two

ARCHITECTURE
AND HOUSING

Visionaries, as much businessmen as philanthropists, planned our communities and then went on to build our model housing and factories.

The first settlements of Long Island City were along the water. Dutch farms lined Dutch Kills and Bowery Bay. Larger, imposing estates stood at Lawrence Point and Hell Gate. The Blackwell family had mansions on Roosevelt Island and Ravenswood. The Lent homestead at Bowery Bay (*c.* 1650) and the Blackwell mansion on Roosevelt Island (*c.* 1790) remain from that era.

Steamboat landings at 37th Avenue and Astoria Boulevard enabled wealthy gentlemen to build suburban retreats from Old Astoria Village (in the 1840s) through Ravenswood (in the 1850s). Their fine cottages on the East River and Bowery Bay were compared to homes in Newport, Rhode Island. A surviving example includes the 1850 Pike-Steinway mansion.

Old Astoria Village, a unique community in New York City, is still a recognizable antebellum community with churches, cemeteries, businesses, great mansions, and humble cottages. It is one of the most significant historic sites in New York state. The gardens and cow paths of the Hallett farm, laid out in the mid-1600s (a mere generation after the lower Manhattan street grid), form the basis for its streets. Each year, several of the beautiful homes of Old Astoria Village are torn down.

After its 1870 incorporation, Long Island City reflected its satisfied status as an independent city with a pleasing collection of cultural and civic buildings. Many of the schools, social clubs, churches, and firehouses built during that period are still standing. Public School No. 1 (PS 1) was the largest school on Long Island when completed in 1892. Several churches from the golden age of Long Island City's independence remain the tallest structures in their neighborhoods, their spires proud place markers pointing to their communities from afar.

Our community became the obvious choice for the county seat of Queens County, which, at the time, included today's Nassau County. The imposing Queens County Courthouse (later Long Island City Courthouse) dates from 1876.

The Queensboro Bridge (1909) and the elevated trains (after 1915) opened Long Island City to explosive development. The timing proved to be fortuitous—not only was it a time when civic planners were passionate about remedying the twin evils of tenement housing and sweatshops, it was also a time when planners were anxious to find a place for their ideas to see the first light of day. Long Island City moved to the forefront of American civic planning.

Long Island City, boasting both substantial residential and industrial areas, presented a rare opportunity to showcase innovative commercial and residential construction. Innovative and

affordable model housing (Mathews Model Flats), planned communities (Sunnyside Gardens), and industrial parks (Degnon Terminal) attracted thousands to live and work there.

Along the Sunnyside Railyards, most buildings, such as Degnon Terminal, are solid, fireproof structures with large windows and good ventilation. Unlike manufacturing structures in other cities, they never dropped out of favor. They are convenient to transit. Some can accommodate rail freight cars within their buildings. Whether these remain commercial structures or have been converted for nonindustrial use (as with LaGuardia Community College), they remain as viable today as when they were built nearly a century ago.

At the foot of the Queensboro Bridge, the Queens Plaza transportation hub was designed not only as a commercial and banking center for Queens, but the linchpin for New York City's fourth business district. Here, a number of notable commercial buildings are experiencing a renaissance. The restored façade of the former Brewster Building, now MetLife, looks as sharp and clean as it did when it was built in 1910 (if only the clock could be restored). A few blocks to the south, the 1989 Citicorp tower at Court Square (the tallest building between Manhattan and Boston, standing at 663 feet and 48 floors high) will soon be joined by a number of other similar towers.

Massive development projects are not new to the community. Millions of square feet of earth were moved to build the Sunnyside Railyards. By mid-20th century, the largest public housing development in the country, at Queensbridge, joined other projects giving shelter to thousands in Ravenswood and Astoria. Undoubtedly the most ambitious proposal in the metropolitan region, the Queens West Development Corporation, a subsidiary of New York state's Empire State Development, under the collective sponsorship of the Port Authority of New York and New Jersey and the New York City Economic Development Corporation, plans a number of enormous apartment buildings, permanently transforming the waterfront at Hunters Point.

The successful Hunters Point Historic District is the first designated New York City landmark community in Queens.

The Long Island City Courthouse, in the county seat of Queens, was completed in 1876 and dedicated in April 1877. George Hathorne was the architect. This Beaux Arts–Baroque building was destroyed by fire in 1904. The present building, rebuilt by 1908, was constructed upon the remaining walls of the former courthouse. Today, the courthouse is now home to the New York State Supreme Court. (Courtesy GAHS.)

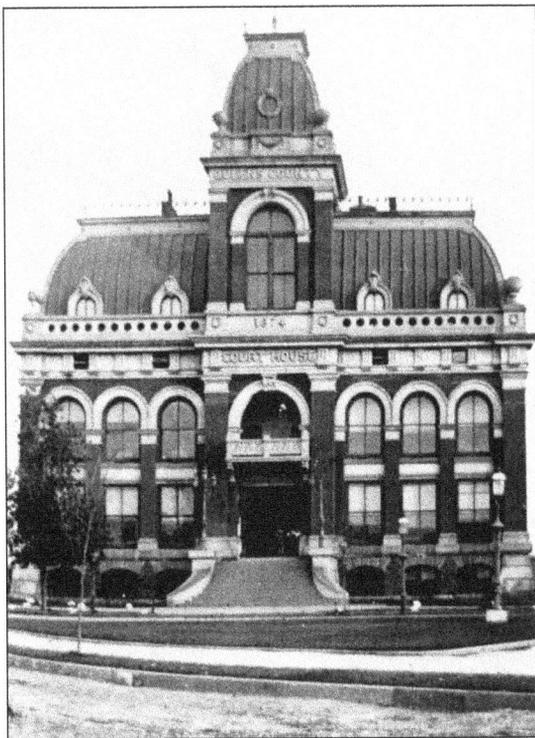

This red-brick Romanesque Revival structure lost its clock and bell tower in the 1960s. Public School No. 1, originally built in 1892, was once the largest grammar school on Long Island. It originally had 35 classrooms. A new brick wing in 1905 added 21 classrooms on the Jackson Avenue side. It has found a new life since its 1976 conversion into an international art museum—an excellent example of adaptive reuse. (Courtesy GAHS.)

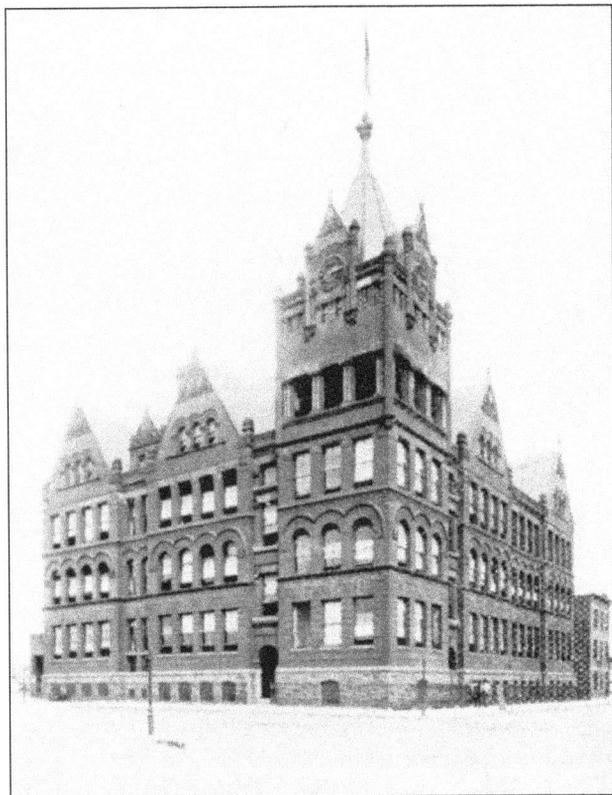

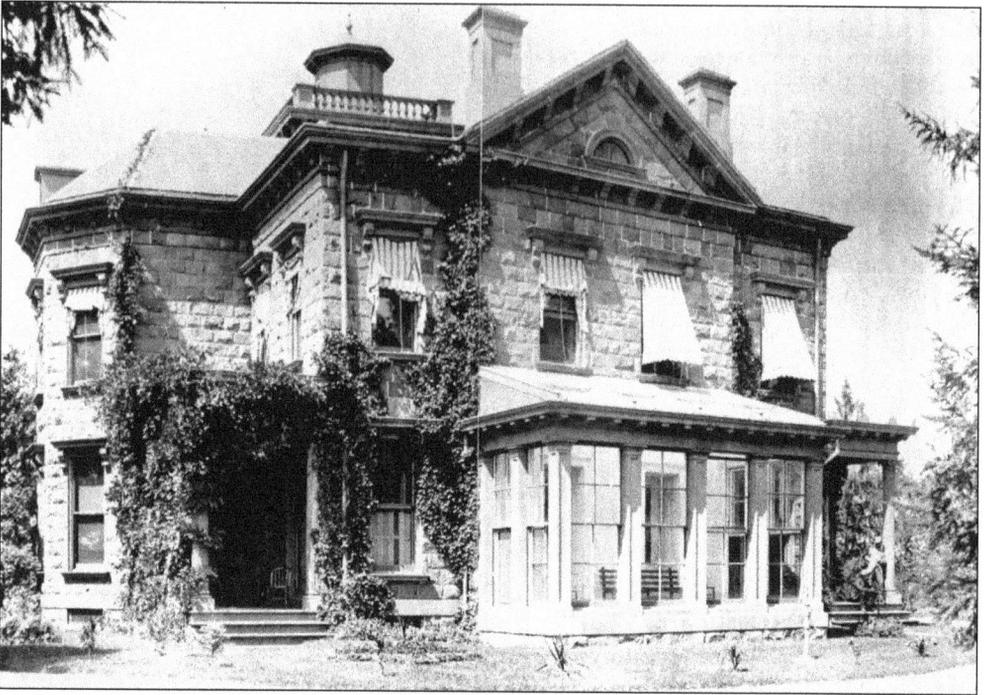

Originally the Benjamin T. Pike house, this Italianate granite villa was built in 1853. In 1870, it was purchased by the Steinway family as their summer residence. In 1966, it was designated a New York City landmark. (Courtesy GAHS.)

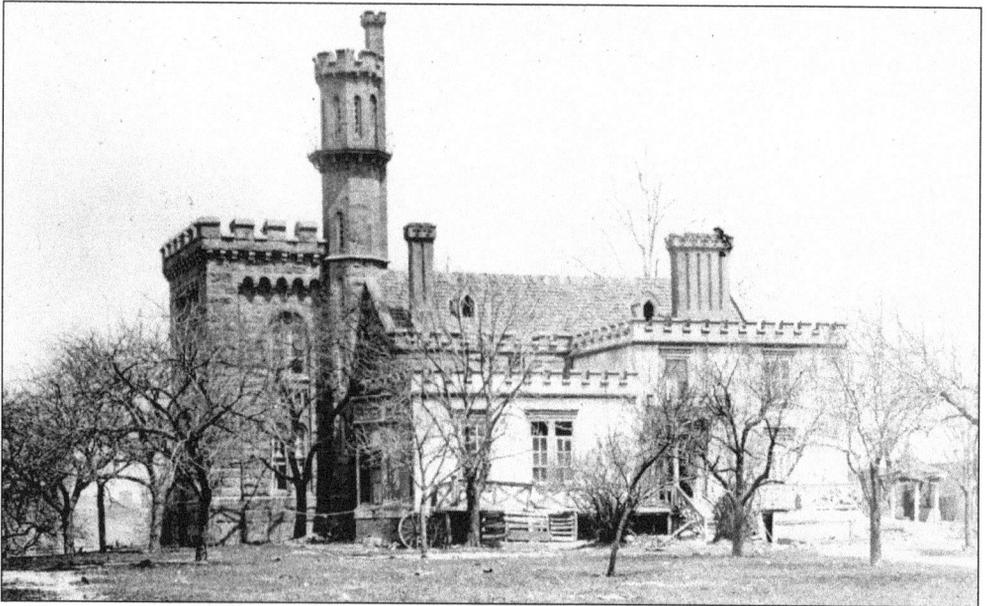

Ravenswood became a fashionable community c. 1840. The most spectacular mansion, Bodine Castle (c. 1850), was a Gothic Revival gem on Vernon Boulevard. This magnificent structure inspired wild myths of dark dungeons and star-crossed lovers. Col. John Bodine, a merchant, lived here from 1860 to 1885. Within a few decades, overwhelmed by industry, Bodine Castle was the last mansion in the area. It was demolished in 1966 by Con Edison. (Courtesy GAHS.)

St. Raphael's Church, at 35–20 Greenpoint Avenue in Blissville, started as the mortuary chapel for Calvary Cemetery. Its congregation was organized in 1867. The original building was a wooden framed structure, and the current brick-and-sandstone building opened for Roman Catholic services in 1885. Its steeple is a prominent local landmark visible throughout the community. (Courtesy GAHS.)

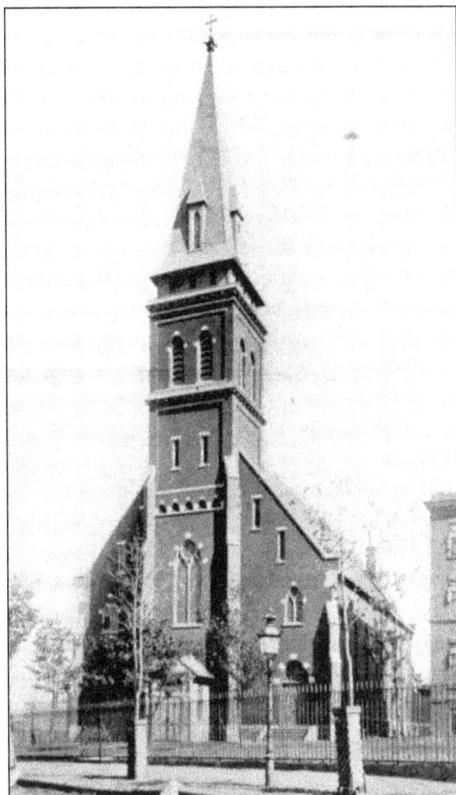

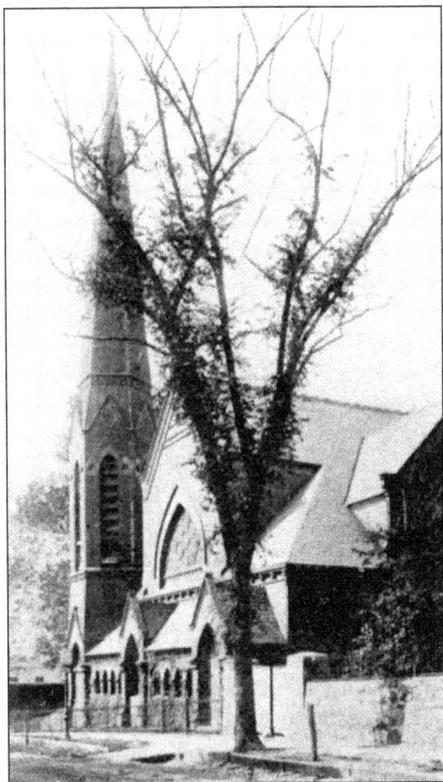

The Reformed Dutch Church, on 12th Street near 27th Avenue in Old Astoria Village, was built in 1889. This building still stands, although the 1900 steeple has been removed and the stained-glass windows are bricked up. Organized in 1836, it is one of the oldest cultural institutions in the community. It has a tiny cemetery in the back that supposedly holds the remains of Stephen Halsey, "the Father of Astoria." (Courtesy GAHS.)

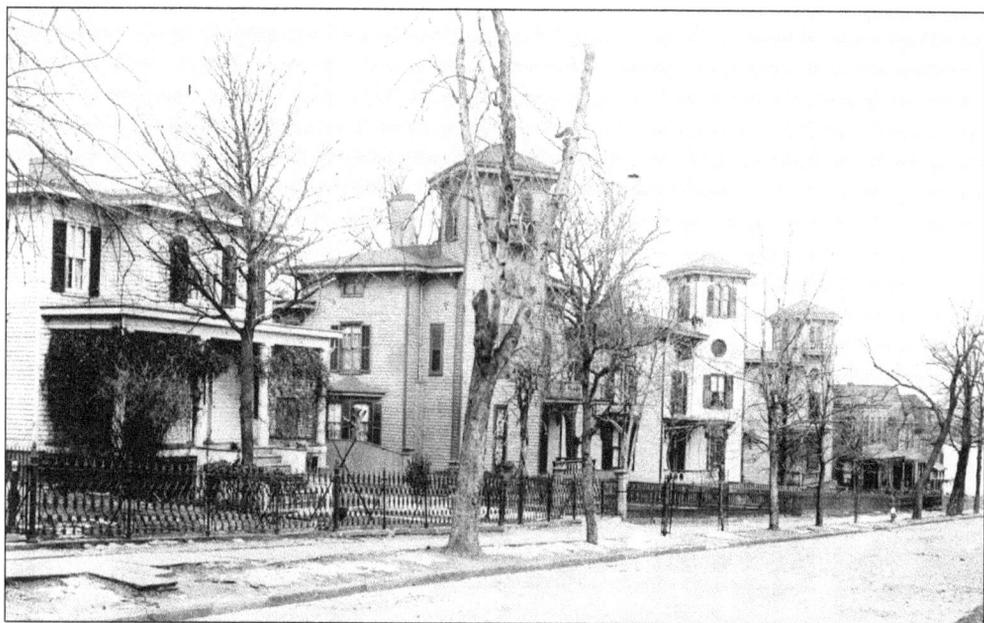

Representing a pleasing sweep of domestic Victorian architecture of its day, this block of stately homes on 12th Street in Old Astoria Village existed up to about 20 years ago. Only the structure on the left remains, as this community has seen overwhelming development (see page 123). (Courtesy Bob Stonehill.)

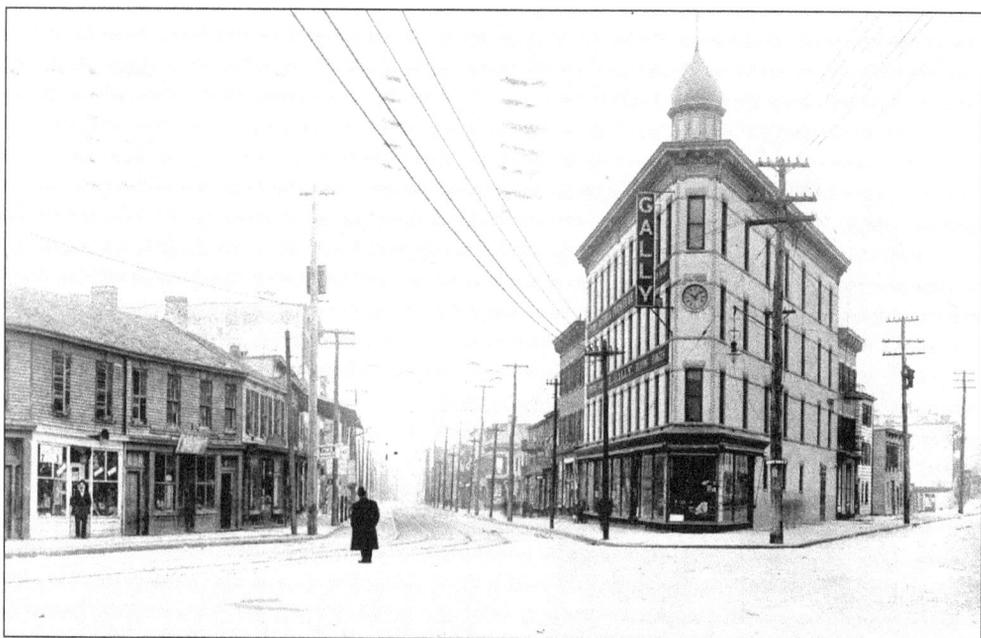

Located at 21st Street, Astoria Boulevard, and Newtown Avenue, the Astoria "Flatiron" building still commands this intersection. Newtown Avenue, on the left, was the mid-17th-century road to the Hallett settlement. This was the commercial center of Old Astoria Village, housing a series of furniture stores from Gally's (*c.* 1910) to Ethan Allen (the 1980s). (Courtesy Bob Stonehill.)

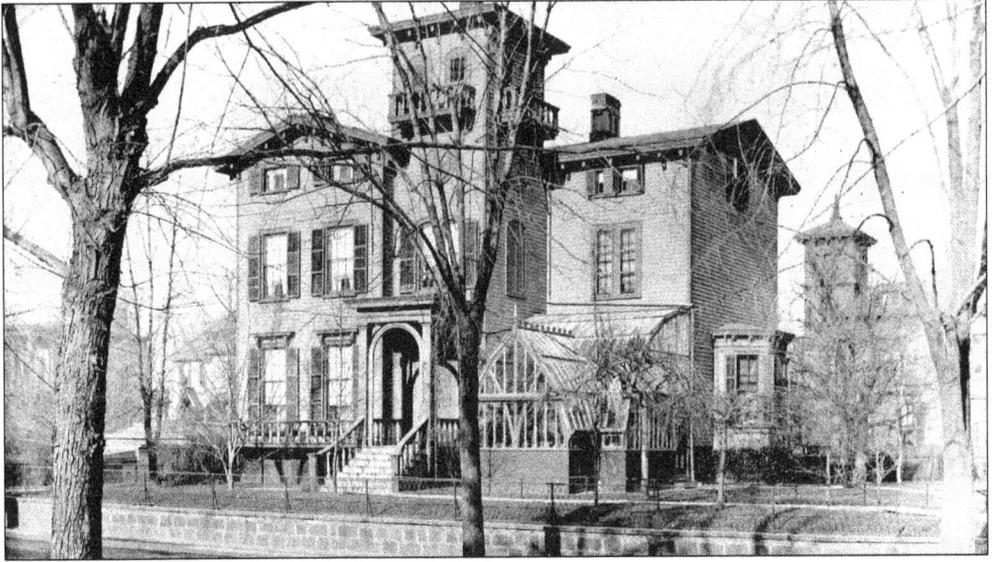

This was the home of the Hagemeyer family from 1878 until 1894. This Italianate structure was located on the corner of 27th Avenue and Ninth Street, on the Hill, the most fashionable section of Old Astoria Village. (Courtesy GAHS.)

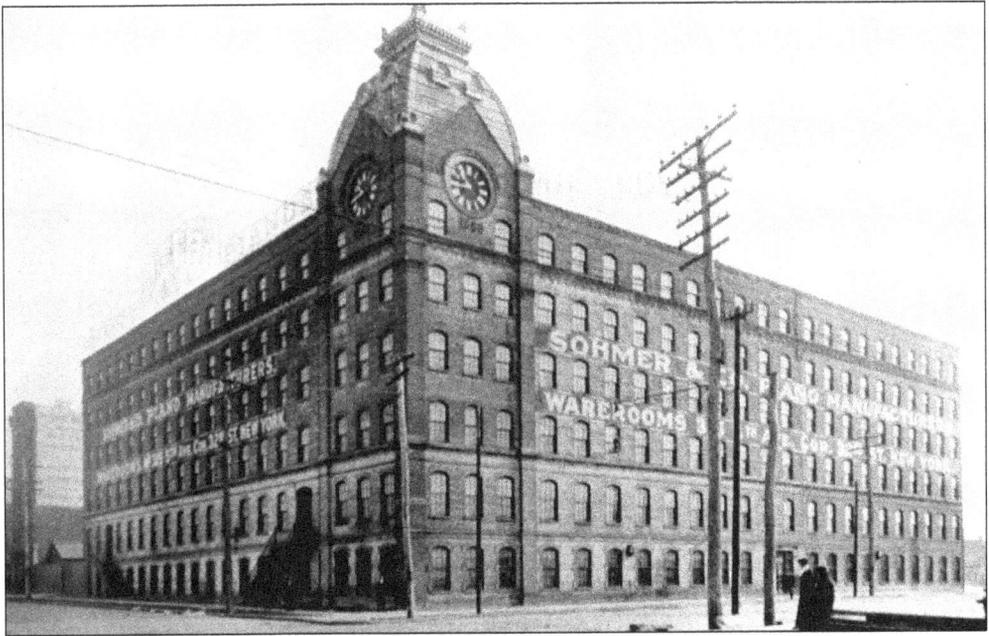

This stunning early industrial building was the home of the Sohmer Piano Company and, later, Adirondack Furniture. The building was constructed in 1886, and the top story and mansard roof were added in 1910. Located at Vernon Boulevard and 31st Avenue, this landmark-worthy building is endangered. (Courtesy GAHS.)

800 HOUSES SOLD_150 BUILDING

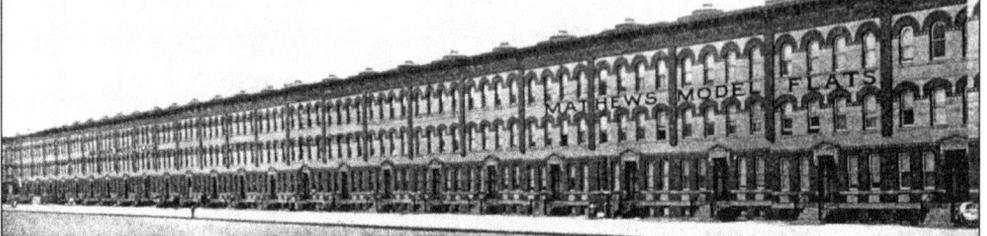

MATHEWS MODEL FLATS

JACKSON AVE. & 18TH AVE., L.I. CITY

Mathews Model Flats on 48th Street in Long Island City were built between 1915 and 1925. These landmark-worthy, three-story, six-family model apartment buildings are named for the builder Gustave X. Mathews. His family built over 1,000 of these buildings in Ridgewood, Astoria, Sunnyside, and Woodside from yellow Kreischerville (Staten Island) brick. (Courtesy the Mathews family.)

SOLVING THE N. Y. CITY HOUSING PROBLEM

MATHEWS MODEL FLATS

QUEENS COUNTY N.Y. CITY.

800 OF THESE HOUSES SOLD -NEVER A SINGLE FORECLOSURE.

IMPROVEMENTS:

1. EVERYTHING "NEW LAW"
2. TILED VESTIBULE.
3. OPEN PLUMBING.
4. IRON FRONT DOORS.
5. PERFECT DRAINAGE.
6. 30% LOT VACANT.
7. WELL LIGHTED HALLS.
8. HOT AND COLD WATER.
9. ELECTRIC LIGHT & GAS.
10. CLEAN CELLAR WITH AMPLE STORAGE BINS.
11. PERFECT TRANSIT – 8 MINUTES TO TIMES SQ.
12. B.R.T & INTERBORO' SUBWAY STATION ON PROPERTY.
13. 5 CENT FARE TO ANY PART OF N.Y. CITY.

– INTERIOR VIEW –
– OF –

MATHEWS MODEL FLATS

MAXIMUM COMFORTS
FOR LOWEST RENTS IN GREATER NEW YORK.

800 OF THESE 6 FAMILY HOUSES BUILT BY US
25000 PEOPLE NOW LIVE IN THEM.
1000 HOUSES TO BE ERECTED

– ON –

QUEENS BOULEVARD L.I. CITY
N.Y.

MATHEWS MODEL FLAT CO.
BUILDERS

A.F. MATHEWS,
PRESIDENT

Addressing the ills of tenements, these apartments had a window in every room, allowing for light and air circulation, and were built on only 65 percent of the building lot. Louis Allmendinger was the architect. These homes were exhibited as housing marvels at the Panama Pacific Exhibition in San Francisco in 1915. The following year, one quarter of all building permits in Queens were granted to Gustave X. Mathews. (Courtesy the Mathews family.)

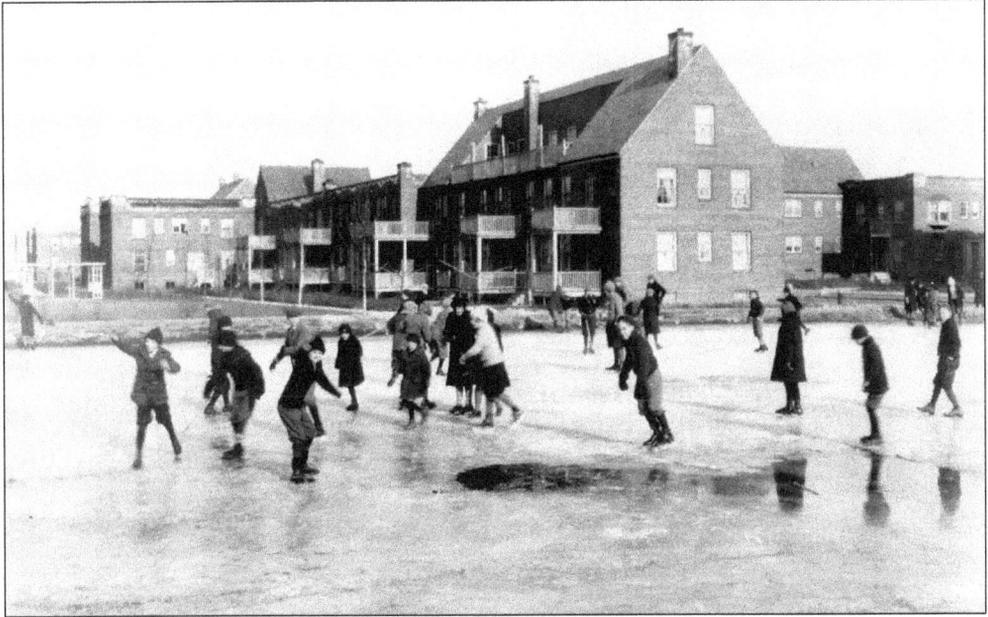

Sunnyside Gardens, built on 77 acres between 1924 and 1928, was modeled after the English garden city. This was one of the earliest and finest planned communities in the nation. It was home to famed urban planner Lewis Mumford. It boasts one of the two private parks in New York City. (Courtesy Sunnyside Foundation.)

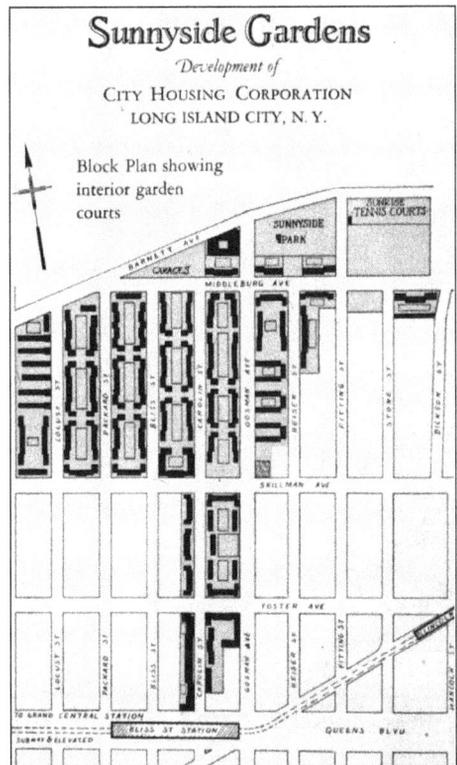

The homes in Sunnyside Gardens were designed around common courts where group activities could take place. Architects Stein and Wright arranged row housing to face both the street and interior garden spaces. This stunning development was placed on the National Register of Historic Places in New York State and is worthy of being named a New York City landmark district. (Courtesy GAHS.)

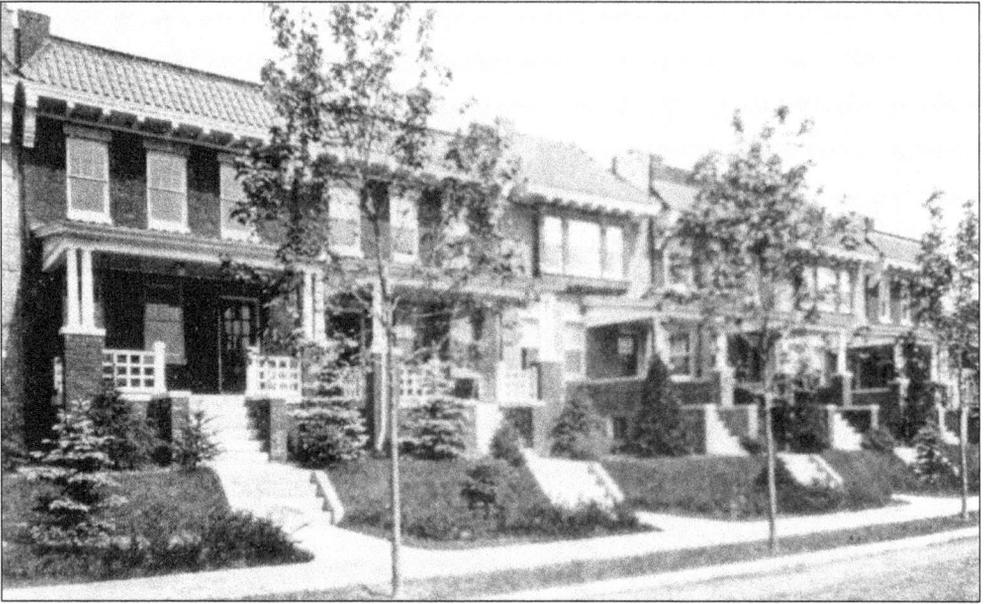

New 20th-century housing provided the residents with a healthful, suburban environment in which to raise their families. The Arleigh Houses on 28th and 29th Streets between 21st Avenue and Ditmars Boulevard, built by the Rickert-Brown Company, are an excellent example of this. These speculative mid-block row houses were completed *c*. 1925. (Courtesy GAHS.)

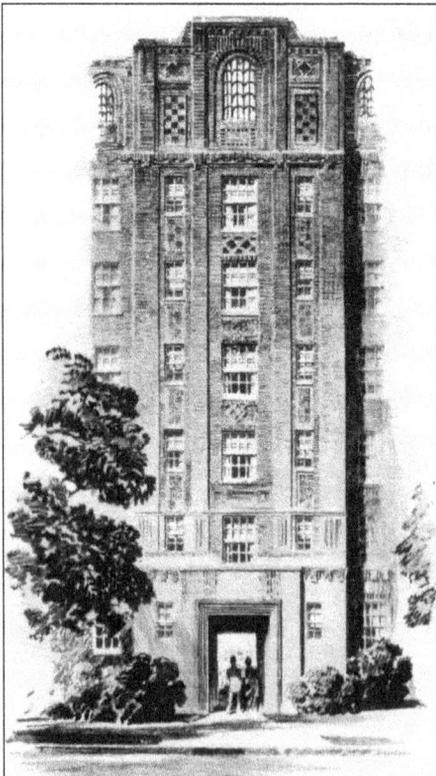

Phipps Garden Apartments are located on 39th Avenue between 50th and 52nd Streets. These apartment buildings surround a lush private center court. They were built in 1931. The apartments were designed by the firm of Clarence Stein, the architect of Sunnyside Gardens. (Courtesy Sherry Gamlin.)

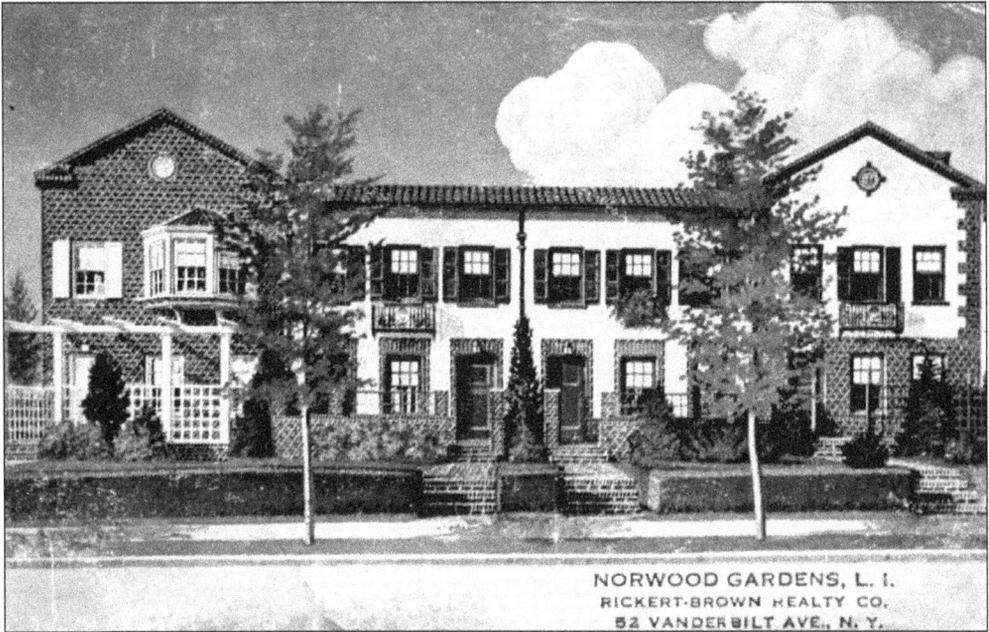

NORWOOD GARDENS, L. I.
RICKERT-BROWN REALTY CO.
52 VANDERBILT AVE., N. Y.

The red-brick and white-stucco-walled Norwood Gardens is located at 36th Street between 30th and 31st Avenues. Enhanced by lavish front yards, this landmark-worthy neighborhood is another of the fine planned housing developments unique to Queens. (Courtesy GAHS.)

The Kindred-McAvoy twin apartments are on 24th Street. Built c. 1920, these six-room homes feature decorative tapestry brick fronts. (Courtesy GAHS.)

43

Beginning in 1922, the Metropolitan Life Insurance Company became one of the largest developers and builders in Long Island City. It erected 50 buildings of 39 apartments each accommodating 1,950 families in 8,250 rooms. The idea of investing funds derived from insurance premiums was so unusual it required special action by the state legislature. (Courtesy Sunnyside Chamber of Commerce.)

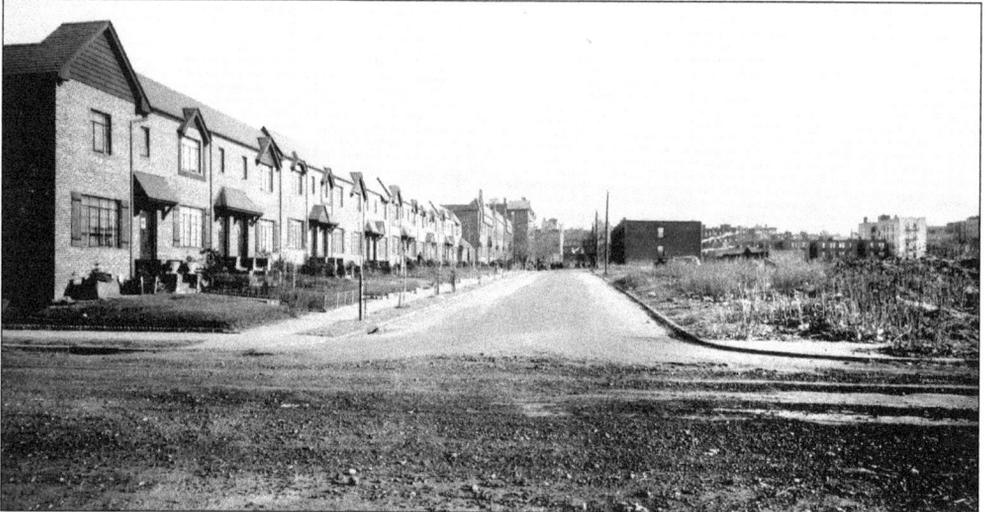

Before the 1920s, housing in Long Island City consisted mostly of two-story, frame, detached houses. Several factors created a sudden housing boom in the community, including mass transit, the lower cost of automobiles after World War I, the increase in the number of families that always follows wars, and workers wanting to live near the local factories of Long Island City. (Courtesy GAHS.)

44

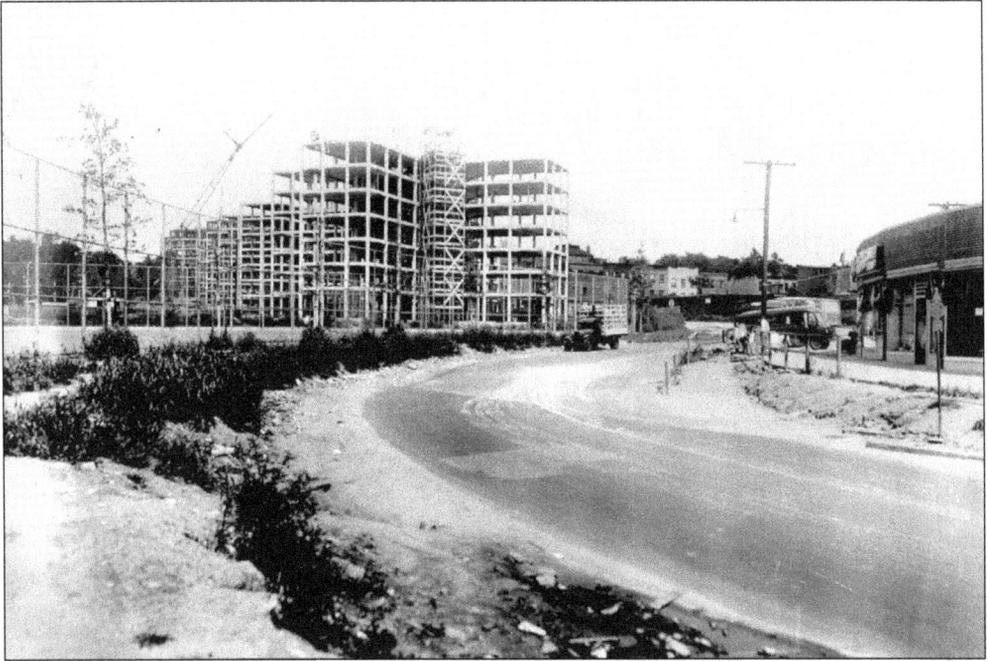

The 1,104-unit Astoria Houses are being built (1948–1949) at the site of the earliest Hallett settlement of 1652. Other public housing projects include the 1939 Queensbridge Houses, between 21st Street and Vernon Boulevard, the largest public housing development in the nation. This massive project has 3,142 units on 50 acres with 26 buildings. Also, the Ravenswood Houses (2,166 units), at the site of the former headwaters and tidal marshlands of Sunswick Creek, are between 34th and 36th Avenues. (Courtesy GAHS.)

City Lights, built in 1998, is part of the proposed Queens West master plan. It is designed to bring a Manhattan style to the shores of Long Island City. Rising on 74 acres of prime waterfront property directly across from midtown, Queens West Development is New York's largest mixed-use project in recent memory. (Courtesy GAHS.)

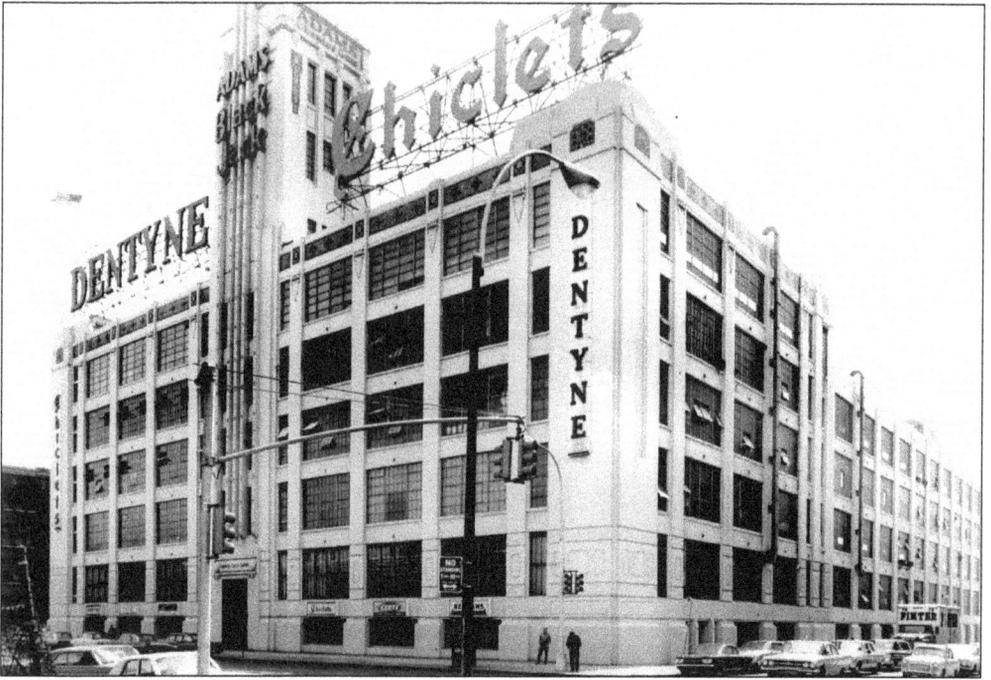

This 1914 Adams Chewing Gum factory was part of Degnon Terminal, a state-of-the-art industrial park that offered plenty of space, convenient shipping, and inexpensive utilities. These fireproof buildings lowered insurance premiums. The first big client was Loose-Wiles Biscuit at Skillman and Thomson Avenues. Within a short time, a row of big buildings sprang up, housing Packard, American Ever Ready, and White Motor. (Courtesy GAHS.)

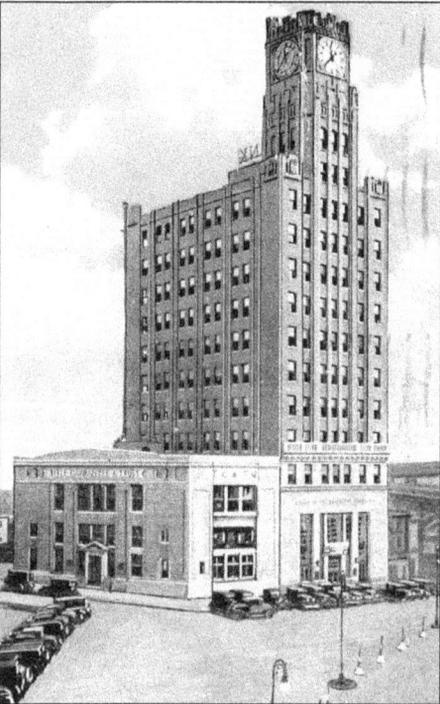

The Clock Tower Building, originally the Chase Manhattan Bank, was built by the Bank of Manhattan in 1927 in two sections. The crenellated tower designed by Morrell Smith was added to a three-story base. With several of its neighbors, it formed the financial center for Long Island City. Its handsome clocks, newly lit for the first time in decades, shine on Queens Plaza (see page 68). (Courtesy Bob Stonehill.)

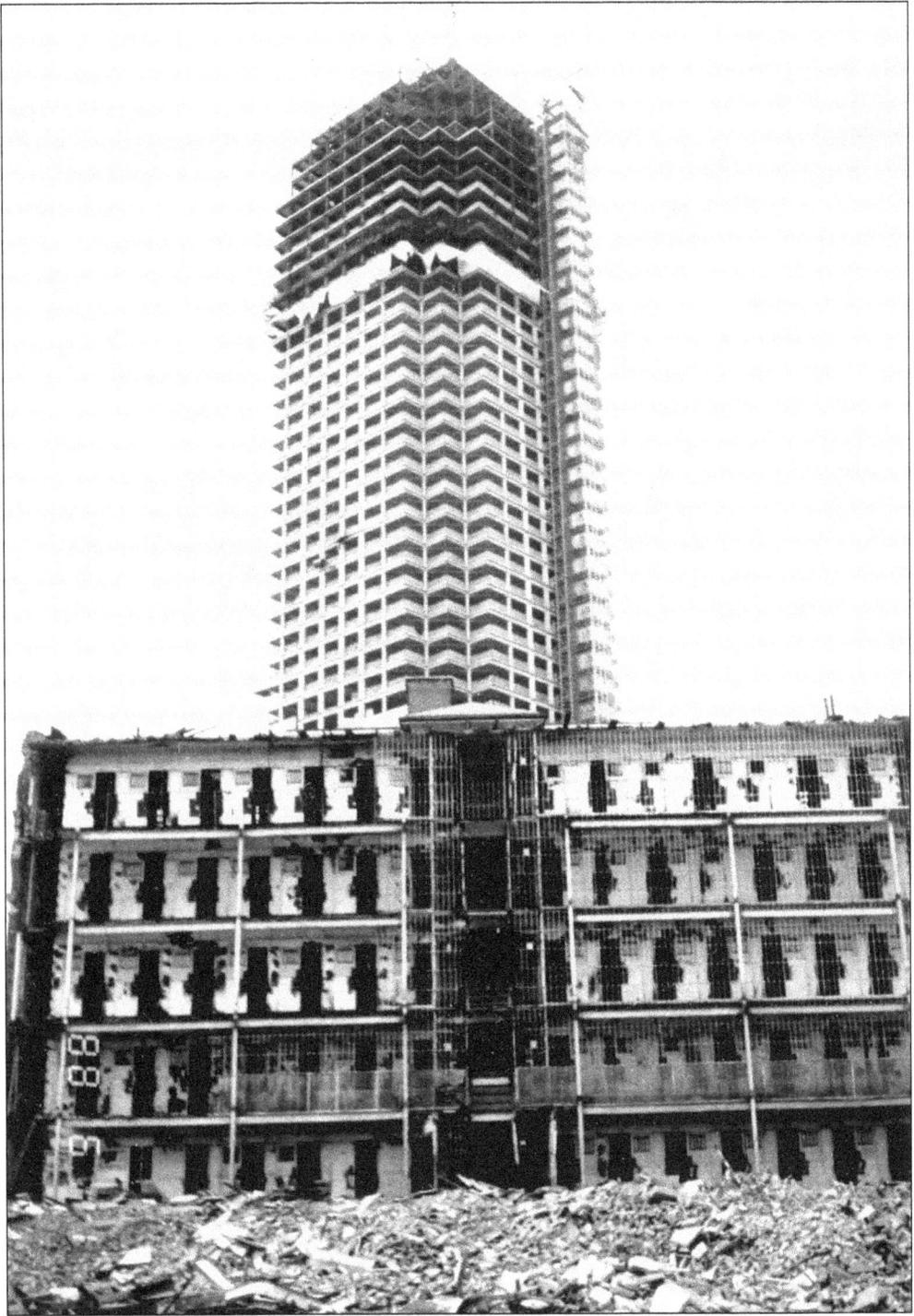

This late-1980s picture shows a community reinventing itself. As the old Queens County jail gets torn down, the new Citicorp office tower at Court Square goes up. Advocates of preserving architecture and history understand that a community must evolve and take advantage of new opportunities. It is a careful balance. (Courtesy George Andrew.)

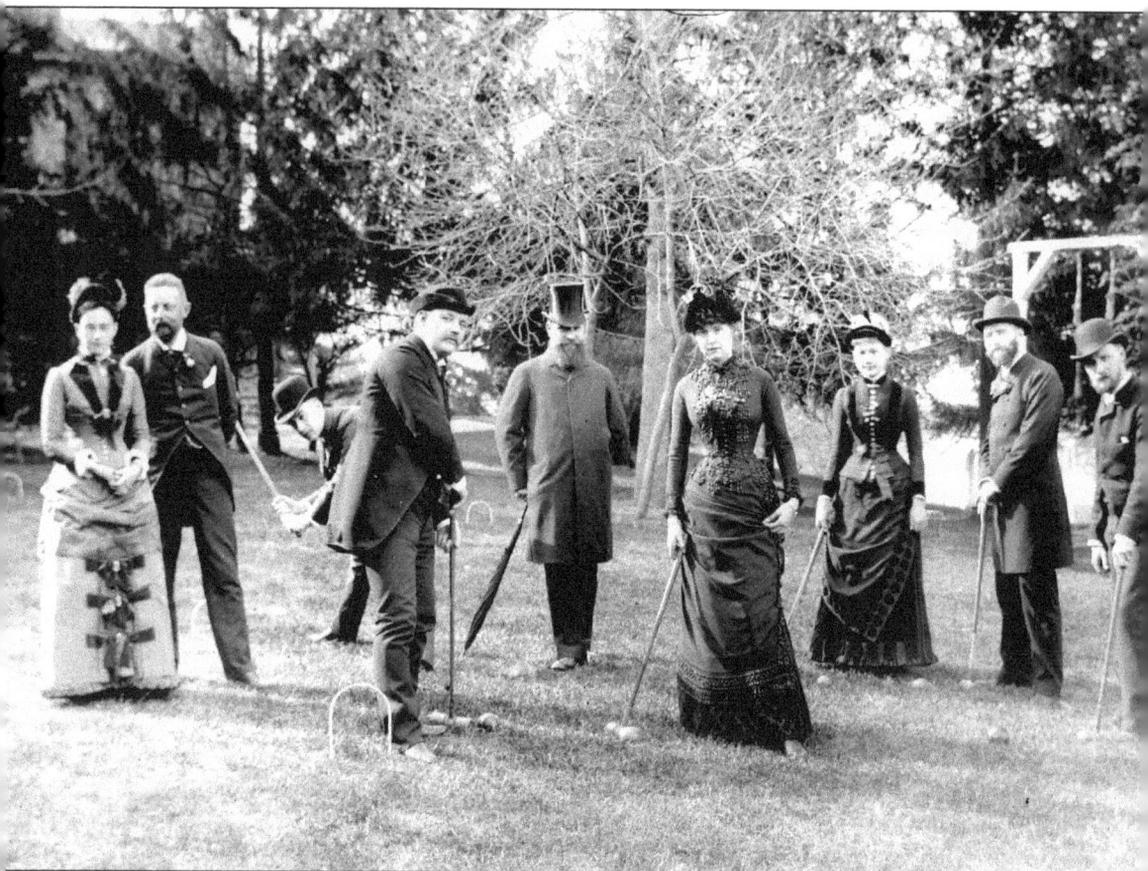

Two generations of Steinways summered in their mansion to escape Manhattan's heat. Located on a bluff, it offered cool breezes and pleasant days all within sight of the Steinway factory. Croquet was a pastime popular with the upper class. In this 1888 photograph are, from left to right, Julia Ziegler Schmidt, Henry Cassebeer, George Steinway, Charles Steinway, F. A. O. Schwarz (in the top hat), Marie Steinway (the wife of Charles), Ida Schwarz (the daughter of F. A. O.), Fred Steinway, and Henry W. T. Steinway. (Courtesy Henry Steinway.)

Three

AMUSEMENTS AND ENTERTAINMENT

Before the 20th-century concept of mass marketing permeated popular culture, leisure was a function of social class. With no radio, movies, or television, entertainment options were limited. Wealthy residents could enjoy a genteel game of croquet on their mansion's lawn. A middle-class family would invite friends over for a few songs around the piano in the front parlor. Singing societies were common, and dancing parties in private houses and hotels held sway until dawn.

But for nearly everyone, leisure was scarce and precious. For women at home, housework was unrelenting. For men (and some children) work was often dawn to dusk. Our five-day, 40-hour workweek was a distant promise.

Working-class families flocked to beer gardens where, undisturbed, men could talk politics as they lifted steins of beer to assuage their thirst, and women would socialize as they watched their children play. These important gathering places played a vital role in holding the fabric of the community together.

One such place, attracting crowds from both the local community and as far away as Manhattan, was Schuetzen Park (which took its name from its shooting galleries). Keeping with the tolerant character of the community, a broad array of ethnic and racial groups rented the facility for their fund-raising affairs.

The Steinways, believing that happy workers were more productive, went to great lengths to provide a full range of cultural and institutional services for the settlement around their factory. In 1886, they created North Beach, a group of amusement parks where the beer garden concept reached its highest development. The site proved popular and lucrative (the Steinways even collected fares on trolleys bringing in crowds). Thousands from the metropolitan area flocked to its charms.

North Beach closed c. 1929 after Prohibition (which ended alcohol sales in 1919), anti-German sentiment (lingering from World War I), competition from Coney Island (it was larger and on the ocean), and widespread ownership of the automobile all conspired to kill it off. It is today the site of LaGuardia Airport.

However, the formula of a hot night, good friends, and cold beer never really went out of fashion. Bohemian Hall and Park, owned by the Bohemian Citizens' Benevolent Association of Astoria, remains New York's last beer garden. It still serves fine food and drink in the cozy atmosphere that echoes of days gone by. Its old-world charm and ambience make the garden the community's premier nightspot, attracting capacity crowds. Publications as far away as Japan point it out as a must-see tourist attraction.

A lively culture of song and stage underscored much of the early social life in the community. Newspapers were full of advertisements for skits and plays put on by schools, churches, unions, and fraternal groups at places like Volkert's Hall in Dutch Kills. Horak's Opera House on Steinway Street was built to keep locals (and their money) at home and away from the lure of Manhattan's cultural charms.

Edison Moving Pictures had arrived at North Beach by 1913. During the 1920s, the local community supported at least a dozen theaters (many doubling as vaudeville venues). The Famous Players-Lasky Studios, later Paramount (today Kaufman-Astoria Studios), was the center for movie production on the East Coast. The Triboro Theater at Steinway Street and 28th Avenue was the most elaborate of Long Island City's movie palaces. Unfortunately, it is, like almost every theater built at that time, long gone.

Before Medicare, clubs played a crucial role in people's lives. They not only filled a social function, but through their insurance programs they acted as a safety net for old age.

Sports have an important role in the community. Before the Civil War, a good portion of ferry traffic carried sporting crowds to horse-racing events in Long Island. Later, illegal betting parlors and unlicensed fight clubs were common.

Semipro baseball clubs played in several locations. The U.S. Olympic team held competitions at the Astoria pool for both the 1936 and 1964 games.

There were a number of major sporting arenas in the area, including the Queensboro Arena at Queens Plaza, Sunnyside Bowl on Queens Boulevard, and the short-lived Madison Square Garden Bowl at Northern Boulevard and 48th Street. There, the heavyweight title changed hands three times in five years during the 1930s, with Jack Sharkey, Primo Carnera, and James J. Braddock all being crowned in Long Island City.

Baseball's Whitey Ford, Sam Mele, Billy Loes, and Tony Cuccincello, boxing's Paul Berlenbach and Lou DelValle, and basketball's Al Bianchi and Ron Artest led an impressive lineup of local stars who have made their mark in sports.

Who does not love a parade? Whether the event celebrated a new theater or promoted a local shopping district, holiday, or wartime bond rally, everyone always seemed ready to throw a party. Today, old-fashioned civic boosterism is still a hallmark of the community.

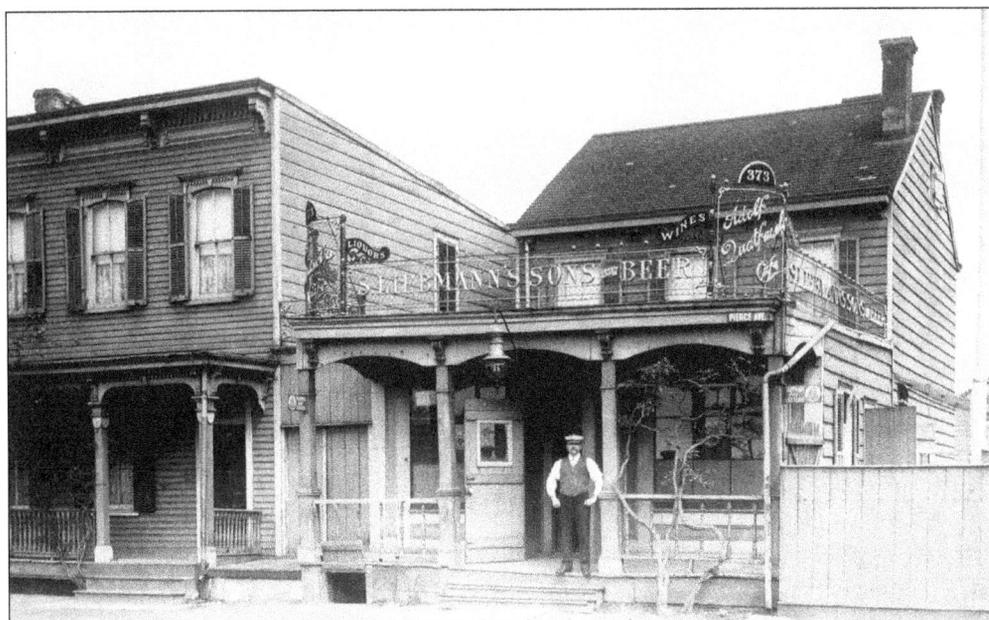

Local bars, such as S. Liebmann's & Sons, were not only social clubs for the working class but were also the nerve center for a community. At a time when private phones were few and far between, this Ravenswood establishment on 35th Avenue would be the place to reach people on the block with phone messages. Note the early telephone signs on both sides of the building. (Courtesy Bob Stonehill.)

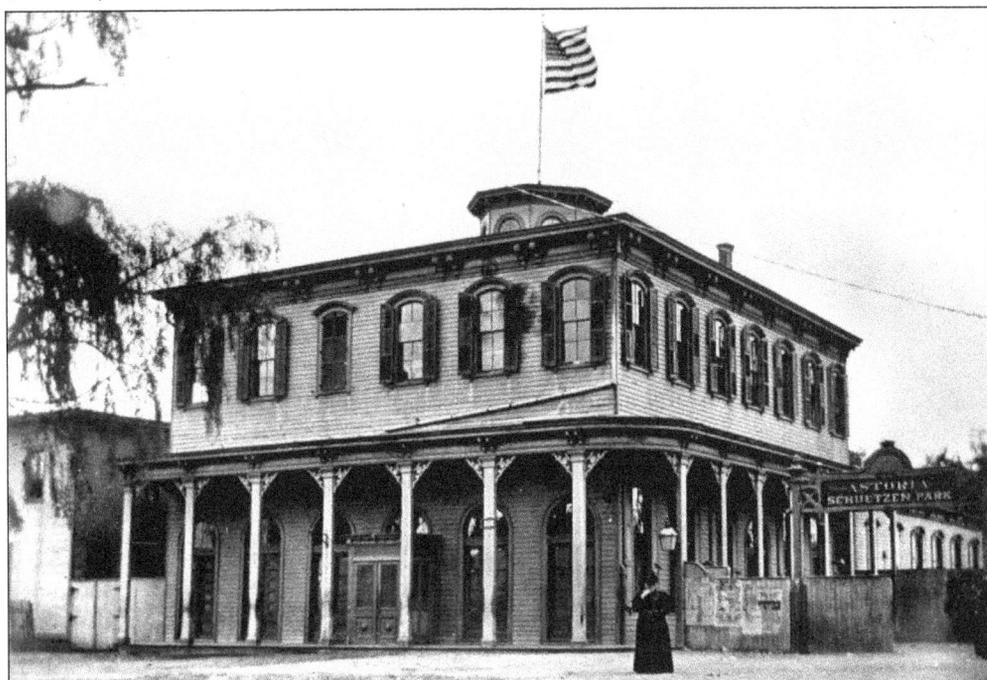

Schuetzen Park was a seven-acre picnic ground and beer garden at the intersection of Broadway and Steinway Street. It was at the heart of political rallies and social club events in the community during the height of the beer garden era, from 1870 to 1924. (Courtesy GAHS.)

51

THIRD

ANNUAL BALL

. . . OF THE . . .

Ravenswood Association

AT TVRDIK'S RAVENSWOOD HALL,
No. 74 and 76 Sherman Street.

SATURDAY EVE'G, NOVEMBER 3, 1894.

MUSIC BY PROFESSOR FRANK DILLY.

TICKETS, Admitting Gent and Ladies, 25 CENTS.

| EDWARD LAWLER, President. | ALBERT FOLLMER, Fin. Secretary. | WILLIAM DONADL, Treasurer. |
| JAMES C. SHERIDAN, Vice-Pres. | PETER RIDER, Rec. Secretary. | JOHN WELSH, Sergt-at-Arms. |

The Ravenswood Association was typical of the community's many social clubs. For a 25¢ admission to its Third Annual Ball, held at a local hall on Sherman (12th) Street in 1894, a gent and his lady could have themselves a fine evening. As late as the 1940s, newspapers devoted entire pages to club meetings on every topic of interest, from bowling leagues to political groups to ethnic societies to fraternal organizations. (Courtesy GAHS.)

Long Island City Turn Verein

54th Annual
Masquerade Ball

At the Turn Hall, Sat. Eve., March 2, 1929

The Long Island City Turn Verein (gymnastics club in German) was located at 44th Street and Broadway in what was once called the German Settlement. Ethnic social clubs, as in this example, helped keep the German culture in the hearts of the new immigrants. (Courtesy GAHS.)

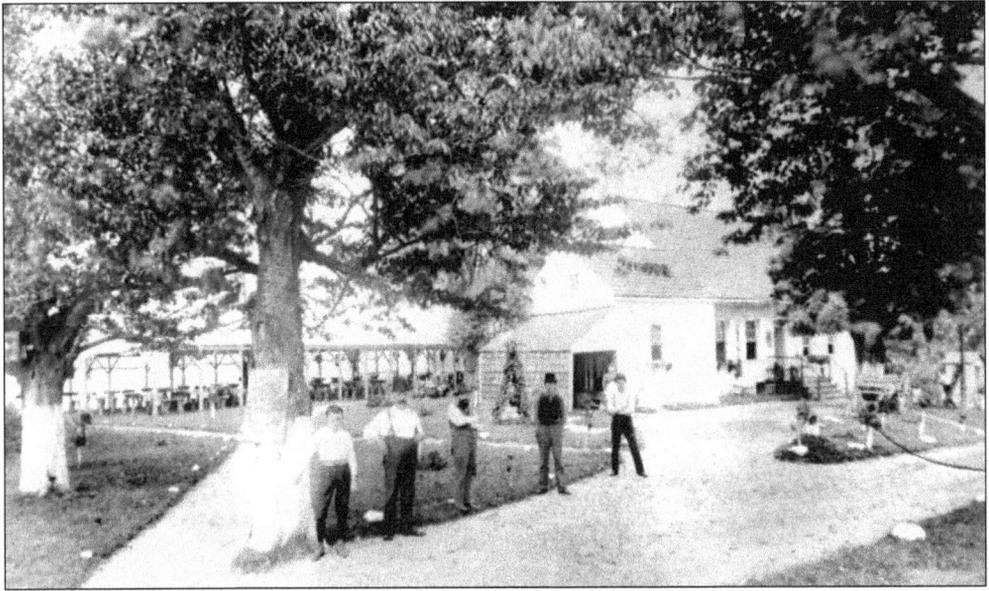

The picnic grove at North Beach offered families respite from the six-day workweek. Thousands came by trolley and steamboat on summer weekends to this business venture between William Steinway and beer baron George Ehret. Here, the beer flowed freely and couples danced until dawn. (Courtesy GAHS.)

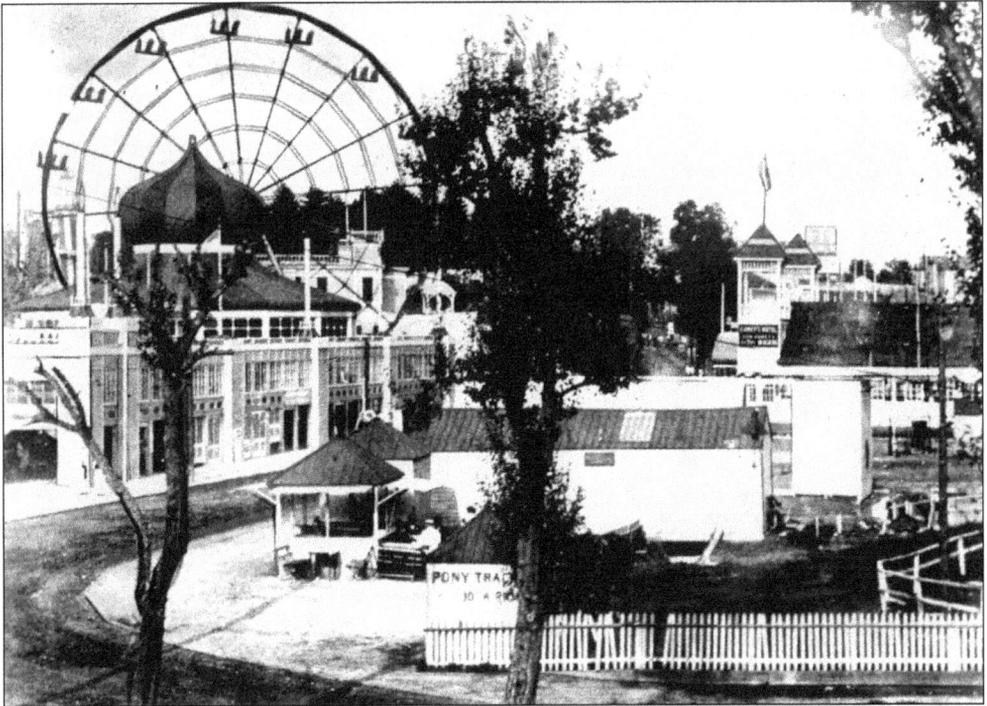

Dancing pavilions, amusement park rides, Bowery Bay, picnic groves, shooting galleries, playgrounds, nightly fireworks, dining, and theater—North Beach had it all. Many longtime residents of Long Island City have fond memories of summer days at this resort. (Courtesy GAHS.)

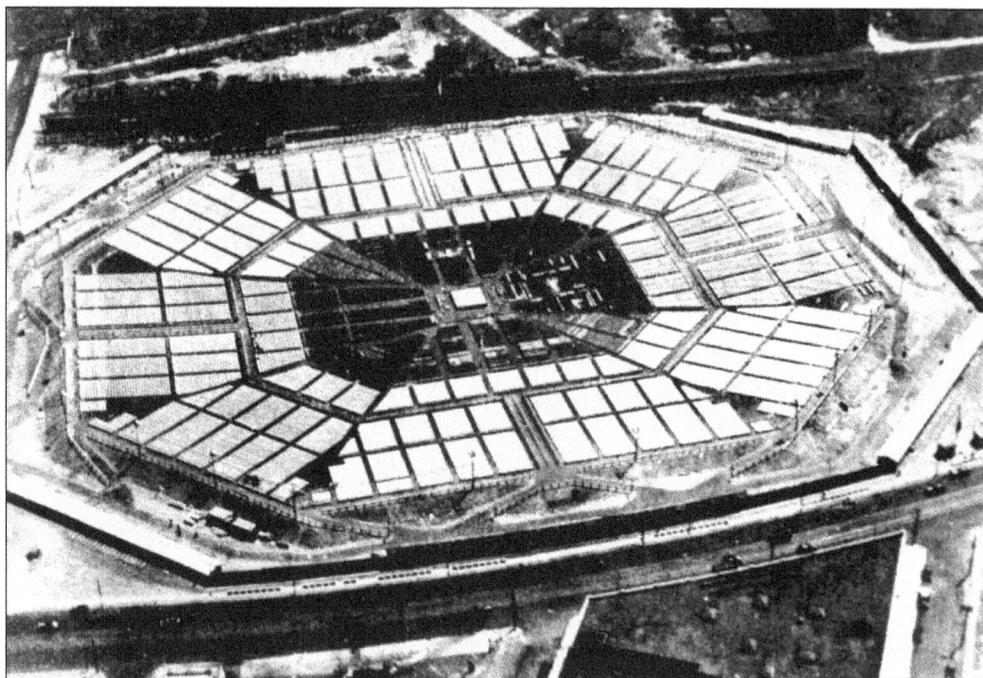

The 1932 Madison Square Garden Bowl, seating 72,000, was at Northern Boulevard and 48th Street. Marquee names such as Primo Carnera, Max Baer, and James Braddock fought here. After the famous Sharkey-Schmeling fight, Schmeling's manager shouted, "We wuz robbed!" After successive heavyweight championship bouts saw the reigning champ lose each time, promoters claimed that "the joint was jinxed." This short-lived attempt by Madison Square Garden to bring boxing to Long Island City was soon razed. (Courtesy GAHS.)

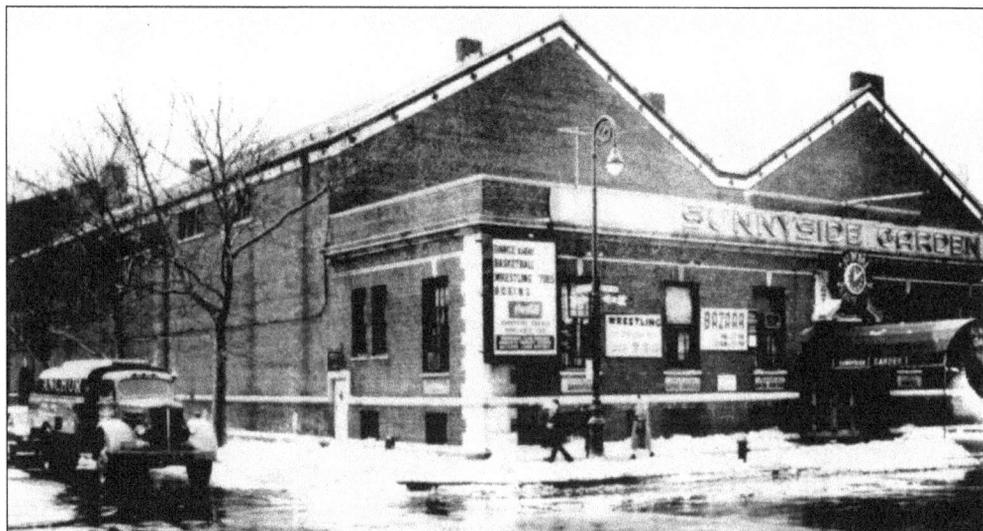

Sunnyside Garden Arena dates from 1926 and was a smaller venue, seating only 2,400. Located on Queens Boulevard between 44th and 45th Streets, the arena hosted such events as Golden Gloves boxing competitions, wrestling, basketball, and dancing. Remembered fondly as an old-time, smoky, noisy fight club, Sunnyside Garden closed for good in 1977. There is now a Wendy's restaurant on the site. (Courtesy Sunnyside Chamber of Commerce.)

54

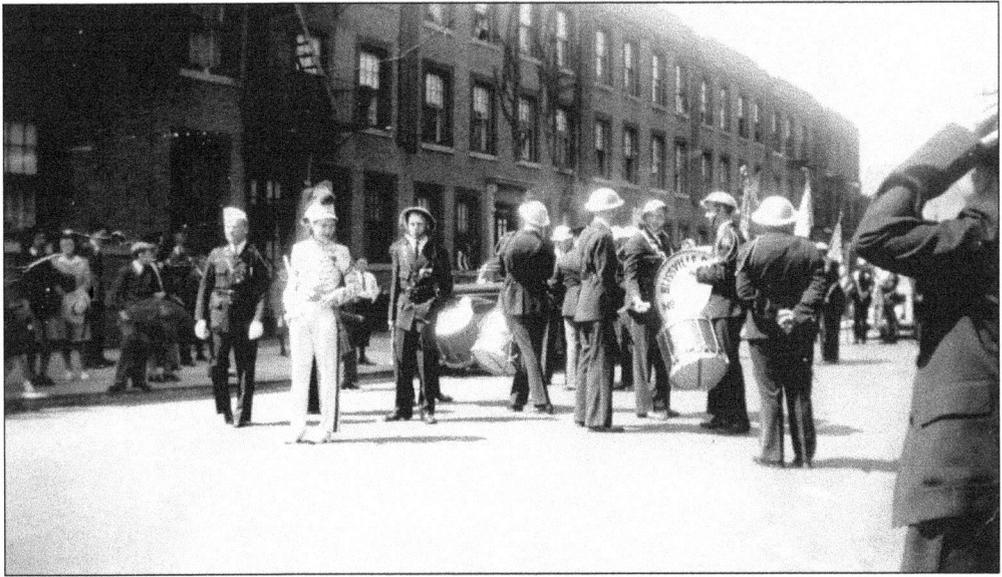

This 1940s Blissville drum corps is representative of the marching bands common in almost every community. Long Island City had many parades that celebrated Memorial Day, civic events, and religious holidays. (Courtesy Sunnyside Chamber of Commerce.)

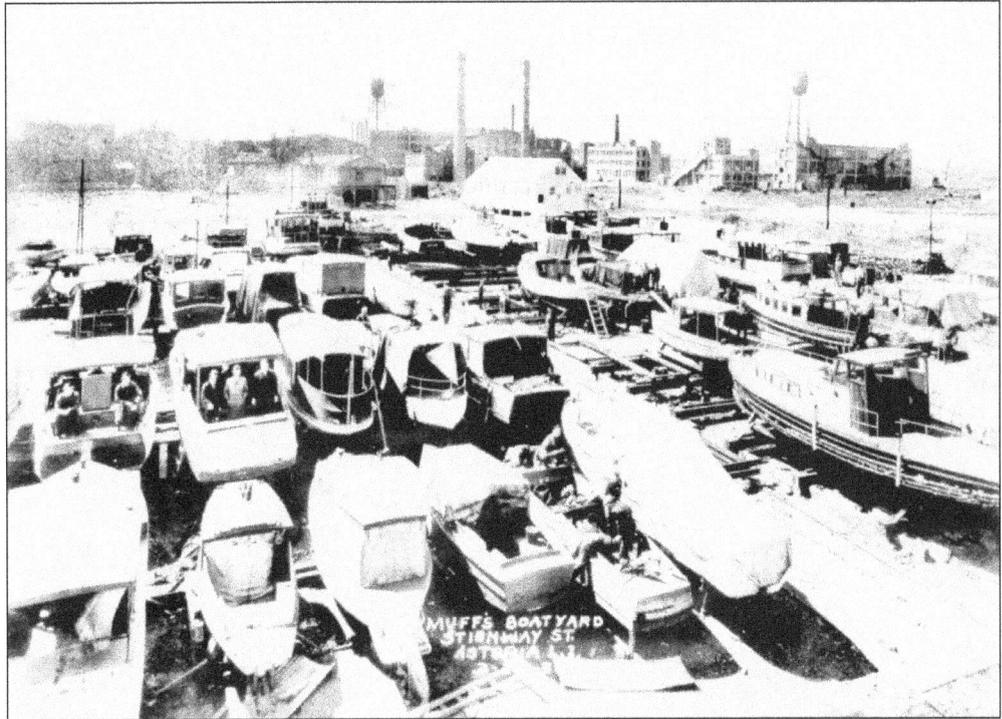

Muff's Boatyard, in March 1938, was at the end of Steinway Street. Nearby was the former Ravenswood Boat Club, which competed on Long Island Sound against rowing teams from around the country. Other docks were at 37th Avenue, Pot Cove, Broadway, Astoria Boulevard, and Steinway Creek. Although Long Island City is surrounded on three sides by water, most of its shore is given over to industry and power plants. (Courtesy Robert Biliski Jr.)

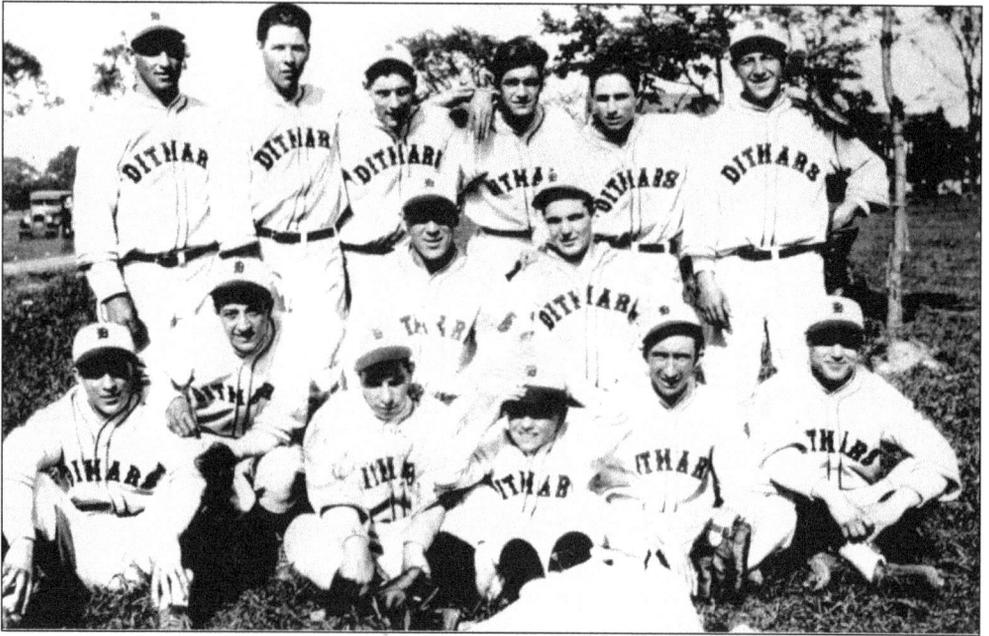

Organized sports were an important part of life as much as they are today. The Ditmars baseball team, one of the many semipro teams, played at area parks. In the 1920s and 1930s, Recreation Park, just north of the Queensboro Bridge, featured the Springfields, and in 1935, the Negro League's Cuban Stars. The park was bulldozed in 1938 to build the massive Queensbridge Houses development. (Courtesy GAHS.)

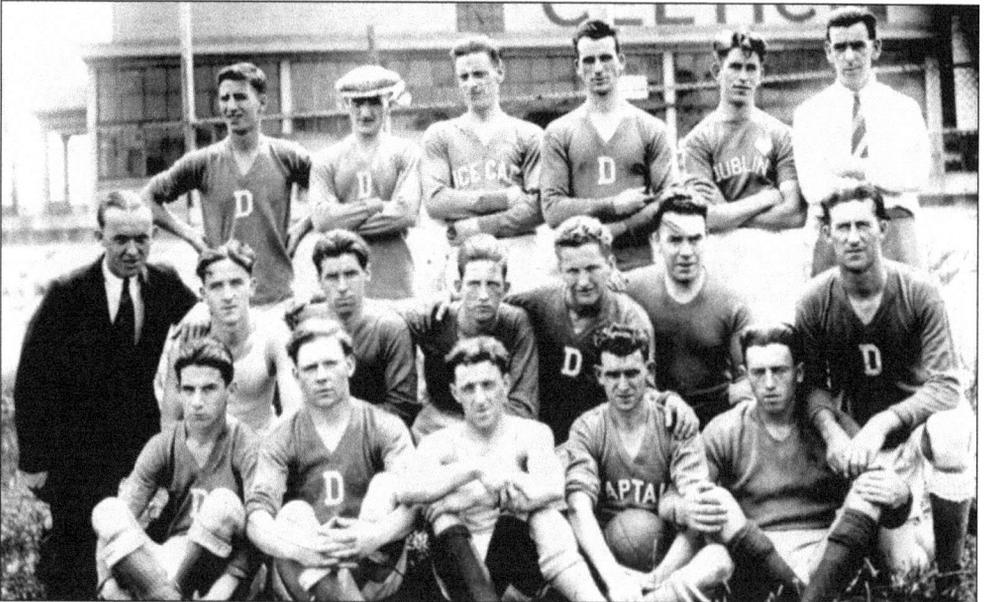

In this rare image, an Irish football team poses at Sunnyside's Celtic Park during its last season, in 1930. Their clubhouse had trophies and medals from the Olympics won by prominent track-and-field groups who trained at the field. Olympian Jim Thorpe practiced here prior to his gold medal performance in the 1912 Olympics in Stockholm. The location was developed into housing. (Courtesy Sunnyside Chamber of Commerce.)

The Sokol (Bohemian for hawk) program at Bohemian Hall trained gymnasts in the Czech tradition. Based on the philosophy of a healthy body and healthy mind contributing to a healthy country, the program was open to people from all backgrounds. The Sokol program still continues at Bohemian Hall. (Courtesy Bohemian Hall and Park.)

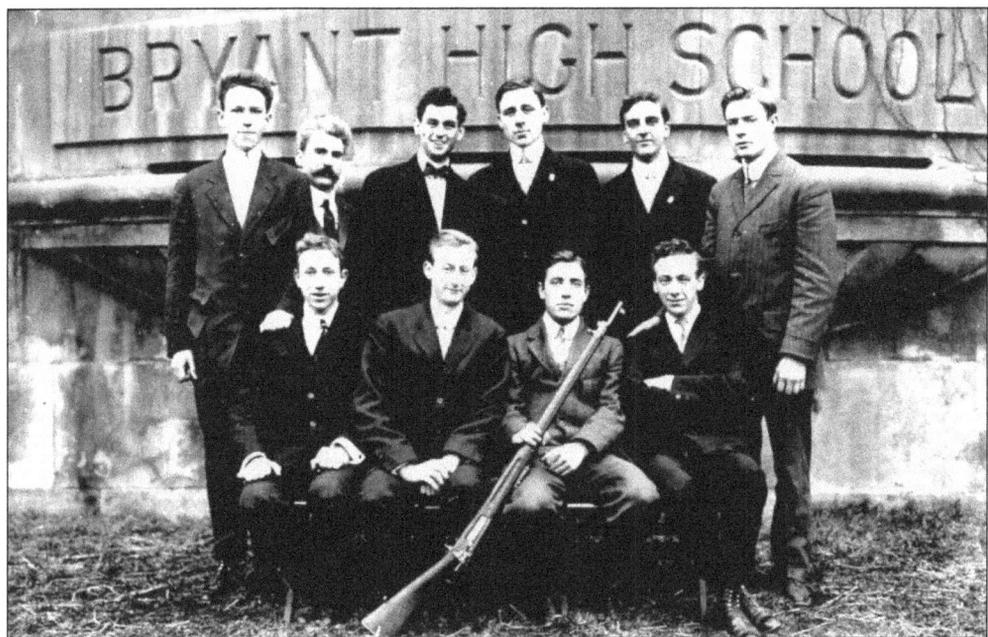

Long Island City High School and Bryant High School are annual contenders in citywide sporting events. Here, the Bryant High School gun team, winner of the 1909–1910 New York City championship, poses proudly before their school. The team captain, Ira Terwilliger, holds the gun as a pleased Mr. Lowey, the teacher and advisor, looks on. (Courtesy GAHS.)

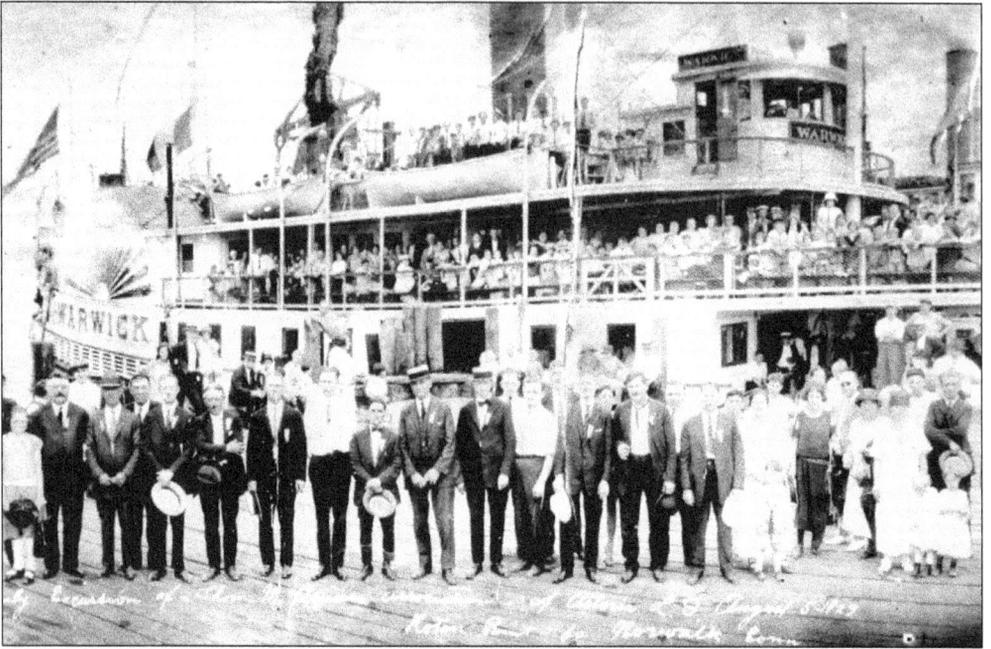

The Thomas M. Quinn Democratic Club enjoyed a trip on the steamer *Warwick*. These sturdy vessels were rented out to large groups for a full-day boat excursion to a pleasant resort locale outside the city. Church, political, and social groups embarked from Greenpoint and Old Astoria for trips out to Long Island Sound. There was regular service between North Beach and the Bronx, Harlem, and lower Manhattan. (Courtesy William Quinn.)

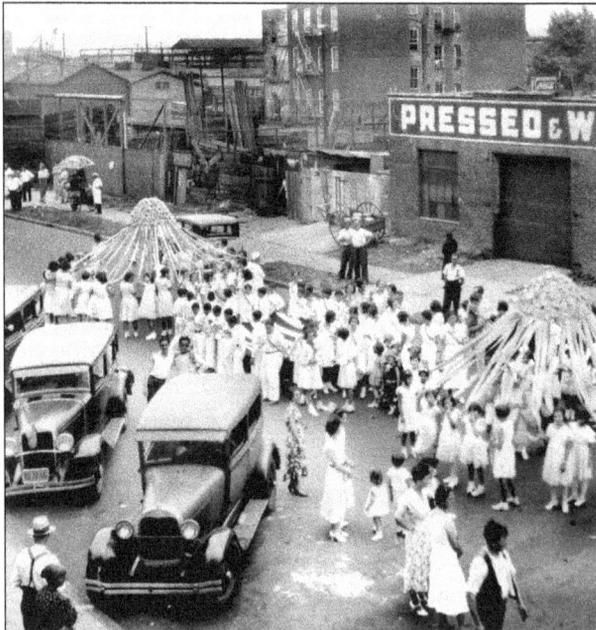

A festive May Day celebration in Hunters Point brought out the children and the Maypole c. 1930. Today, the spring season brings out festivals, block parties, and street fairs sponsored by the many ethnic, civic, and cultural groups in Long Island City. Notice the two fellows buddying up for the photograph. (Courtesy Bob Ulino.)

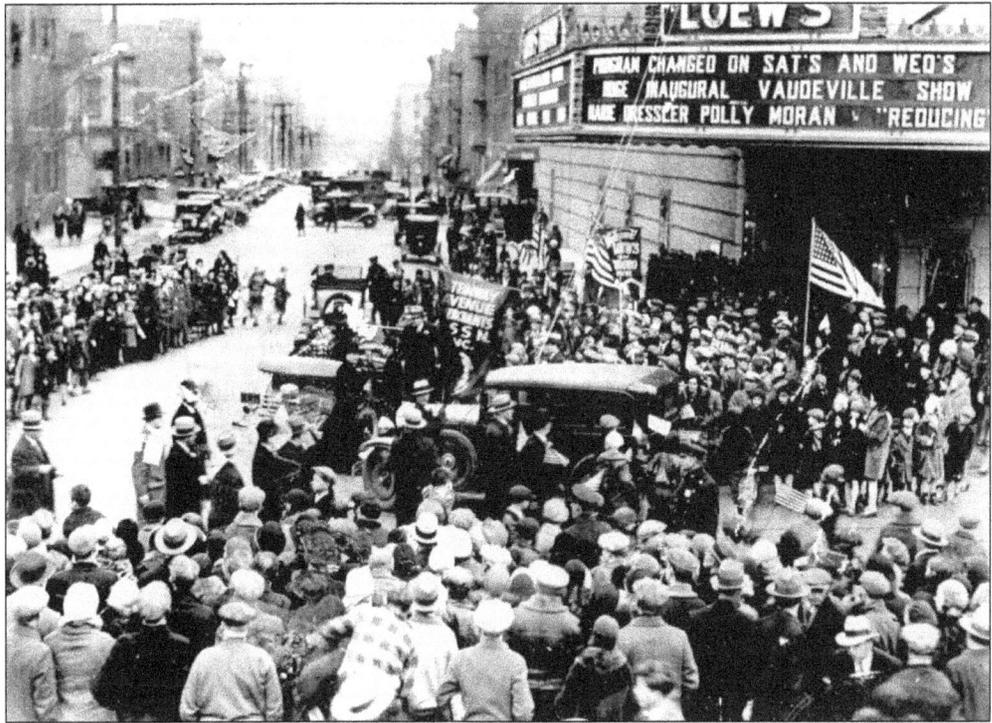

This is the opening day in 1931 at Loew's Triboro Theater at Steinway Street and 28th Avenue. With seating for 3,290, it was the largest movie palace in Long Island City. The culmination of the movie palace of the 1920s, it was an architectural showpiece, both outside and inside. It also doubled as a vaudeville venue with headliners such as Ed Sullivan. It was demolished in 1974 and redeveloped to the disappointment of the community. (Courtesy GAHS.)

At 66 acres, Astoria Park is a stunning jewel in the city parks system. Astoria Park Pool, here under construction in 1936, is the largest in New York City. It has been described as the finest pool in the world. It was the site for the finals of the Olympic swim tryouts for the 1936 and 1964 games. (Courtesy GAHS.)

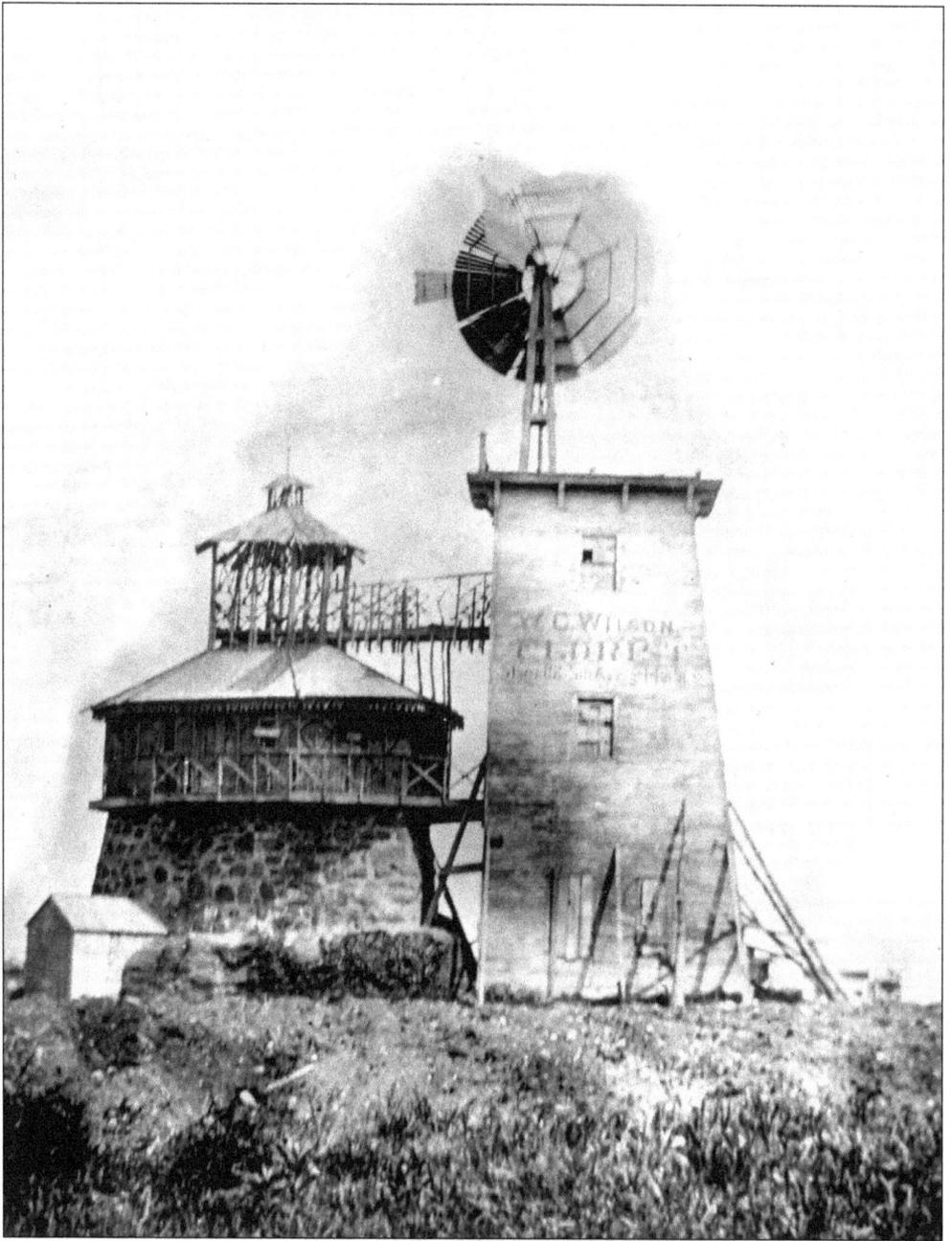

William C. Wilson (1831–1897) ran a large commercial florist operation at Astoria Boulevard and 31st Street from 1852 to 1890, when William Steinway bought out the nursery. The windmill and water tower, shown here in 1886, were located near the southeast corner of Astoria Boulevard and Steinway Street. It was built on a giant boulder left by the massive Wisconsin ice sheet 12,000 years ago. (Courtesy GAHS.)

Four

INDUSTRY AND COMMERCE

Near Newtown Creek, which handled more traffic than the Mississippi River, Rockefeller built some of his first refineries. A few blocks away, the 1,000-window bakery of Sunshine Biscuits nightly filled boxcars with food. Area manufacturers made automobiles a decade before Henry Ford. Exquisite violins and unsurpassed pianos made Long Island City a byword for quality known around the world.

From Colonial times to today, owning a piece of Long Island City has been a good investment.

Fertile soil and a mild ocean-tempered climate in close proximity to Manhattan made the community's farms valuable. The finest land in Queens was supposedly at today's Calvary Cemetery, which, in Colonial times, supported tobacco plantations on its rich loam. In an age of poor transportation, numerous greenhouses and truck farms provided a bounty of flowers and vegetables that could be quickly shipped to the markets and hotels in New York City. Fields along Steinway Street, leased by Chinese residents, supplied Chinatown with vegetables.

Grant Thorburn, who started a seed business near 30th Road, generated so much volume he was asked by the postal authorities in Newtown to set up his own post office. He became the first postmaster of Astoria.

A rail and turnpike network reached Hunters Point just prior to the Civil War. Piers enabled ferryboats to convey both people and wagons full of produce to Manhattan. Hotels and restaurants sprang up to serve the needs of thousands of commuters. The iron horse required extensive machine shops and rail yards.

As early as the mid-1860s, a number of kerosene and oil refineries located along Newtown Creek. Later, firms specialized in building materials, oil refining, varnish making, piano manufacturing, cabinet works, machine shops, metal work, ink and paints, sugar refining, boot and shoe making, and house furnishings.

Today, according to the New York State Department of Labor, the area has over 6,000 companies with nearly 90,000 employees. A modern diversified industrial base continues to make Long Island City synonymous with industry, as large and small manufacturers thrive in apparel and textile, metalworking, food processing and baking, printing and publishing, electronic equipment and components, Internet and computer services, and telecommunications industries.

With countless retail establishments clustered about its transportation hubs, Long Island City always enjoyed the unusual distinction of having more lively shopping districts than neighborhoods. Its best known commercial mall, Steinway Street, was a successful retail emporium as early as the 1870s. With hundreds of stores, it is considered the world's longest outdoor department store. Other well-known retail strips include Greenpoint Avenue, Queens Boulevard, 36th Avenue, Broadway, 30th Avenue (a gastronomic delight), and Ditmars Boulevard. Northern Boulevard has big-box retailers. Costco, on Vernon Boulevard, is known in Manhattan almost as well as Queens.

The dining experience can be summed up, one merchant's group proclaims, as where "restaurants, cafes, bakeries, and food shops are as close together as pastries in a box or olives in a barrel." Travelers at the ferries could dine at the Astoria Hotel or Miller's Hotel in Hunters Point. Oyster Bay, Kneer's Golden Pheasant, Steinway Brauhal, the Sunnyside Hofbrau, the Boathouse, and the Ratskeller at Turn Hall are still fondly remembered. Italian cafes, Greek tavernas, a Bohemian beer garden, coffee shops, American and continental restaurants, diners, catering halls, and ethnic fast food outlets from every corner of the globe add to the culinary kaleidoscope.

Power generation started when Stephen Halsey set up the Astoria Gas Works. The memory of utility passageways running under Astoria village gave rise to legends of the Underground Railroad. The Astoria Gas, Heat & Power Company built the earliest large power plant at Lawrence Point after 1900. Perhaps as a legacy of its one-time independent status, Long Island City remains on a separate electricity grid from Manhattan. It has a special heavy-duty capacity suitable for manufacturing and, with the largest concentration of power plants in the city, one of the best electric supplies in the five boroughs.

Continuing a tradition that dates from 1920, when the Famous Players-Lasky Studios opened, Long Island City is the East Coast center for television and motion picture production. After becoming part of the Paramount empire in the late 1920s and a stint as the Army Pictorial Center, it was renamed the Kaufman-Astoria Studios in the early 1980s. This 10-acre facility contains multiple sound stages and boasts the largest sound stage on the East Coast. The complex is also home to WFAN radio, Lifetime Television, Sesame Street, and the American Museum of the Moving Image.

Think of offices without xerography (Greek for dry copy) or the Swingline stapler. Consider music with a piano that sounds like a harpsichord. From light switches to Hellmann's mayonnaise, it is difficult to conceive of a world without the products produced, the ideas created, or the inventions made in Long Island City.

Recently, an extensive fiberoptic cable service was installed throughout much of the area, giving incentive for internet and other firms to move here. The industrial Brewster Building, at Queens Plaza, has been reborn as the high-tech MetLife Building. Long Island City remains at the tip of creativity, for it always seems to reinvent and readapt itself.

Ultimately, the success of industry rests upon the shoulders of the worker. Perhaps no one exemplifies better the craftsperson of Long Island City than the artisans of Steinway & Sons, whose hands create timeless art that is not transient, or trivial, but is classical, demanding, and ultimately beautiful. The firm remains both a cultural and industrial icon known around the world for making "the instrument of the immortals." The Steinway labor force, keenly aware that their work will be admired for generations, maintains traditions immune to time, fad, and fashion. As long as pianos are made, the Steinway & Sons label will be the standard against which all others are judged.

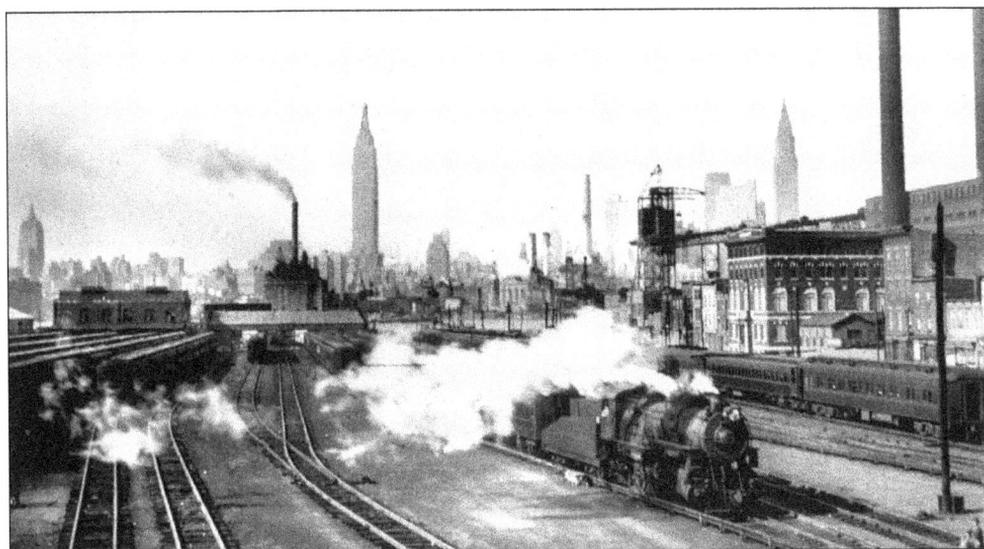

By 1861, the Long Island rail network ran into Hunters Point, which is centrally located, being adjacent to Manhattan at the East River and Brooklyn at Newtown Creek. In one hour, freight could come by barge or by tunnel from New Jersey. It was then linked by rail to New England. The rail network was the centerpiece of transportation when this 1940 photograph was taken. (Courtesy GAHS.)

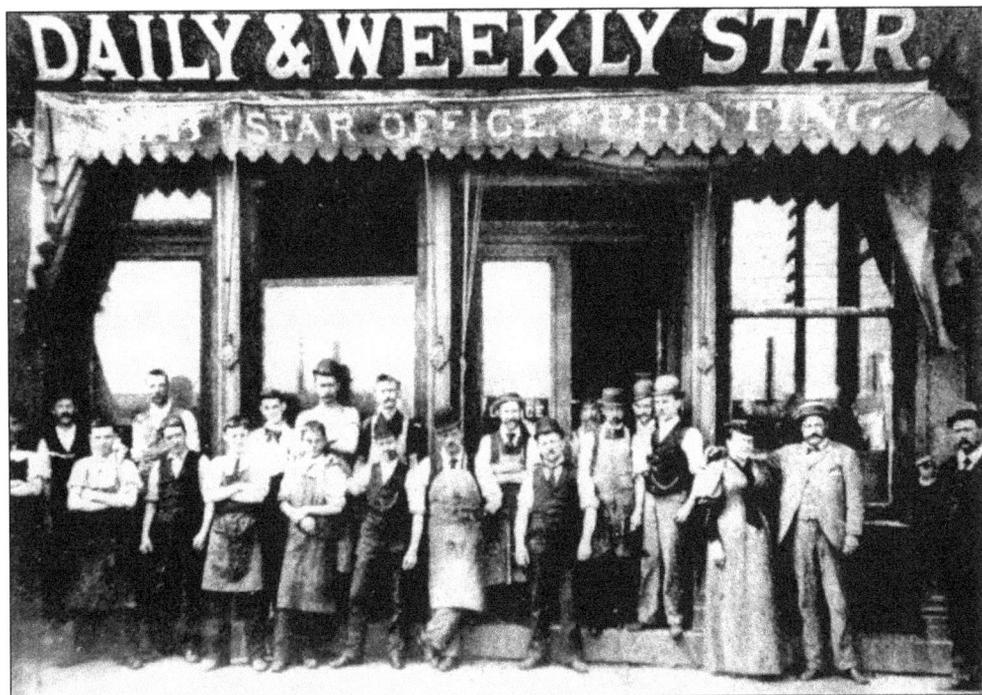

From the 1870s to the 1960s, the *Long Island Daily* (and weekly) *Star* (which became the *Long Island Star-Journal* after its merger with the *Flushing Journal* in the 1930s) was the primary newspaper serving Long Island City. Founded in 1865 under Thomas Todd, it was an independent nonpolitical voice that was unafraid to do investigative reporting. (Courtesy GAHS.)

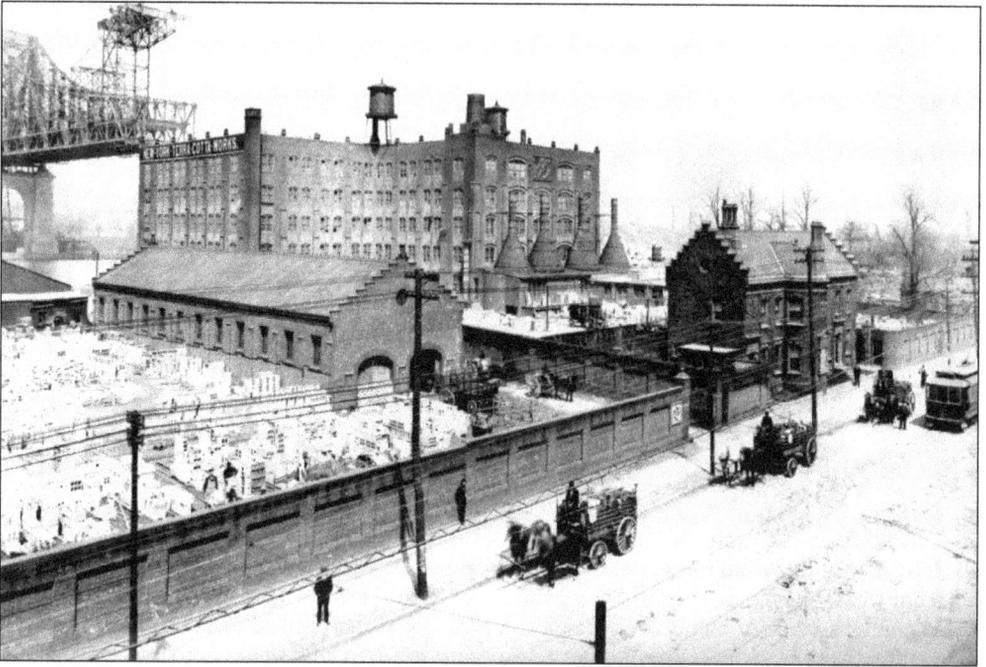

The New York Architectural Terra Cotta Company on this three-acre site produced ornately crafted building ornaments that adorn many buildings in Manhattan such as the Plaza Hotel and Carnegie Hall. The factory opened in 1886, and its proximity to the East River allowed material to be shipped right to the plant. The office building on Vernon Boulevard in Ravenswood, built in 1892, is a New York City landmark. (Courtesy GAHS.)

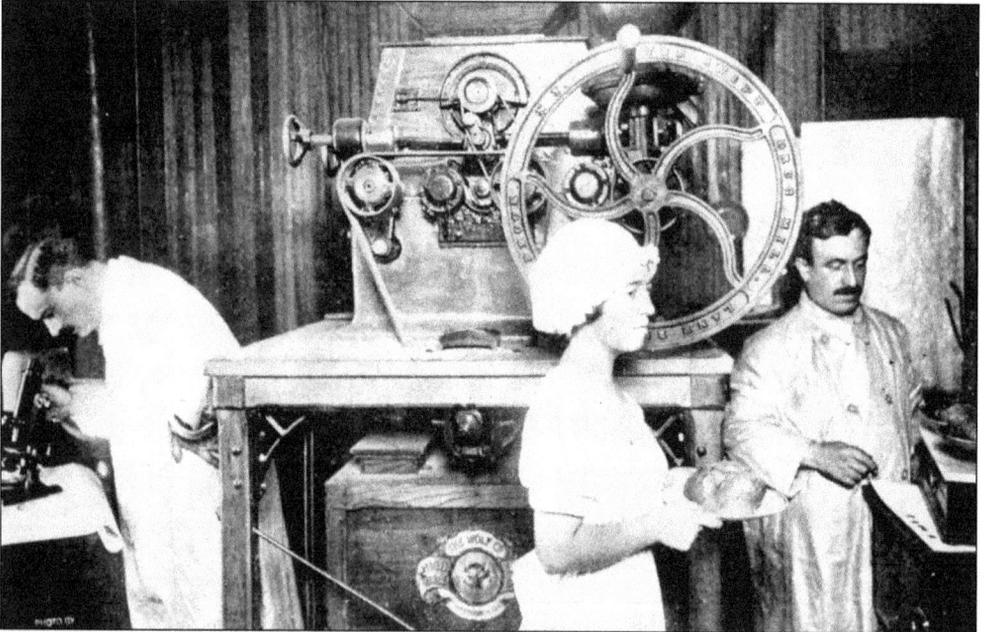

Known for its good pasta, Ronzoni, a major employer in Long Island City, had a large plant on Northern Boulevard until closing in the late 1990s. In the pasta laboratory products are tested for quality assurance c. 1920. (Courtesy Al Ronzoni.)

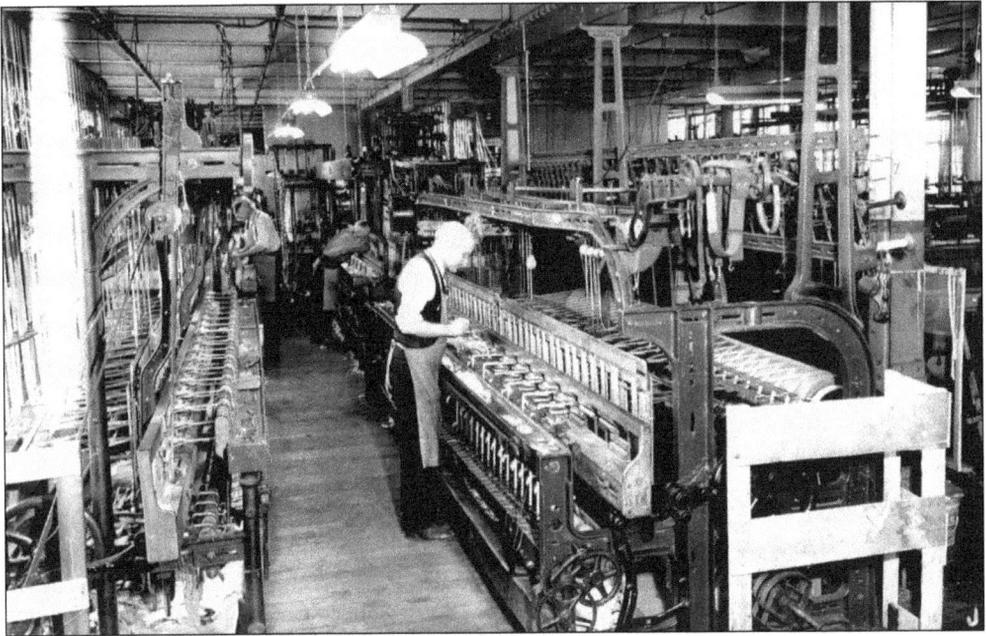

Miles of looms at Scalamandré Silks are seen at work. Established in the 1920s, this company wove exquisite fabric for the White House, Gracie Mansion, Monticello, and museums and theaters around the world. It also produced silk-screen wallpaper for homes. Scalamandré is to textiles what Steinway is to pianos. (Courtesy Scalamandré Silks.)

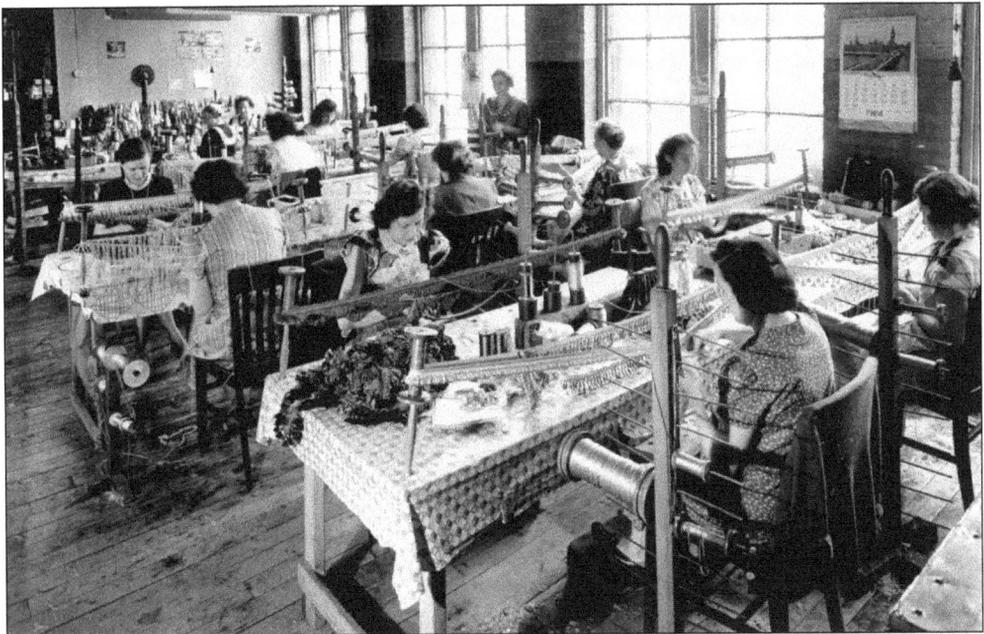

This is the fringe and tassel room, where all the tassels are cut by hand at Scalamandré Silks. The factory had examples of every type of loom, from spinning wheels and rope walks to state-of-the-art automated systems. Although they were forced to move a part of their operations out of their Ravenswood plant, a portion will remain, maintaining a tradition of the weaving industry that goes back 150 years in the community. (Courtesy Scalamandré Silks.)

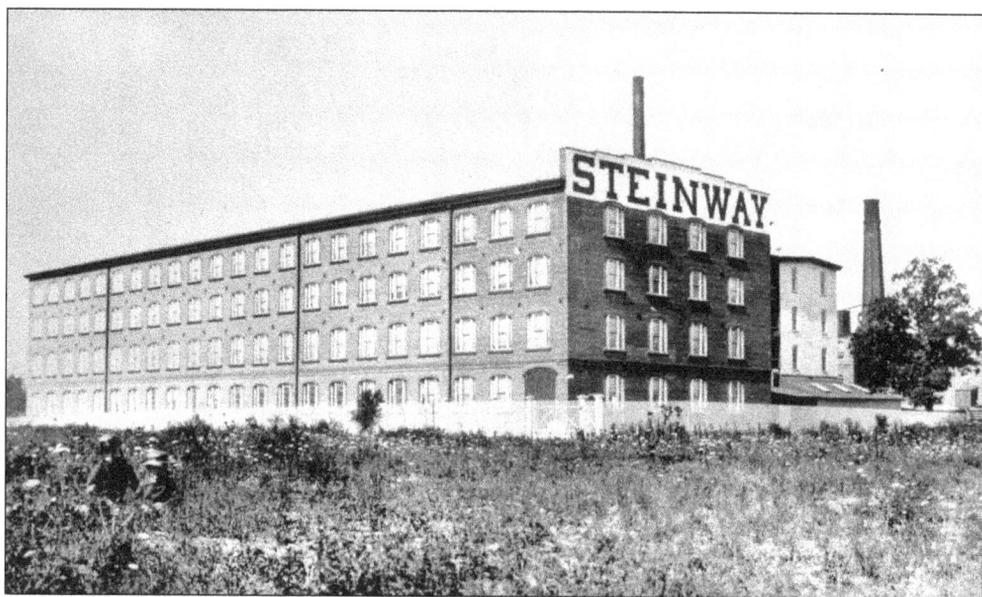

Built after 1870, the Steinway piano factory is still a cornerstone of the American entertainment industry. For 150 years, and with over 100 patents, a happy marriage of skilled labor and cutting-edge technology has given birth to over a half million pianos. Today, the Steinway piano remains the envy of the industry. There is a Steinway instrument on the stage at Carnegie Hall and in the White House. (Courtesy Henry Steinway.)

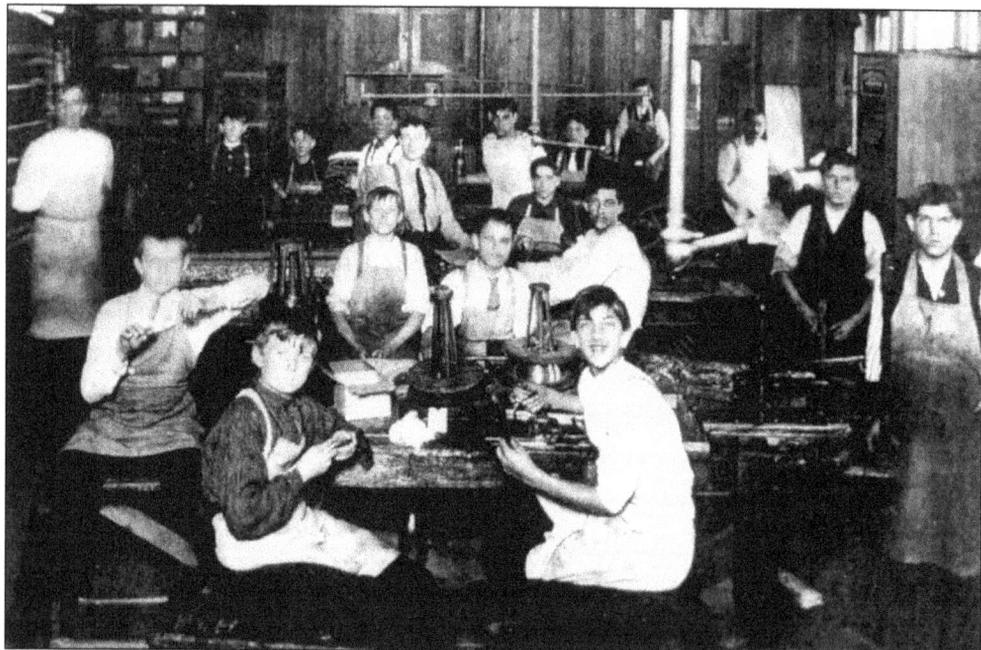

In the 19th century, it was not uncommon to hire children and teenagers to perform unskilled, often menial, tasks. Regulations existing for education and employment were often ignored. These boys worked at the Steinway piano factory for wages that were probably meager and under conditions difficult by today's standards. However, the boys' work was a welcome source of additional family income. (Courtesy Henry Steinway.)

66

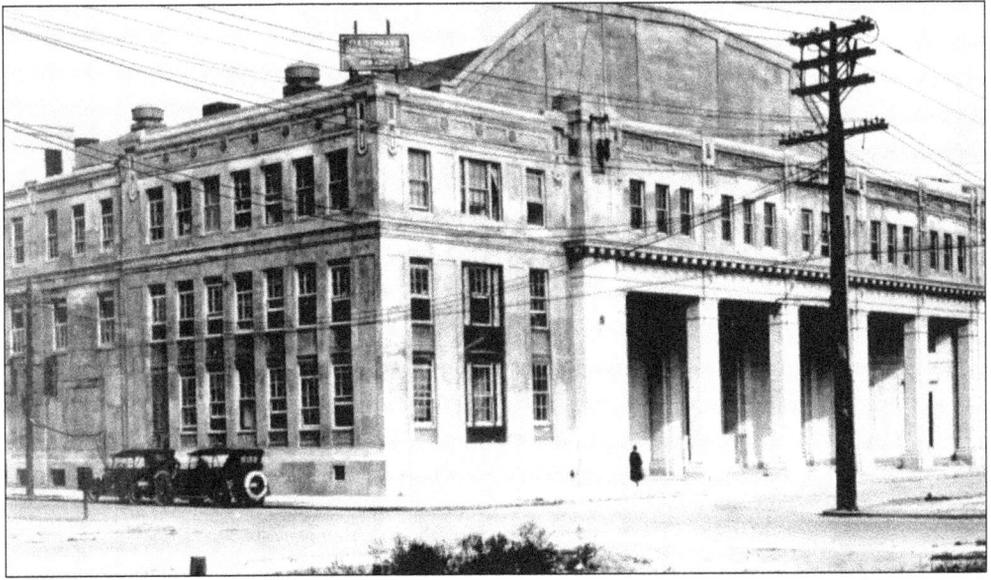

Kaufman-Astoria Studios began as the Famous Players-Lasky Studios in 1920. Building No. 1, completed in 1921, well before Hollywood, produced classic films, drawing upon the theater stock from Manhattan's Broadway stages. Gloria Swanson, Rudolph Valentino, W. C. Fields, and the Marx brothers graced these stages. After use as the U.S. Army Signal Corps pictorial center from 1942 to 1971, the studio experienced a revival and again became a great production complex. (Courtesy Kaufman-Astoria Studios.)

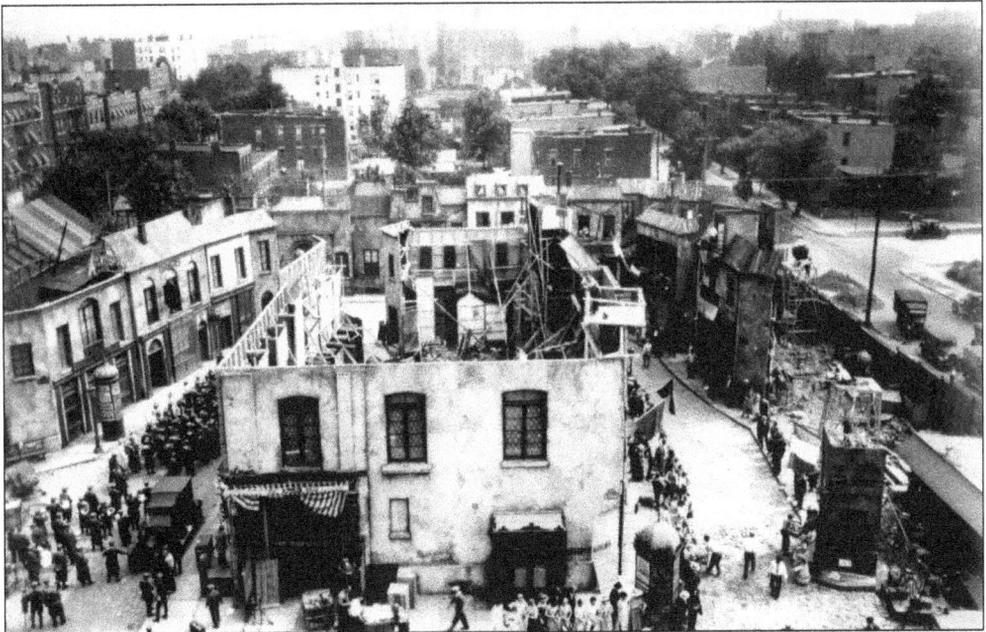

On the site that is now the lobby of the Kaufman-Astoria Studios, *The Battle of Paris* (1929) was filmed in a back lot. This view faces north toward 34th Avenue, with the surrounding neighborhood and period automobiles in the distance. Extras were hired locally, film sets were built by area craftsmen, and costumes and fabrics were sewn by talented area seamstresses. (Courtesy Kaufman-Astoria Studios.)

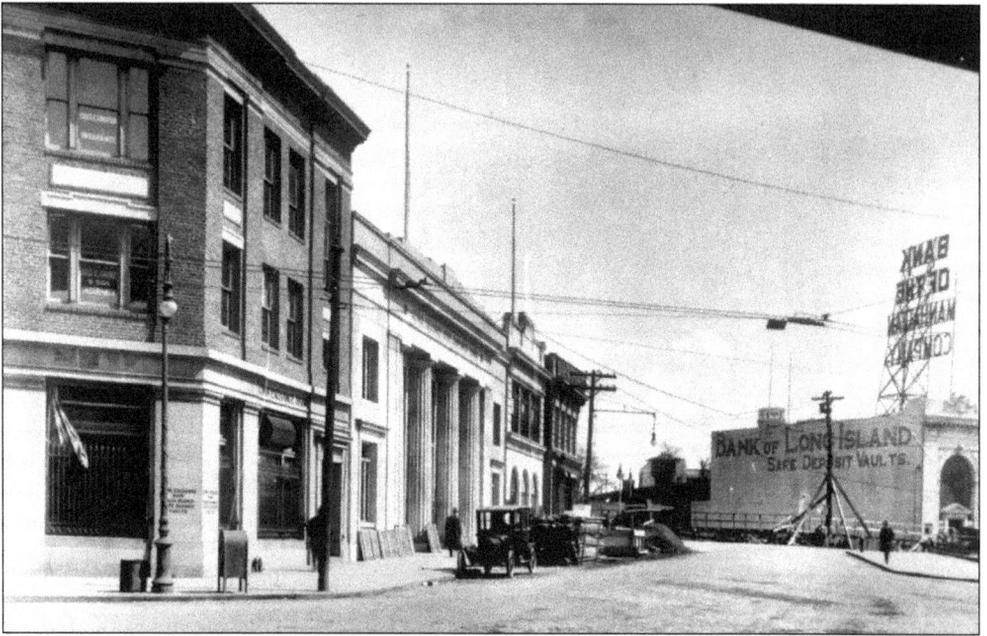

The 1909 Queensboro Bridge changed everything for Long Island City. The eastern end of Bridge Plaza near 29th Street and 41st Avenue became a banking and commercial center. All these buildings had additional floors built during the 1920s. On the left is the Long Island Savings Bank. On the right is the former Bank of Manhattan building (see page 47). (Courtesy Stephen Leone.)

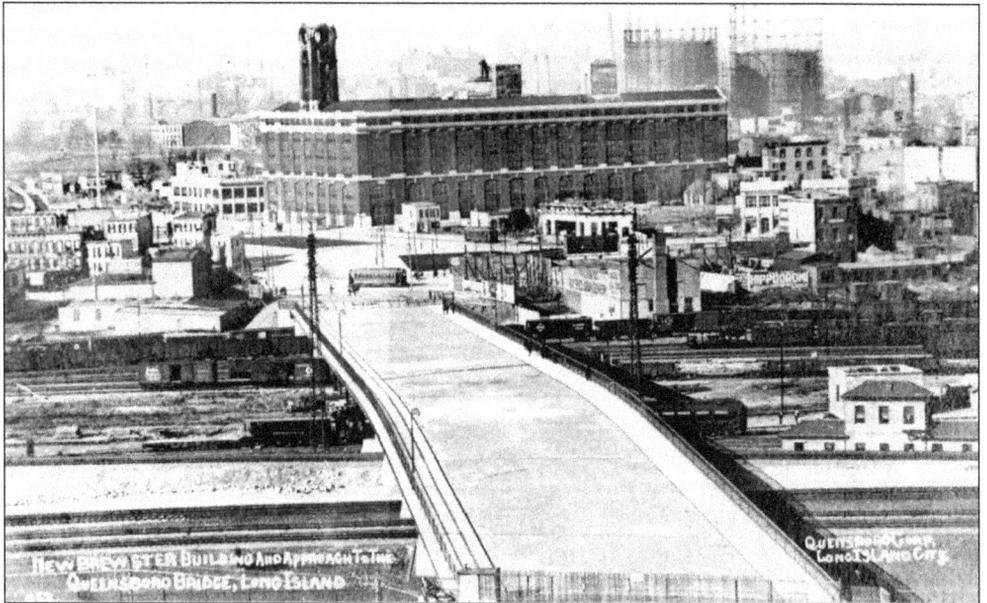

The viaduct in the photograph, completed in 1910, connected Queens Plaza to Queens Boulevard, the great conduit of the borough. Beyond the viaduct, the Brewster Building manufactured horse-drawn carriages, automobiles, and later, airplanes. The building's clock tower, long gone, hopefully will be replaced. The two large gas tanks in the distance are on the site of the current Con Edison power plant, known as "Big Allis." (Courtesy GAHS.)

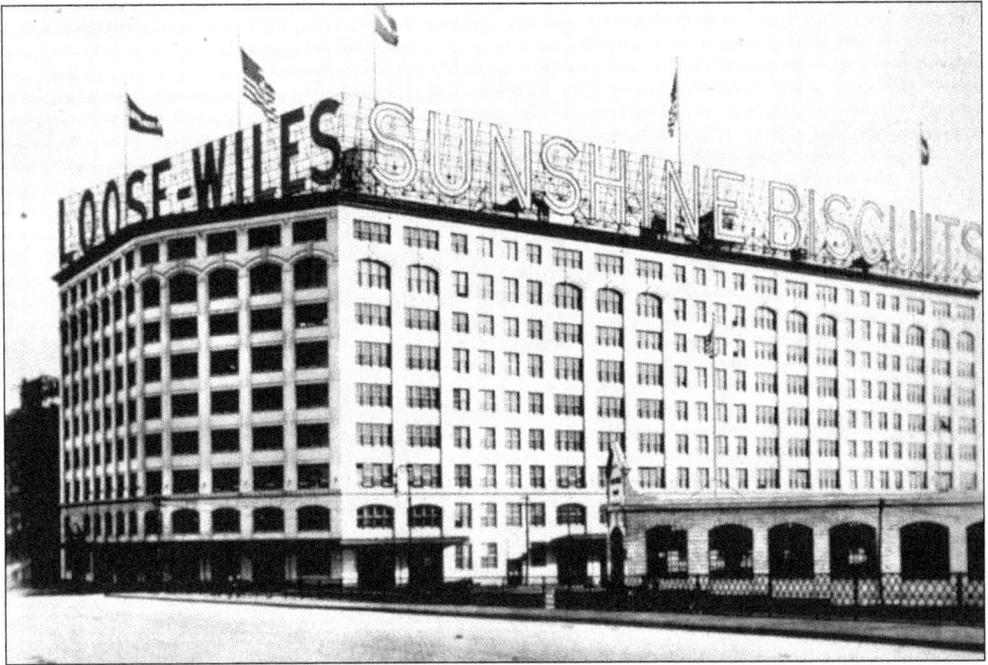

Jacob Loose was the baking mogul of Kansas City. The famous 1,000-window bakery of the Loose-Wiles Biscuit Company opened at Degnon Terminal in 1914. Employing 2,500, it was the largest firm in Long Island City. This building enjoys a second life after a 1980s conversion to offices and classrooms. (Courtesy GAHS.)

With intermodal rail facilities and cheap shipping by water, Degnon Terminal had a state-of-the-art distribution network. This great manufacturing center not only had rail siding inside buildings, but elevators could take cars to the floors where they were needed. (Courtesy GAHS.)

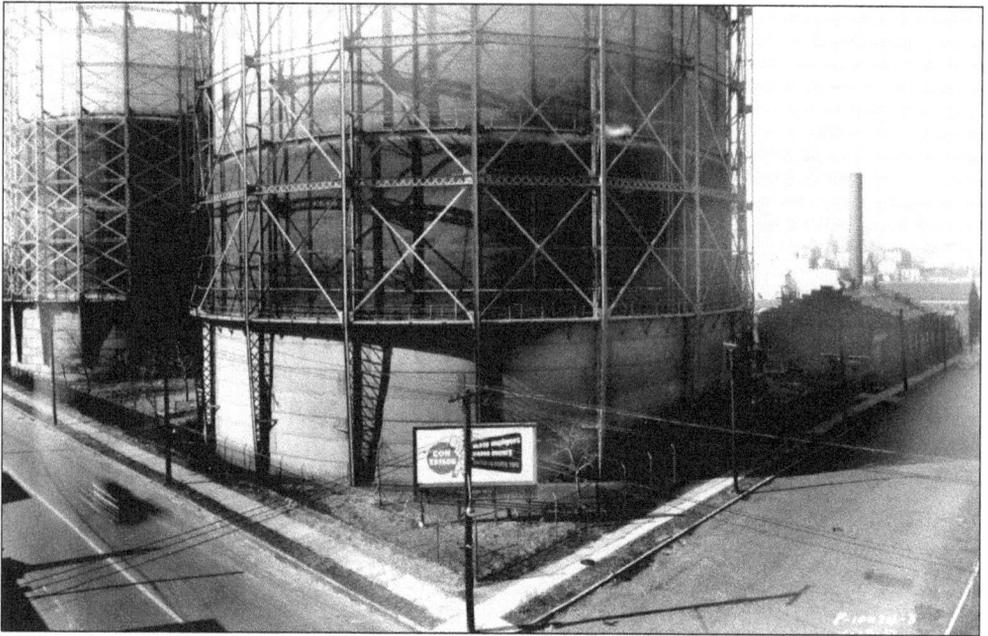

A few decades after the Ravenswood waterfront started to decline from graceful mansions to industry and utilities, the East River Gas Company began to supply Manhattan with gas through the first tunnel between Manhattan and Queens. These gas holders on Vernon Boulevard were replaced in the 1950s with the enormous Big Allis power plant. (Courtesy GAHS.)

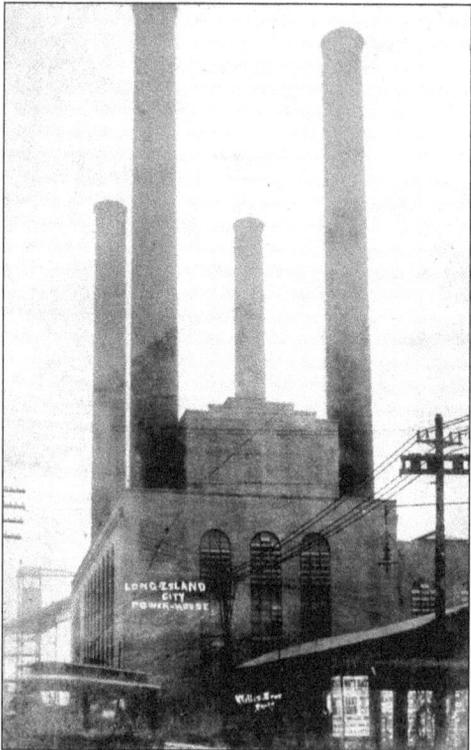

The Pennsylvania Railroad generating plant, later the Queens Electric Light & Power Company, was a 1909 commission by McKim, Mead and White. Located on Second Street between 50th and 51st Avenues, all but empty, its four great stacks loom like question marks over its future. (Courtesy Stephen Leone.)

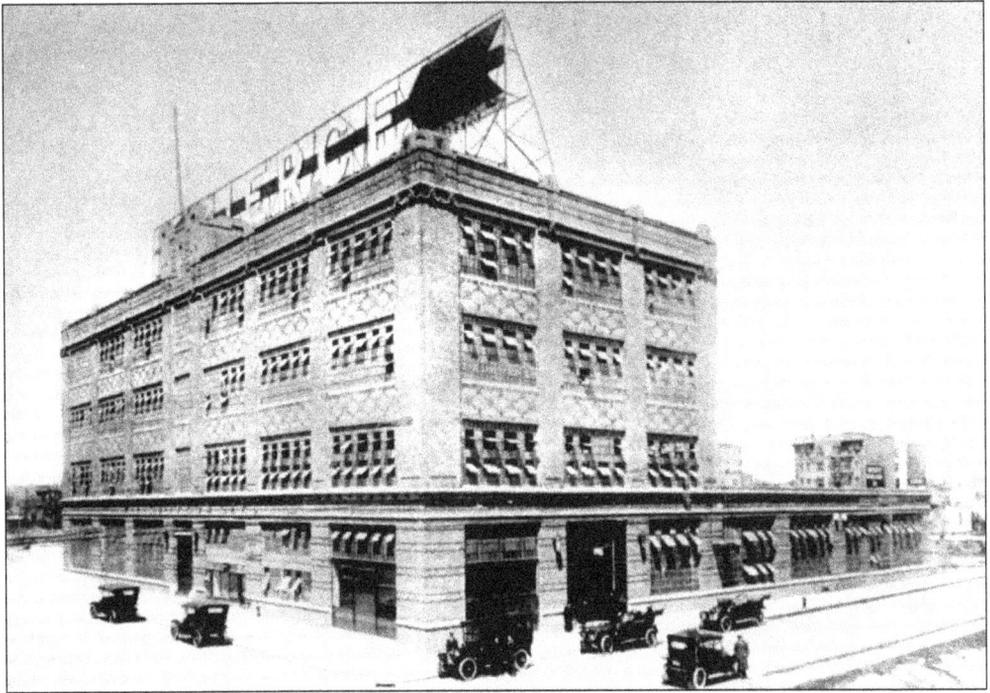

Located in an area once called "Detroit East," the Pierce Arrow factory was one of a number of plants in the area. Both Brewster and Rolls Royce automobiles were assembled in the Brewster Building at Queens Plaza. Well into the 1940s, Ford owned a large building on Northern Boulevard. Near Degnon Terminal, White Motor made trucks and American LaFrance fire engines. (Courtesy GAHS.)

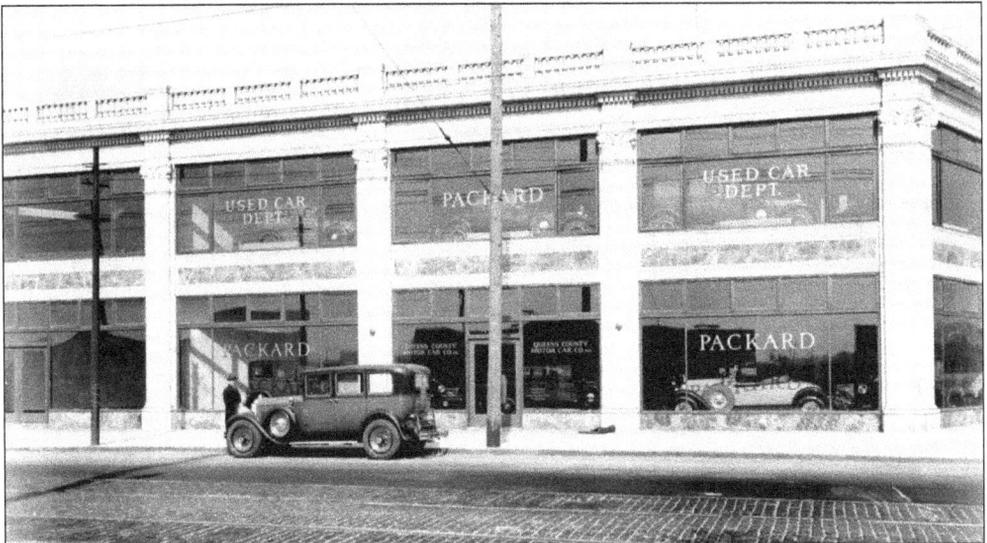

"Ask the man who owns one" was an early advertising slogan for Packard. When this picture of their February 1929 showroom on Northern Boulevard was taken, the boulevard was already home to automobile dealers. Today, almost every major car company has a showroom and maintenance facility on the strip. Some have been there for several generations. Notice the trolley tracks in the middle of Northern Boulevard. (Courtesy GAHS.)

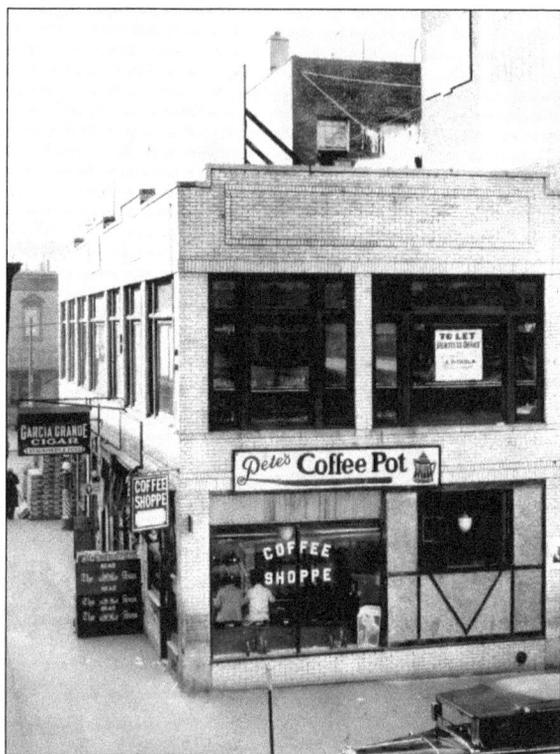

Pete's Coffee Shop, pictured here in 1934, was located on the southwest corner of Hoyt Avenue and Second Avenue (now 31st Street). To support the many workers and commuters in the area, diners and coffee shops provided people with quickly made, inexpensive, and nutritious meals. In New York, the diner is often synonymous with Greeks, who own and run many of them. (Courtesy GAHS.)

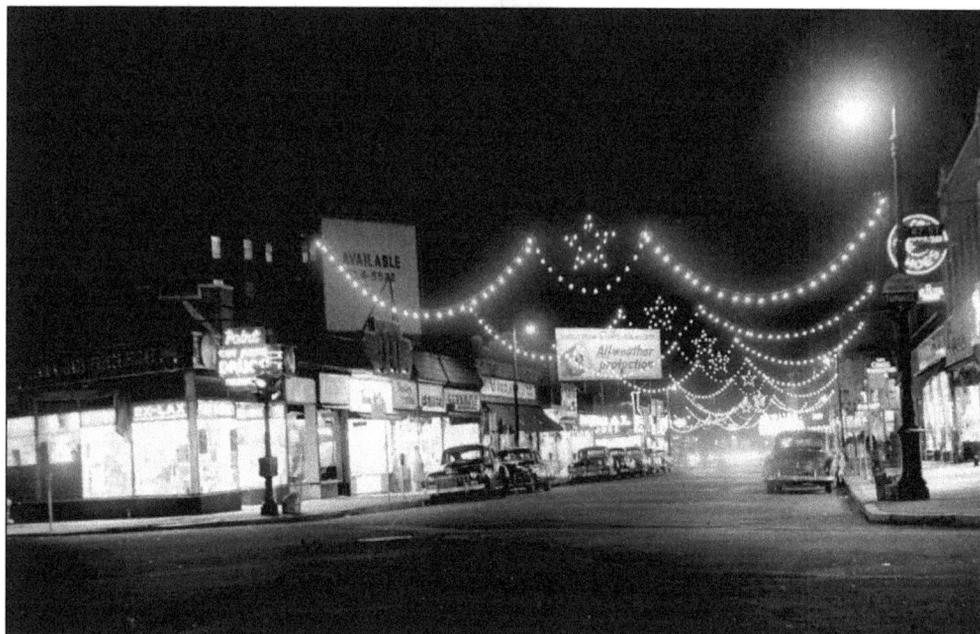

Unique to Long Island City, there is a major shopping district in every neighborhood. From Ditmars Boulevard to Queens Boulevard, no one has to travel far to enjoy a good bargain. As in this c. 1950 picture of Greenpoint Avenue, vibrant merchant associations add excitement to the holiday season by dressing up their district with lights, music, and a visit by Santa. (Courtesy Sunnyside Chamber of Commerce.)

Physicist Chester F. Carlson produced the first successful photocopy on October 22, 1938, through a process called xerography. Eventually, the Haloid company bought the rights to this invention and provided Carlson with financial backing to improve the process. Haloid later became the world-famous Xerox Corporation. The community has always been a cradle to creativity, and Chester Carlson's invention, which made him a millionaire, set the modern business age in motion. (Courtesy Xerox Corporation.)

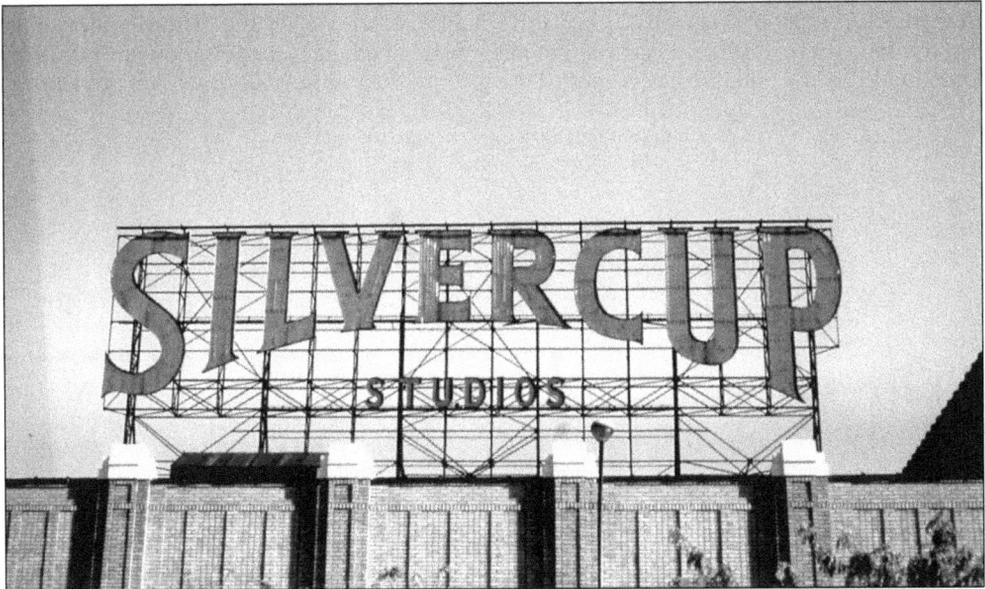

Since its 1983 opening in the landmark 1939 Silvercup Bakery, Silvercup Studios quickly established itself as the largest independent film and television production facility in the northeast. Older residents fondly recall crossing the Queensboro Bridge and enjoying the aroma of freshly baked bread. Movies shot here include *Men in Black* and *Gangs of New York*. Television shows produced here include *Sex in the City* and *The Sopranos*. (Courtesy GAHS.)

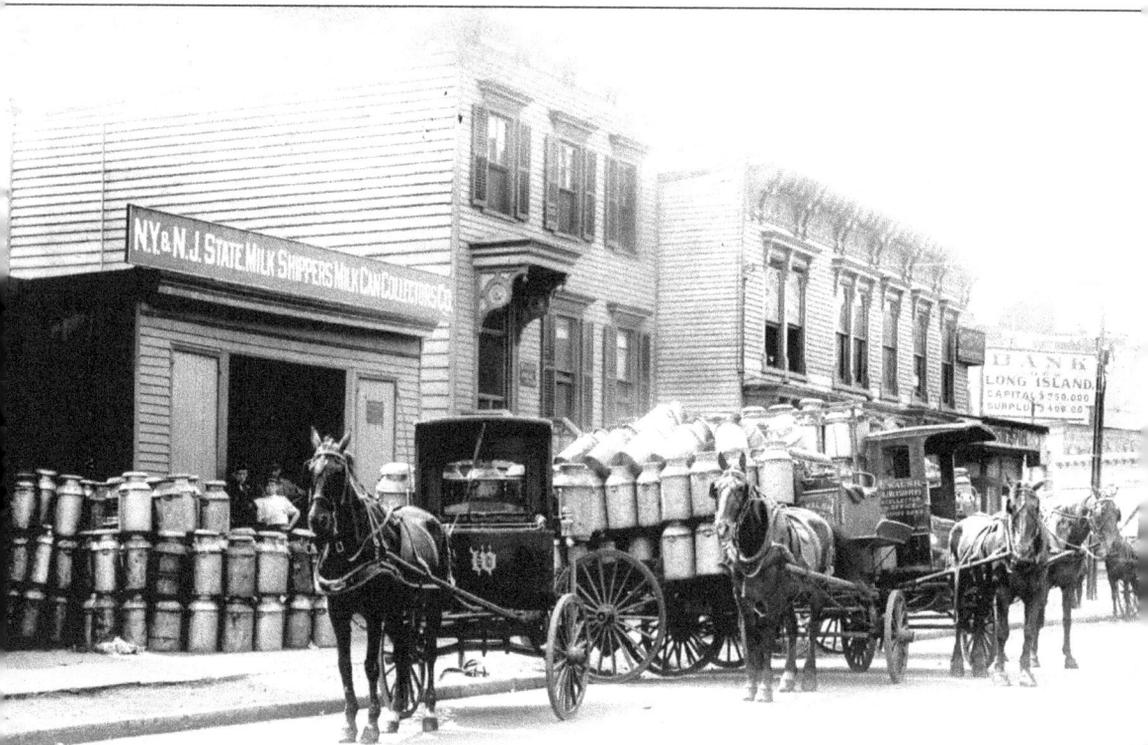

J.G. WALSH'S EMPLOYEES SORTING & DELIVERING STRAY MILK C
TO THEIR OWNERS

In this 19th-century photograph, J. G. Walsh's employees are sorting and delivering stray milk cans to the owners. The horse cart was the main mode of ground transportation until *c.* 1915. One wonders if the milk cans were washed out prior to their reuse. (Courtesy Bob Stonehill.)

Five

TRANSPORTATION

One of the most essential keys to the success of any municipality is good transportation. Long Island City's excellent location between Manhattan and Long Island was tarnished by its widely scattered collection of hamlets, separated from one another by marshes and ponds. Along a good portion of its waterfront was the Hell Gate, the most dangerous part of New York's harbor. There, dancing around a score of islands, rocks, and reefs, a continuous battle of whirlpools and riptides from three straits, the Harlem River, Long Island Sound, and the East River, grounded hundreds of boats yearly.

These barriers were overcome by a partnership of farsighted private development, shrewd corporate investment, and a massive government initiative spanning several generations.

Stephen Halsey, "the Father of Astoria," built two turnpikes. Linking Long Island City to Brooklyn was Vernon Boulevard, and linking Flushing with Long Island's North Shore was Astoria Boulevard. Halsey also secured the charter to the 86th (later the 92nd) Street ferry to Manhattan, bought ferryboats for the route, and instituted regular service. After Hunters Point became the terminus for several railroads and enjoyed regular ferry service to Manhattan's 34th Street, another turnpike, today called Northern Boulevard, was built to Flushing.

The Hell Gate remained a significant bottleneck and had to be tamed. Only licensed pilots could take boats through. After flirting with the idea of digging a canal from Pot Cove to Halletts Cove, the federal government made a significant effort and spent a great deal of money undermining and blasting its rocks from the 1870s through the 1920s.

The first horsecar appeared in 1867. Between 1885 and 1896, William Steinway assembled the Long Island City trolley network. He sold it in 1896 to a syndicate who renamed it the New York & Queens County Railway. In 1903, it was snapped up by the Interborough Rapid Transit Company (IRT).

The Queensboro Bridge (originally planned to be located at Rainey Park) opened to pedestrians and vehicular traffic in 1909. A year later, nearly 16 million people used it to cross the East River. In the second decade of the 20th century, automotive traffic far outpaced horse-drawn wagons.

The Pennsylvania Railroad bought the Long Island Railroad system in 1901. By 1910, the Pennsylvania Railroad had driven a tunnel under the Hudson River, across Manhattan, and through the East River to Long Island City. That year, they opened both Pennsylvania Station and the Sunnyside Railyards. The Sunnyside yard was one of the largest rail facilities in the country. By 1917, the Hell Gate Bridge connected the main line to New England.

These steps made Long Island City not only the heart of Long Island's rail system, but the nucleus of New York's transportation network. At the beginning of the 20th century, Hunters Point had the largest concentration of industry in the United States. Degnon Terminal and the Long Island Railroad pioneered many innovations in freight handling.

Other transportation enhancements at the time included the Vernon Avenue Bridge, linking Brooklyn in 1905. By 1913, public transportation reached Queens Boulevard, Sunnyside, and Degnon Terminal.

The network for the New York City subway system was designed in the 1890s by New York City's first subway commissioner, William Steinway. It was his brilliant foresight that planned the East Side and West Side routes, crosstown lines, and service to the Bronx, Brooklyn, and Queens.

The Steinway Tubes under the East River, started and abandoned by William Steinway in 1894, were finally completed in 1907. The elevated road from the tunnel mouth in the Sunnyside Railyards to Queensboro Plaza was open by November 1916.

In Long Island City, the system's centerpiece was Queensboro Plaza. With eight tracks running along its 480-foot length, it was well worth its $884,000 price tag. Passengers could now be whisked to Grand Central in only six minutes.

The tracks split after Queensboro Plaza. One branch continued along Northern Boulevard and 31st Street to Ditmars Avenue, where it was planned to continue to Steinway Street, then on to North Beach. The other branch crossed over the Sunnyside Railyards and through Sunnyside. This line's viaduct on Queens Boulevard is one of the most handsome portions of the city's mass transit system.

The Second Avenue El reached Queensboro Plaza from Manhattan in 1917. Service between Lexington Avenue and Queensboro Plaza started in 1920. By the mid-1930s, the subway crossed the East River through Hunters Point. The tunnel led into a new transit hub, Queens Plaza.

Offering through service to New York, these lines caused a real-estate boom. Empty weed-covered lots were fully developed seemingly overnight.

The ferries were gone by the 1930s. Late in 1939, buses replaced trolley lines. The Triborough Bridge was completed in 1936. For the next 30 years, urban planner Robert Moses built an intricate system of expressways, including the Grand Central Parkway, the Long Island Expressway, and the Brooklyn-Queens Expressway. The Queens-Midtown Tunnel was completed in 1940. The community was made accessible to the automobile, but thousands of citizens were displaced and hundreds of buildings were destroyed in the process.

In the 1950s, a bridge was built to Roosevelt Island. The Pulaski Bridge was opened to Brooklyn in 1954. The Queensboro Bridge trolley held out until April 1957.

During the 1990s, a new subway line to Manhattan was opened. A tunnel for the Long Island Railroad was planned to connect Long Island, for the first time, to Grand Central Terminal. Things went full circle when East River ferries tried a comeback and a major transportation hub was planned, again, for Hunters Point.

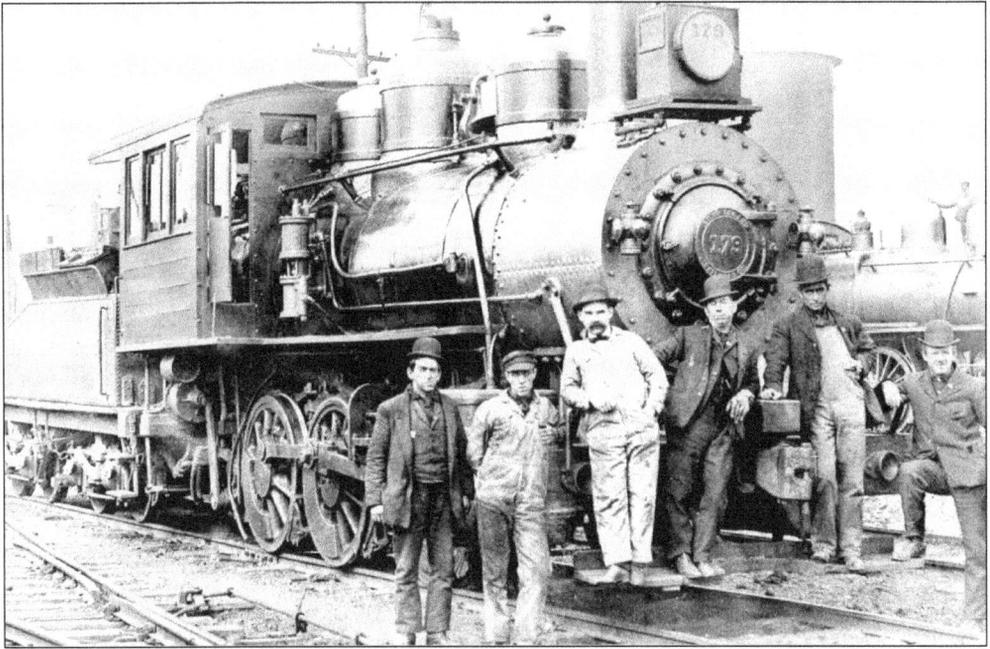

The Industrial Revolution occurred when the horse was replaced by the iron horse, the powerful steam locomotive. Long Island's rail network radiates like fingers in a hand while at the wrist sits Long Island City. A no-nonsense crew stands at the nose of Long Island Railroad's locomotive No. 179 c. 1906. (Courtesy Bob Stonehill.)

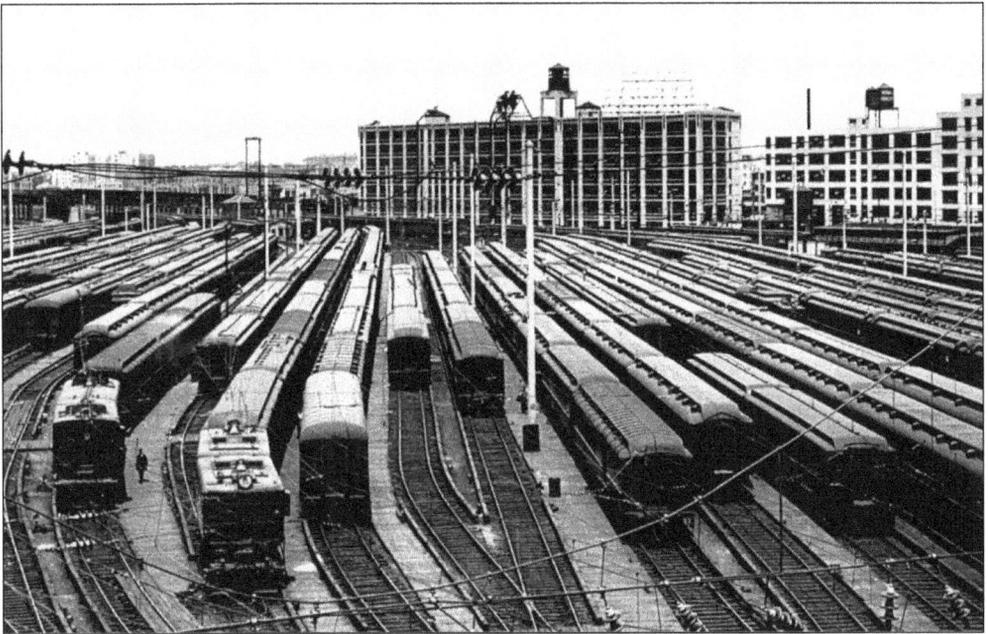

This c. 1950 photograph was taken from a vehicular bridge over the Sunnyside Railyards, a holding and maintenance yard for both passenger and freight trains. In their heyday, the yards were premier rail facilities in the country. In the background is the 1905 Degnon Terminal. (Courtesy GAHS.)

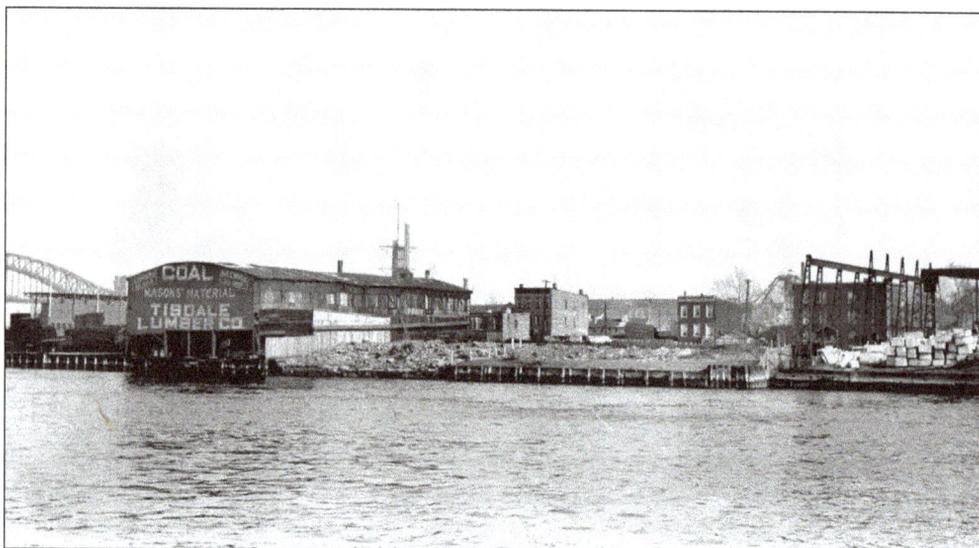

Commercial and residential development in Old Astoria Village occurred simultaneously, as a successful development needed a balanced foundation. James Tisdale, born in Ireland in 1811, became a hardware merchant in New York. In 1846, he established a coal and lumber business in Old Astoria Village at the southwest corner of Vernon Boulevard and Astoria Boulevard. His grandson was running the business when this picture was taken sometime in the 1920s. (Courtesy Robert Singleton.)

The 92nd Street (originally the 86th Street) ferry to Halletts Cove dates from the 1700s. Passengers rang a bell, and the captain, on the other side, would ring the other bell when he was ready to come over. Regular service began when Stephen Halsey took over and bought new boats c. 1840. After the Triborough Bridge opened in 1936, Robert Moses had the ferry dock destroyed. (Courtesy GAHS.)

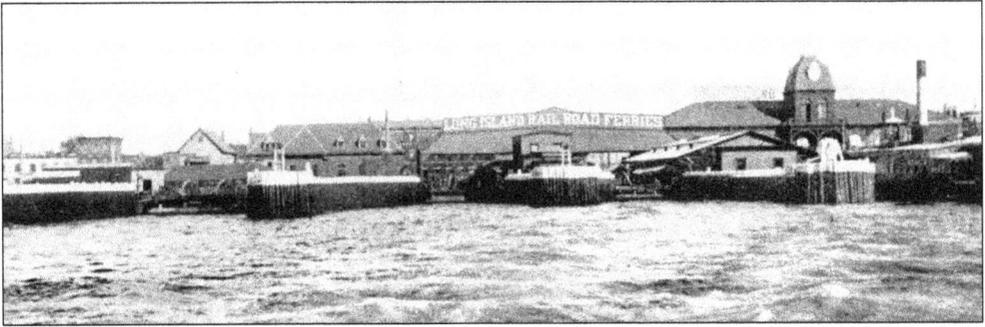

Between 1860 and 1910, the Hunters Point ferry terminal was the most important route to Long Island. The ferry carried up to 10,000 fares in an hour, including the racetrack crowd, beach and picnic crowds, and staid community throngs, who all crossed on the water route linked to the vast network provided by the Long Island Railroad. The Queensboro Bridge and the rail tunnels under the East River made the terminal obsolete, and it closed in 1925. (Courtesy GAHS.)

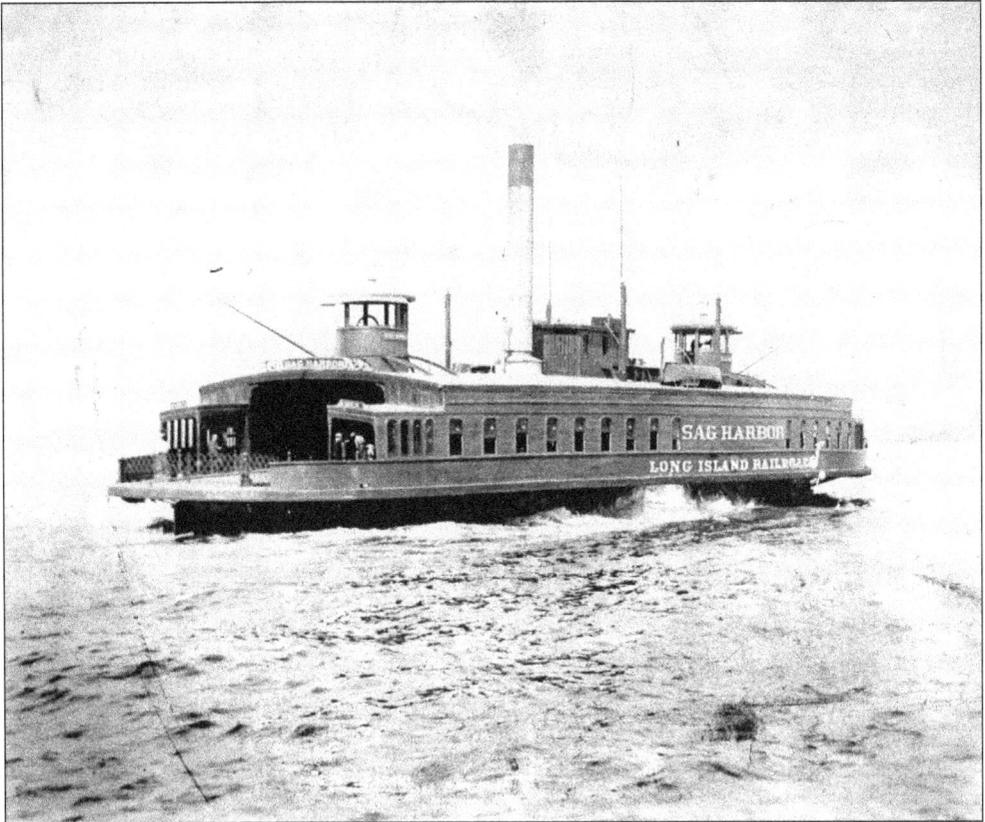

For 67 years, the 34th Street ferry ran on the East River between the foot of Borden Avenue, Long Island City, and 34th Street, Manhattan. It missed only two days during the Blizzard of 1888. There used to be six boats to 34th Street, two to James Slip, and three fast steamers that conveyed bankers to Wall Street. Pictured is the *Sag Harbor*, piloted by Gus Kehoe (see page 100). (Courtesy Tim Kehoe.)

The awakening of Long Island came with spanning the East River with the Queensboro Bridge over Blackwell's Island. This 1909 masterpiece by Gustav Lindenthal (who built the Hell Gate Bridge) is celebrated in movies and song. The advantage of a link with Manhattan was one of the main arguments persuading Long Island City to join with New York. Without safety harnesses or hard hats, workers boldly scramble about its structure. (Courtesy Queens Chamber of Commerce.)

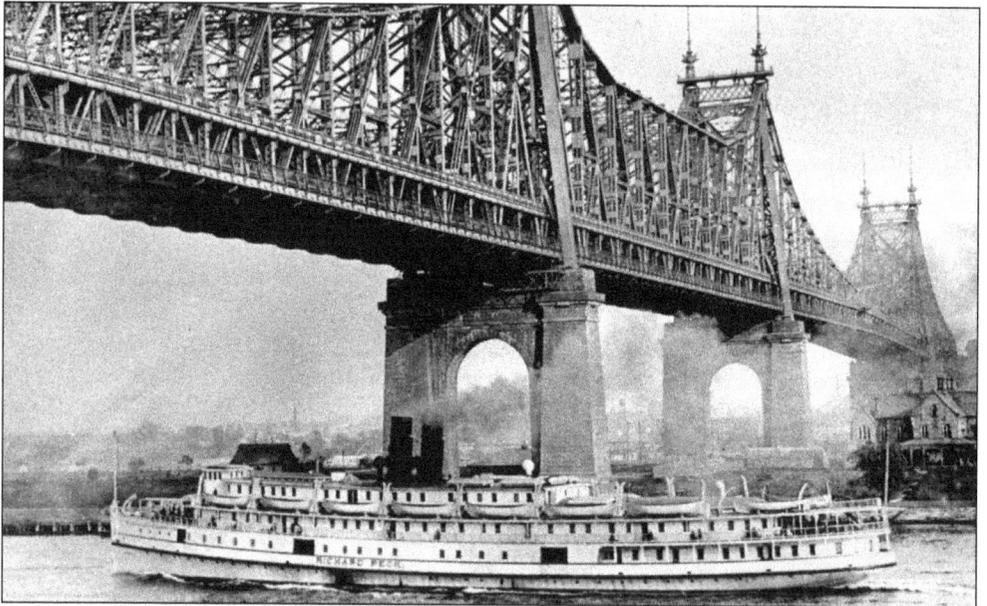

By the 1920s, bridges all but replaced ferries as the primary means to cross the river. Here, the *Richard Peck*, a typical steamer, sails through the East River's West Channel under the mighty Queensboro Bridge, considered one of the most beautiful cantilever bridges ever built. The house on the right was the warden's residence for the penal and medical facilities that once occupied Blackwell's (later Welfare, now Roosevelt) Island. (Courtesy Stephen Leone.)

Three months after this July 1915 photograph was taken, the massive steel arches of the Hell Gate Bridge were connected—at only 5/16 of an inch out of alignment. An engineering triumph by Gustav Lindenthal, the four-track bridge can support 40 locomotives. It opened to traffic in April 1917 as part of the main line to New England. The 3.2-mile bridge includes a long approach through Queens and a viaduct over both Wards and Randalls Islands. (Courtesy Robert Singleton.)

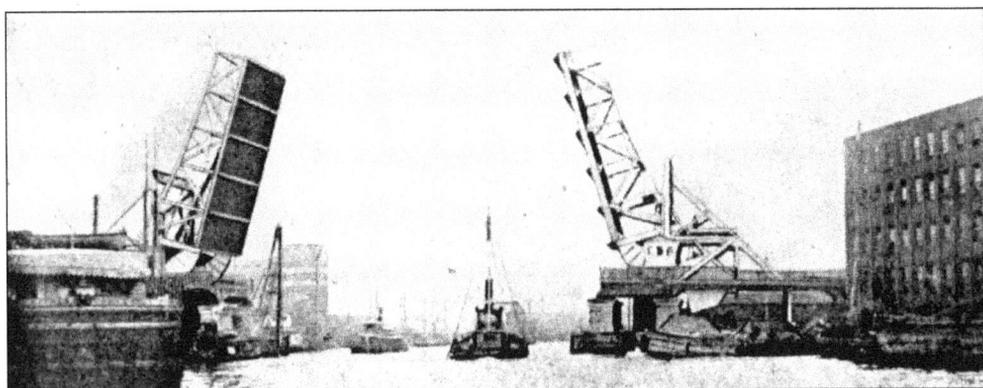

Newtown Creek was spanned by 1840. A rickety swing bridge connected Vernon Boulevard with Manhattan Avenue, Greenpoint. Buffeted by barges and poorly repaired, it threatened to tumble into the creek. Pictured here was the new high-level bascule bridge with its counterbalanced arms that opened in 1905. It was torn down after the considerably larger 1954 Pulaski Bridge opened a short distance to the east. (Courtesy Stephen Leone.)

81

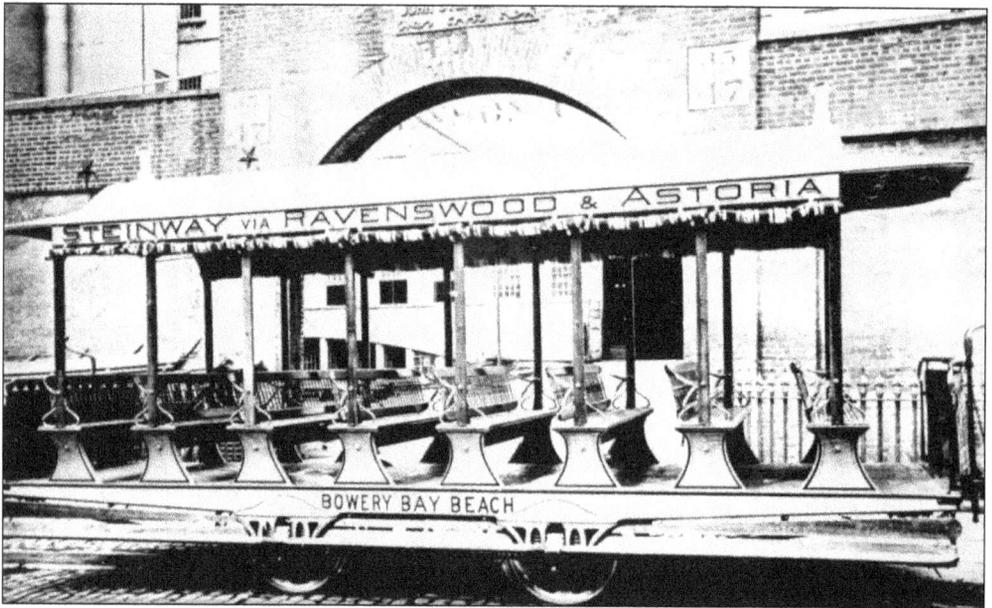

To manage his street railway properties, William Steinway set up the Steinway & Hunters Point Railroad in 1882. This 1886 horsecar went to the resorts at Bowery Bay Beach, whose name was changed to North Beach Amusement Park in 1891. This open-air horsecar was a seasonal conveyance, and the journey was as much fun as the destination. (Courtesy GAHS.)

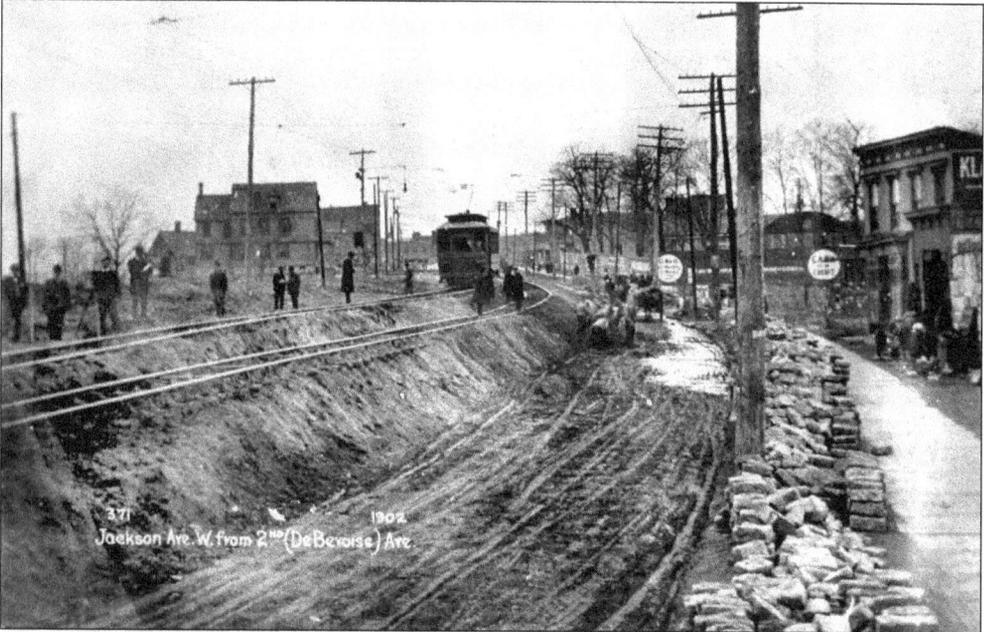

Northern Boulevard was once Jackson Avenue and originally the Hunters Point, Newtown and Flushing Turnpike. It cost $40,000 to build and opened in July 1860, with milestones, a gravel roadbed, and a tollhouse that collected a 9¢ toll from carriages. This 1902 view near DeBevoise Avenue (31st Street) shows a county road getting a facelift in anticipation of becoming a major artery for the future Queens Plaza (right), Sunnyside Railyards (left), and the elevated train (overhead). (Courtesy GAHS.)

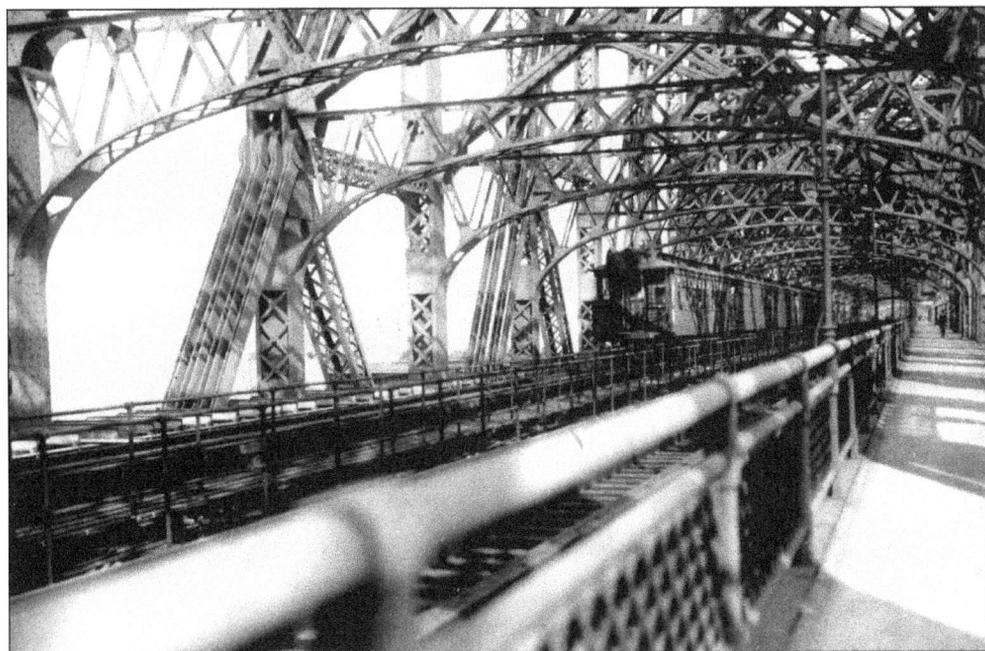

A trolley shuttle ran on the Queensboro Bridge in 1910, and by 1913, it ran from Manhattan to Queens Boulevard. Pictured is the Second Avenue elevated train that reached Queens Plaza by 1917. Today, the upper level has four lanes exclusively for vehicular traffic, with two lanes changing direction at peak hours to accommodate rush-hour traffic. (Courtesy GAHS.)

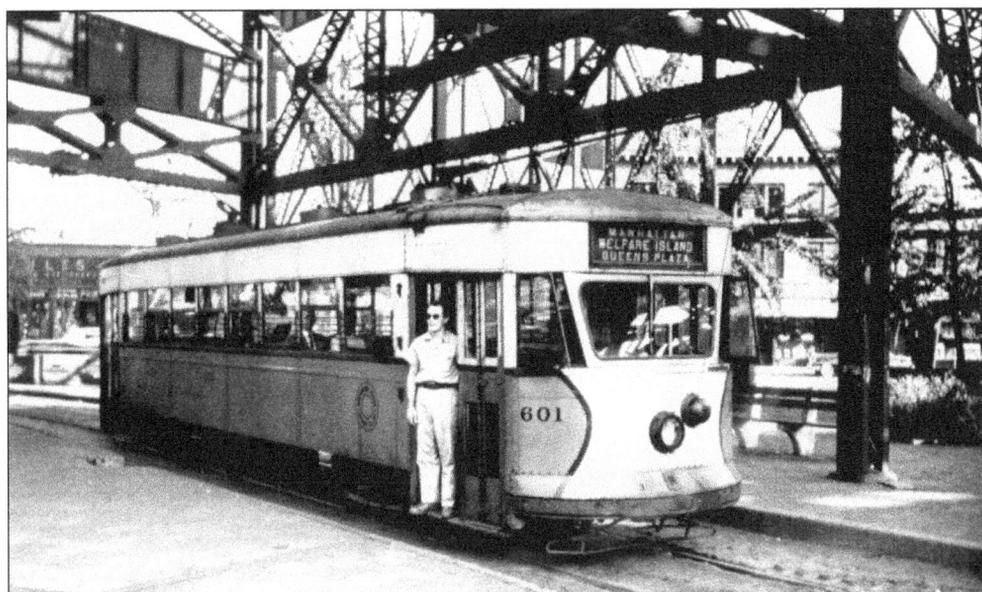

At Queens Plaza, conductor Joseph Biliski readies another run on old No. 601 in the early 1950s. The Queensboro Bridge trolley stopped at Vernon Boulevard and at mid-span, Welfare Island, where passengers would take an elevator from the bridge to the island. With the opening of the Welfare (now Roosevelt) Island Bridge in 1955, this last trolley in the city shut down in 1957. (Courtesy Robert Biliski Jr.)

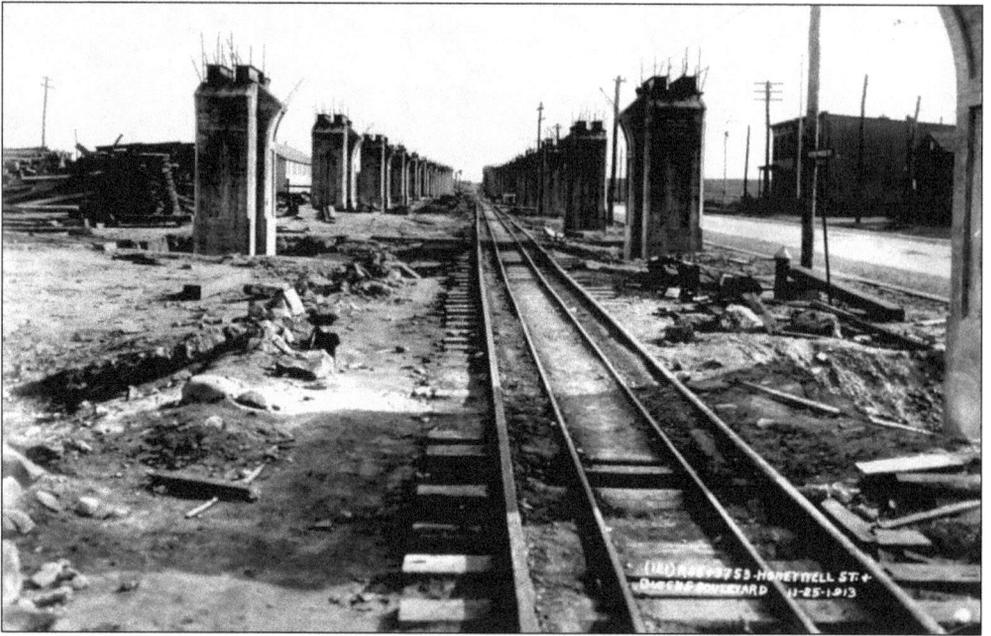

Looking east along Queens Boulevard from 36th Street is the IRT viaduct (today the No. 7 line) under construction in November 1913. When the line opened, empty lots on either side were developed overnight. The tracks underneath the viaduct may be an old trolley line or a temporary rail built to carry heavy construction materials. (Courtesy GAHS.)

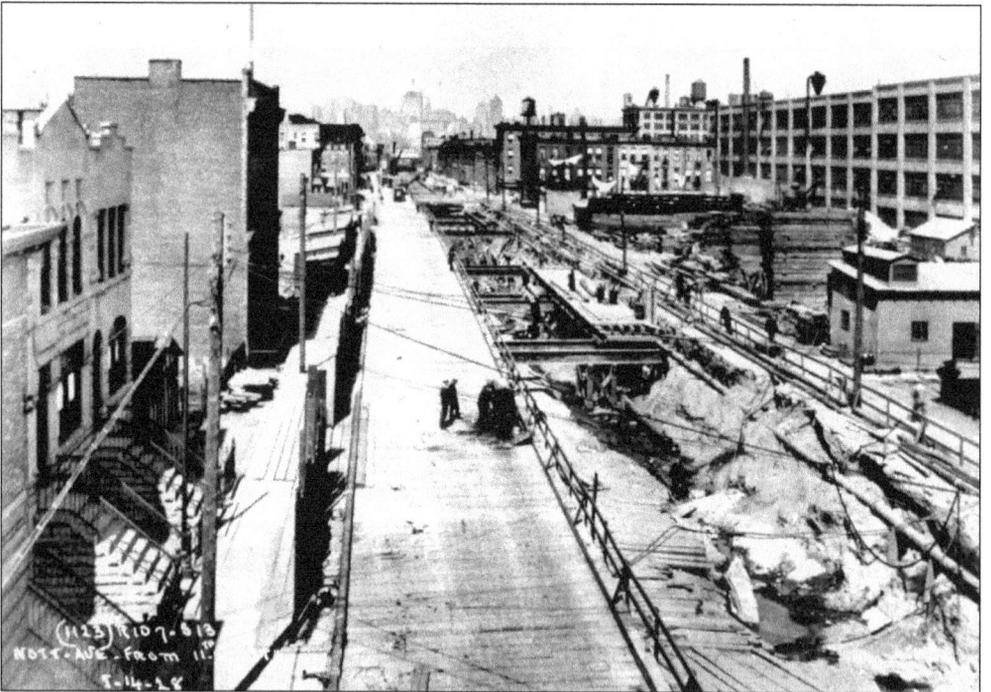

The coming of subways brought in the last great wave of mass transit. This view, looking west along 44th Drive and 23rd Street, shows the construction of the independent system (now the E and V lines) in May 1928. (Courtesy GAHS.)

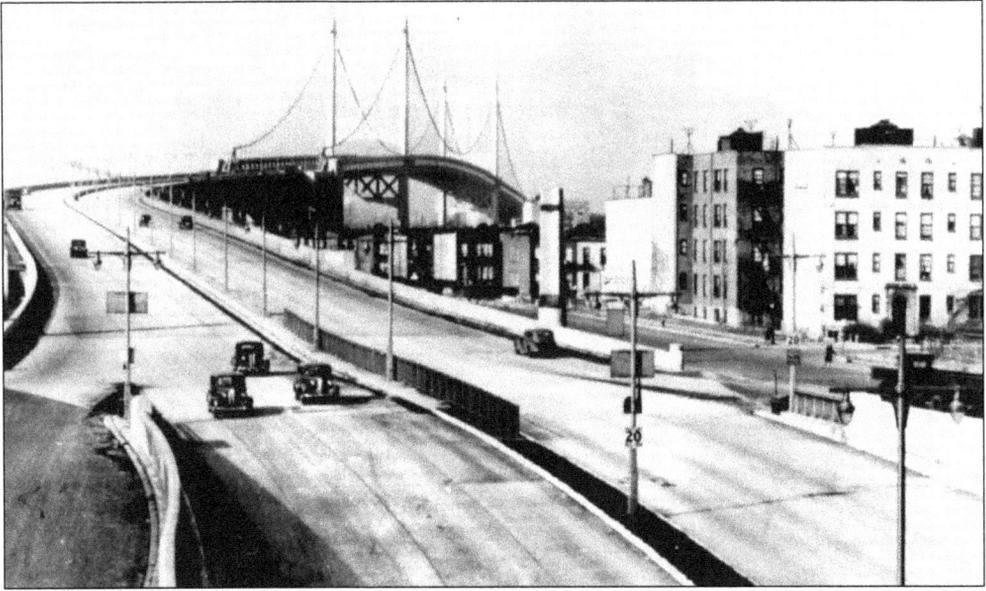

The Triborough Bridge contains three steel bridges and spans the waters between Manhattan, the Bronx, and Queens. It was designed by Othmar Ammann, who also built the Verrazano Narrows Bridge. Construction began on October 25, 1929—the same day the stock market crashed. The Triborough Bridge and Tunnel Authority was formed in 1933, and the bridge was completed and open to traffic in 1936. (Courtesy GAHS.)

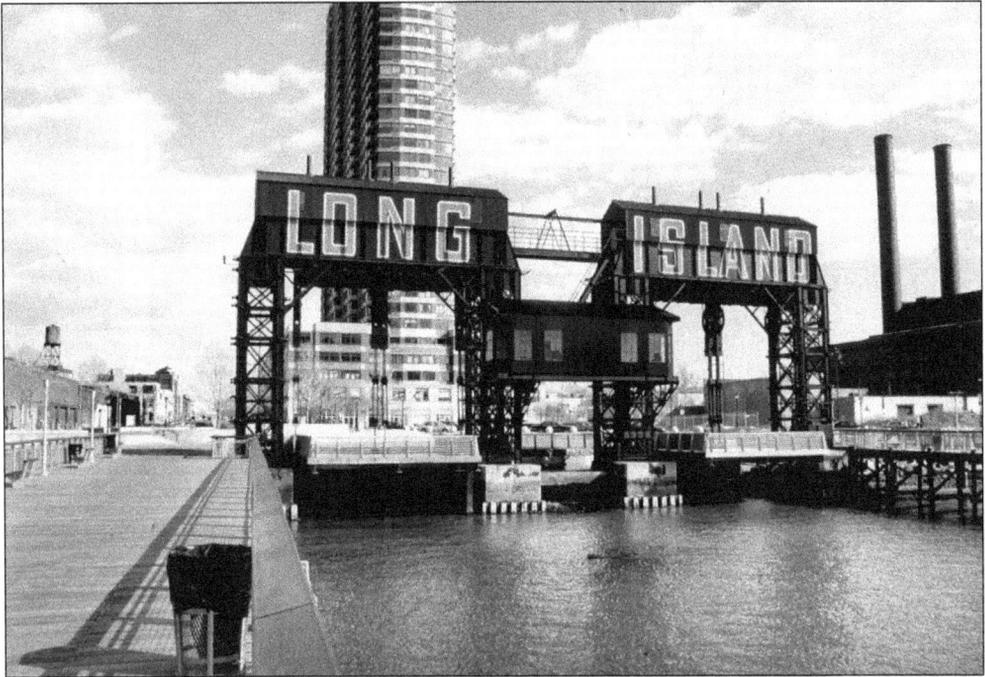

These gantries, or float bridges, at the Hunters Point terminal on the East River helped guide and lift railroad cars. Filled with materials such as coal or gravel, the barges would be floated to Manhattan or New Jersey to link up with the continental rail network. These gantries have been preserved at Gantry Park and Plaza in Hunters Point. (Courtesy Nick Kalis.)

85

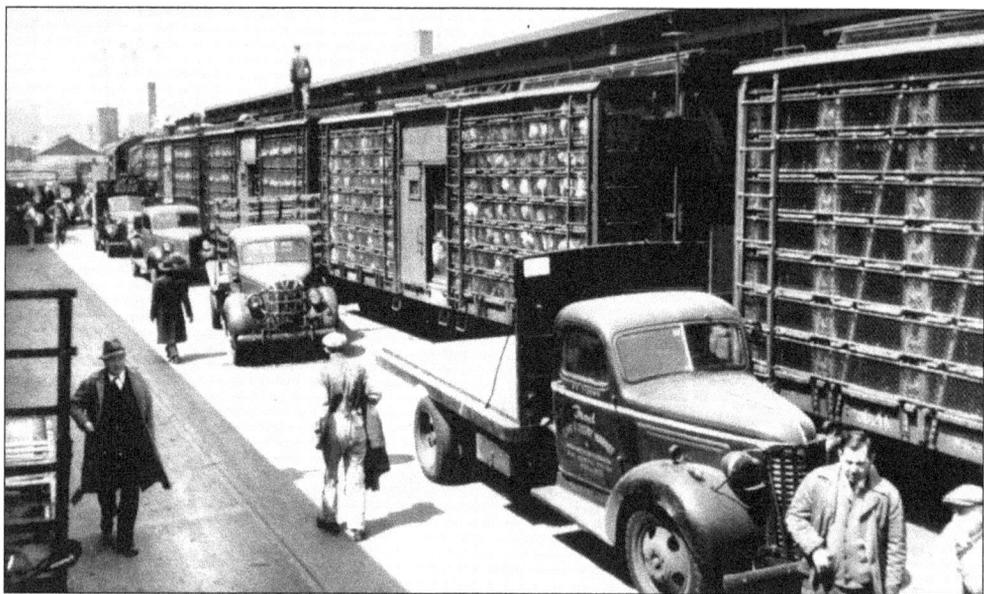

A chicken shipment on rail cars at the Degnon Terminal in 1946 proves, once again, that just about anything could be handled by the local transportation network. Timely delivery of fresh produce and live poultry from farm to table was no problem. (Courtesy GAHS.)

This is the U.S. postal facility for military mail at 48th Street and Northern Boulevard. At the site of Madison Square Garden Bowl, this facility moved millions of pieces of overseas mail during World War II. It was one of the largest postal operations in the world. (Courtesy Queens Chamber of Commerce.)

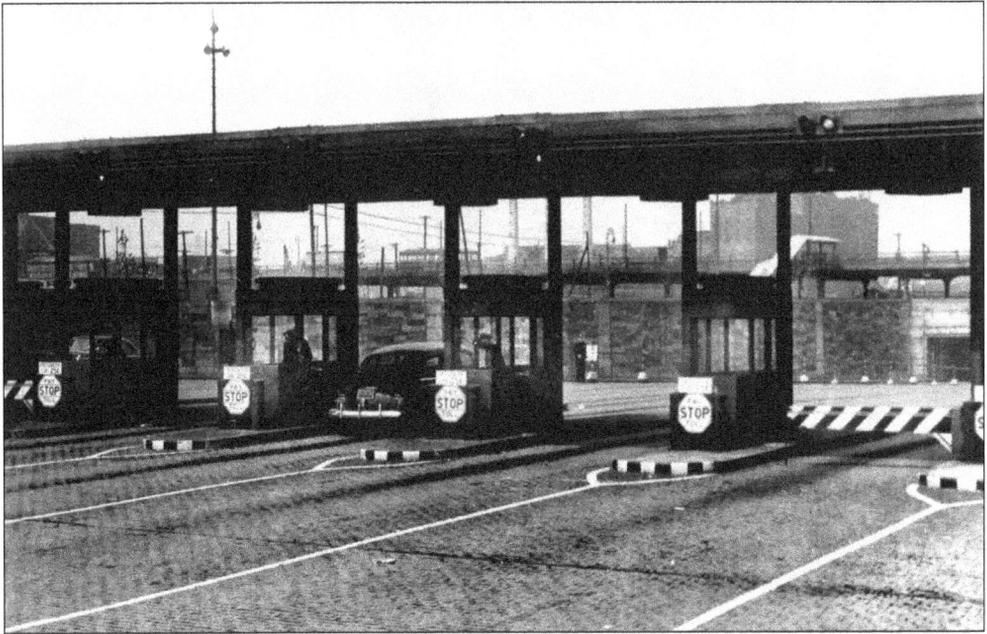

This is the Hunters Point entrance to the 6,200-foot Queens-Midtown Tunnel, which opened in 1940. The passenger cars still paid only 25¢ in 1947. Notice the elevated trolley car in the distance as it crosses Newtown Creek and from Hunters Point to Greenpoint, Brooklyn. (Courtesy GAHS.)

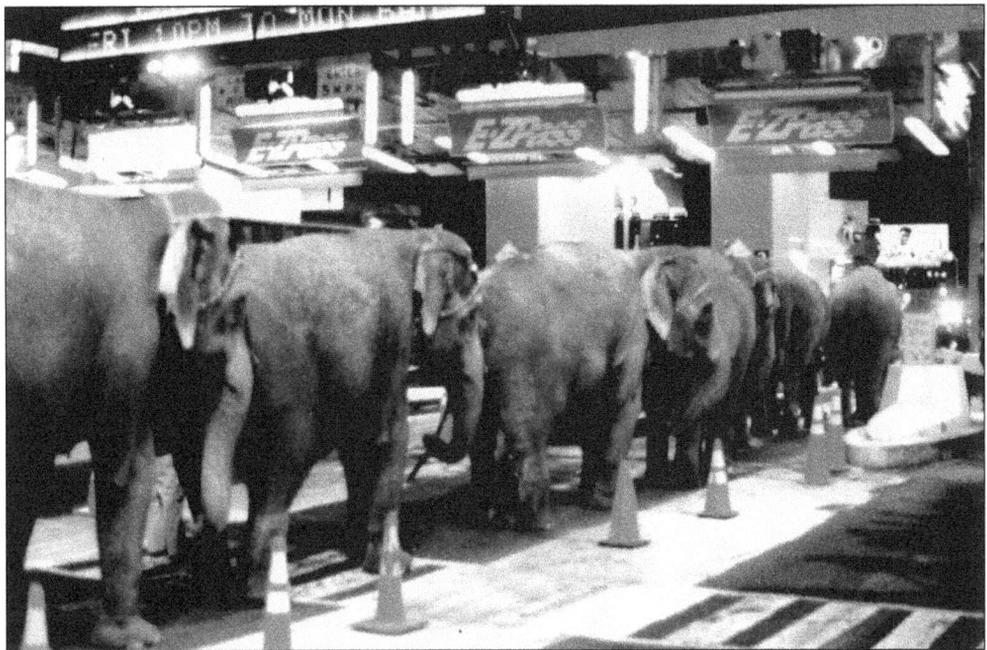

Not only cars, trucks, and vans take the Queens-Midtown Tunnel. Each spring, Ringling Brothers and Barnum & Bailey trains arrive at the Sunnyside Railyards. At night, the elephants take the long walk through the tunnel to Madison Square Garden. (Photograph by Jerry Rotondi.)

Pictured here is amateur photographer Josef Svab taking a picture in Schuetzen Park c. 1920. With the advent of cheap cameras, the events of our lives, as well as the history of our community, could be permanently recorded for posterity. (Courtesy Debbie Van Cura.)

Six

WE THE PEOPLE

The history of a city originates in individuals. In the lives of men, therefore, lie the records of society, whether it is developed into a municipality, state or nation.

—History of Long Island City,
J. S. Kelsey, 1896

From the time of the first European settlers, the record of Long Island City is complete. We know their names, their homes, their professions, their deeds, and those who succeeded them. We know from where they came and why they came. These early pioneers left a distinct impression upon our community.

Long Island City's coat of arms, rich in symbolism, depicts a freedom-loving people ever ready to challenge the wrath of tyrants.

The city remains a magnet for those ready to grapple with the uncertain challenges of a new land. For many generations, it continues to attract those with sturdy energy and creative imagination. In the faces of the people depicted here, you will find a proud, self-confident community.

If people are our greatest asset, then our noblest heritage is found here. Each picture in the family photograph album tells a little part of the story: the retired fireman in full uniform, a squad of police officers ready for patrol, school kids in their classroom. Old sepia photographs show that diversity in Long Island City is not a slogan but has always been a way of life. It shows the charm of a small town and the bustle of a great city.

Idols on stage, heroes of sports, and exceptional talents in politics, business, and the arts have called Long Island City home, including Ethel Merman, Bix Beiderbecke, Tony Bennett, James Caan, Christopher Walken, Patty Duke Astin, Jimmy Durante, Madeline Kahn, George Maharis, Nancy Walker, Melanie, and Patrick McGoohan, to name a few.

In this chapter are the very icons of our national experience—the farmer feeding his chickens, factory workers on break, a comic vaudevillian, a smirking criminal facing hard time. Here you will find proud laborers and skilled craftsman who believe that excellence is not an ideal but a reality.

And what photograph album would be complete without children?

Today, a new wave of pioneers is blazing a trail and showing the way for a rising tide of artists and creative people into the community. Young people, looking for a better quality of life than found in Manhattan, are now flooding into the neighborhood. As the Left Bank is to Paris, this Right Bank of the East River will be to New York.

All these people are in their own way, and in their own time, threads in the pattern of Long Island City.

A traditional small farmer, Jakob Huther purchased a house on Skillman Avenue and 45th Street as a family residence and general store. An enterprising man, Huther delivered produce door to door with a horse and wagon. He used the two ponds in the background to raise ducks. (Courtesy Mike Leahy.)

William Steinway, Long Island City's renaissance man, pauses at the steps of his mansion. He lived simultaneously six successful lives. He was president of a manufacturing empire (Steinway & Sons), started a community (the Steinway settlement), developed real estate (North Beach Amusement Park), owned a transit monopoly (Steinway railways), was a philanthropist (Steinway Library), and an impresario (Steinway Concert Hall.) When he died, the city's flags flew at half-staff. (Courtesy Henry Steinway.)

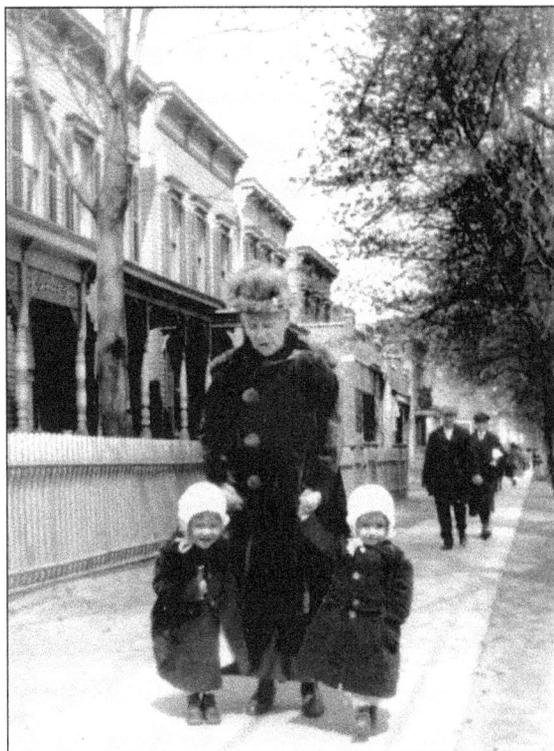

Ottilia Lydike takes her first walk with her twin grandchildren, Lewis and Elissa Greffath, c. 1920. Dressed in their Sunday best, they casually stroll down Broadway near 35th Street. (Courtesy Maureen Sabo.)

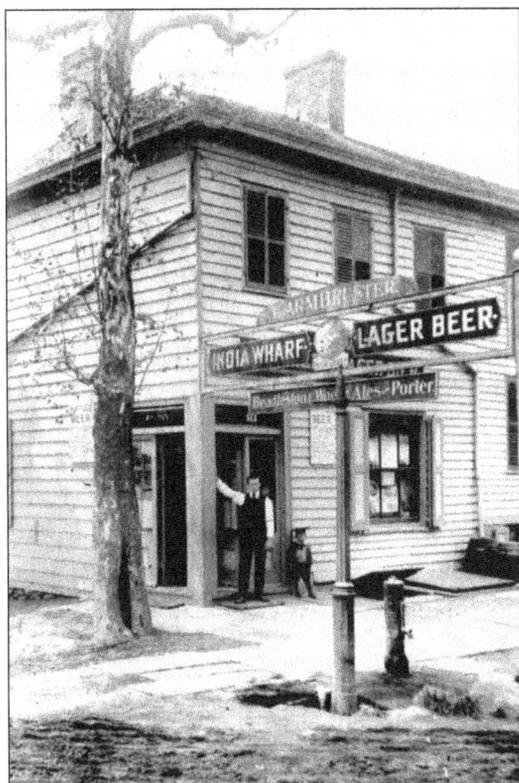

William Stein stands outside the L. Armbruster saloon on Newtown Avenue with his little buddy c. 1890. Also in his Sunday best and mortarboard, this little guy appears to be holding a slingshot. (Courtesy GAHS.)

An unidentified child seems pleased to have discovered a makeshift water fountain. This early-1920s photograph may show an undeveloped Astoria Park, but the little grin suggests hours of imaginative play. (Courtesy GAHS.)

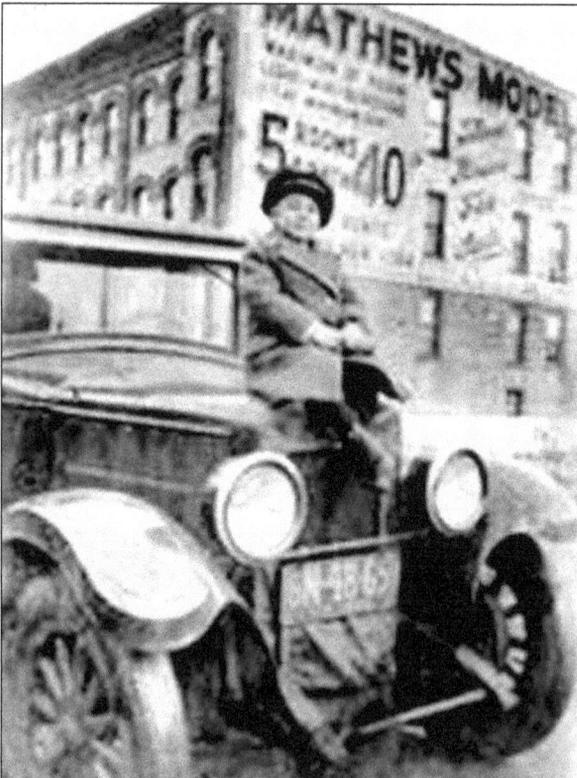

The Ciaffone family owned a gas station, and later an automobile dealership, at the corner of 34th Avenue and 48th Street. Their little boy, Frank, was never bored playing among the cars. (Courtesy the Sessa family.)

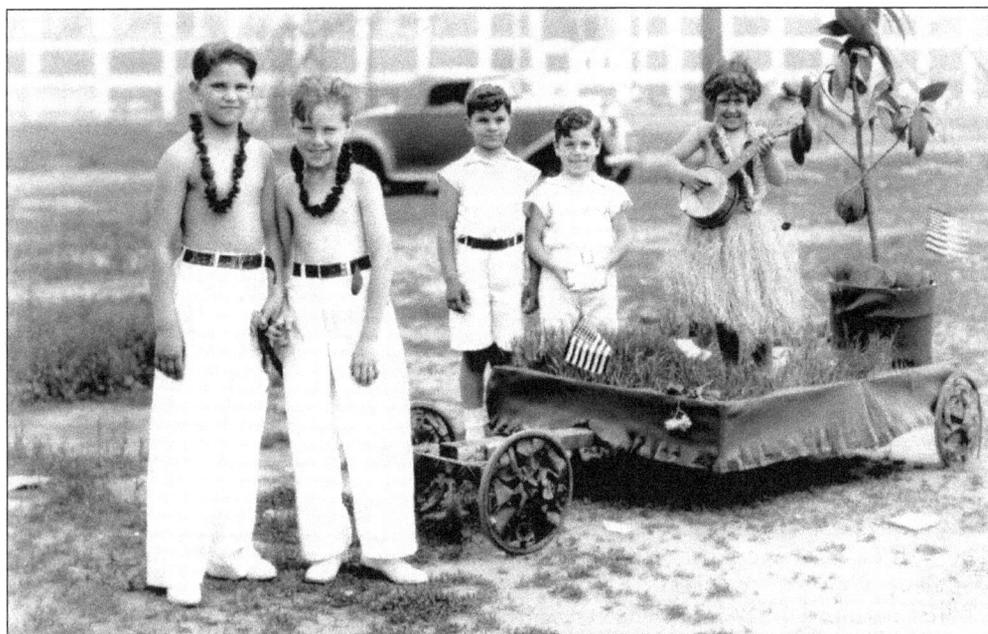

These pretend actors are bringing a little tropical scene to an urban setting. Notice the lush vegetation float being pulled along an open lot. (Courtesy Bob Ulino.)

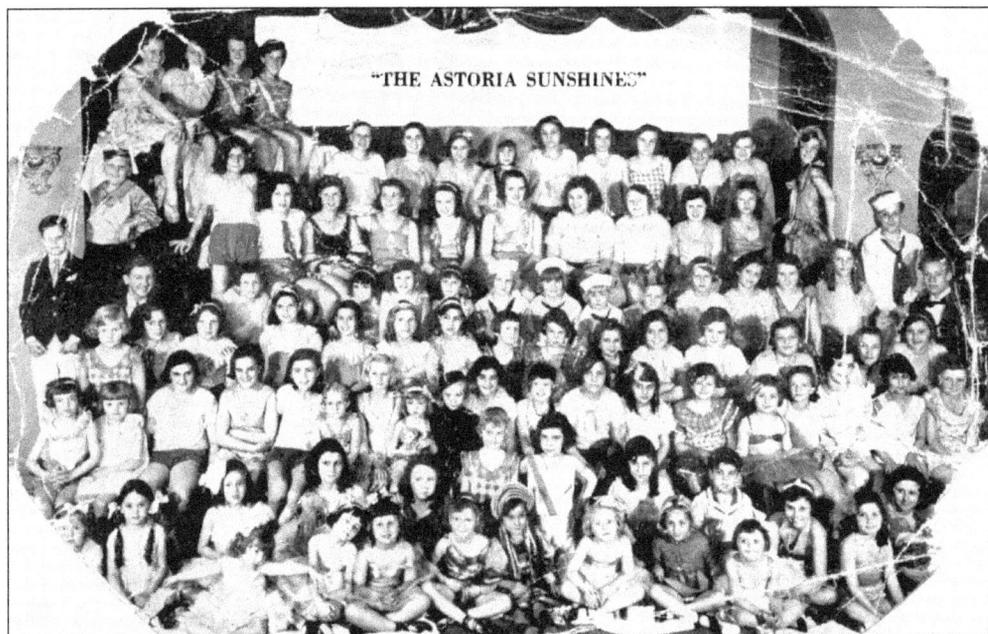

"THE ASTORIA SUNSHINES"

These are the Astoria Sunshines at the Homer Dance Studio, at 31st Street near Ditmars Avenue, c. 1930. Five rows up and second from the left is actor, singer, and dancer Eddie Bracken, who went on to Hollywood performing alongside such film greats as Judy Garland, Ann Miller, Donald O'Connor, and Bob Hope. He won amateur contests at the Astoria Grand Theater and played in a Knights of Columbus revue with neighbor Ethel Zimmerman (Merman). (Courtesy Ruth Meyerhoff.)

The Irish escaping the potato famine found work in the homes of the wealthy and in the factories of Old Astoria Village. They attended Our Lady of Mount Carmel Roman Catholic Church, organized in 1840. The church's cemetery, in use principally from 1850 to 1880, is still on 21st Street (called Emerald Street for a time). The names on the tombstones are almost exclusively Irish. (Courtesy Bob Stonehill.)

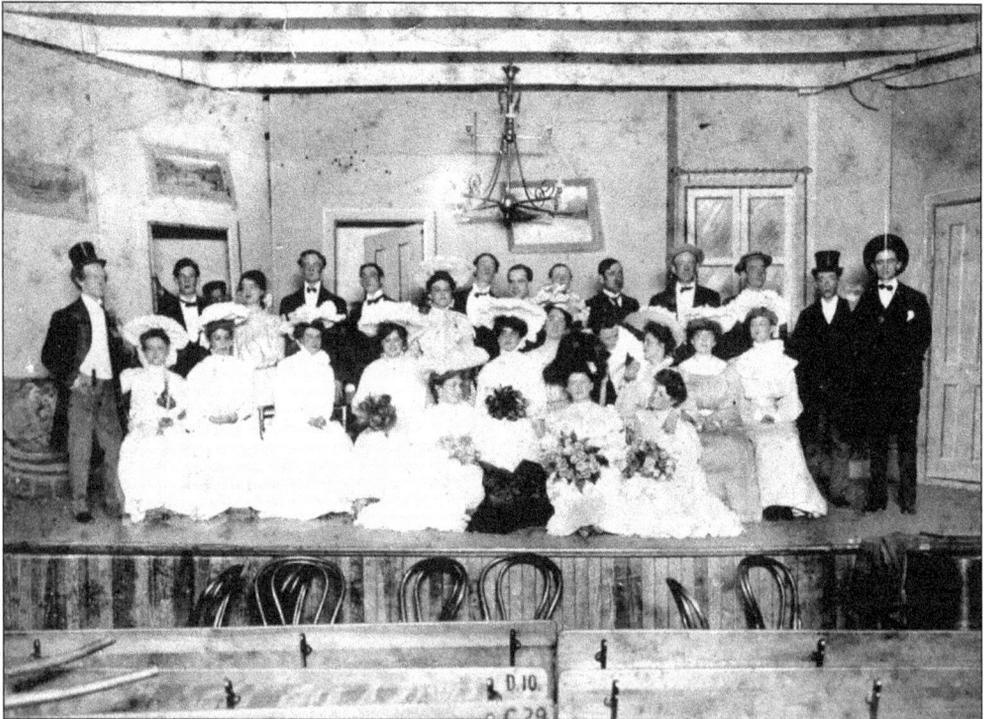

The Catholic Club of St. Mary's Roman Catholic Church of Hunters Point presented a musical comedy, *Woman Hater*. This 1905 production was under the direction of M. J. Colgan. Dancing followed at St. Mary's Lyceum with music by Professor Blue. (Courtesy Patty Fagan.)

94

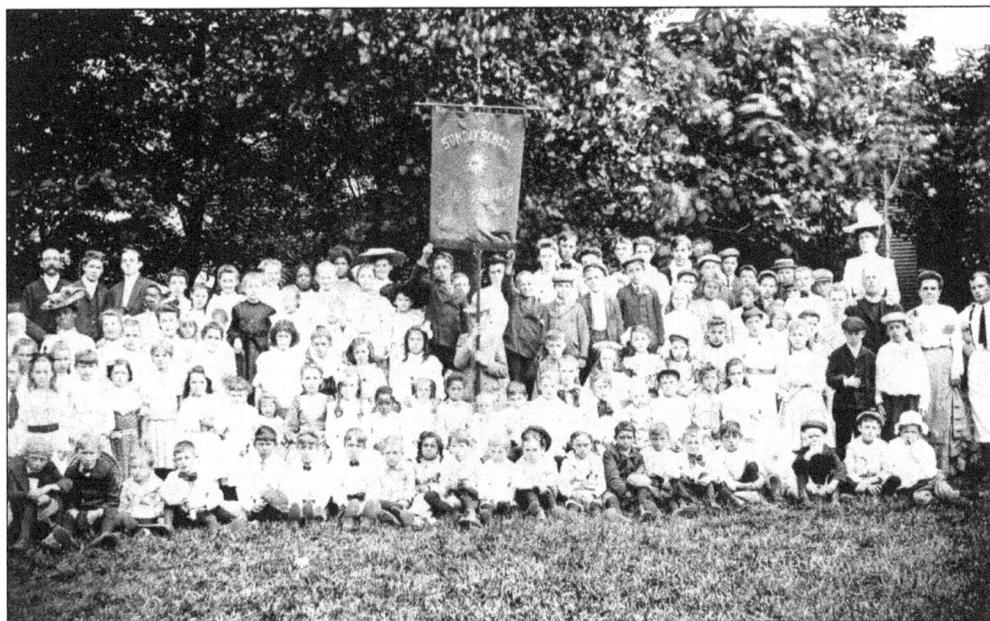

Rev. W. H. Weeks was the minister of St. Thomas Protestant Episcopal Church in Ravenswood when this photograph was taken c. 1900. In addition to organizing this Sunday school picnic, he also built a commodious hall, with reading and lecture rooms, and did work among the artisan population of this community. (Courtesy GAHS.)

The Astoria Center of Israel opened its doors in 1925. Rabbi Joshua Goldberg, pictured with students in the 1920s, had the distinction of serving in the armed forces intermittently from World War I to the 1960s. He became the first Jewish naval officer at the rank of captain. Active in postwar ecumenical efforts, he met the archbishop of Canterbury, the Pope, and other world leaders. Born in Russia, he died in 1994 at age 98. (Courtesy Sydelle Diner.)

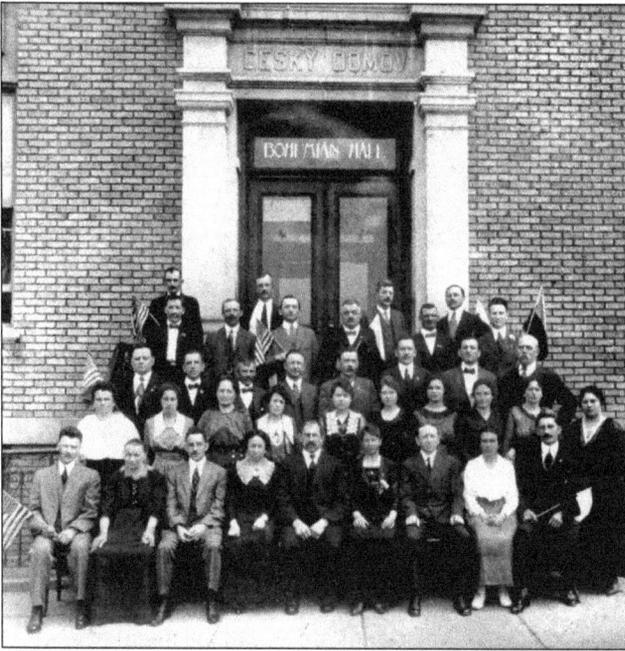

Ethnic benevolent clubs developed to assist newly arriving immigrants to become better American citizens. These members of the Bohemian Citizens Benevolent Association of Astoria gather outside Bohemian Hall in the early 1920s. They hold the flag of their new home, America. (Courtesy Bohemian Hall and Park.)

Benevolent clubs also kept ethnic traditions alive and taught the first generation the culture of their homeland. These women are, from left to right, Elsie Brozek, Francis Poskocil, Marie Vanecek (partially hidden), and May Svab. The little girls are, from left to right, Marie Svab and Helen Poskocil. This 1929 photograph was taken inside the beer garden at Bohemian Hall. (Courtesy Marie Blanda.)

96

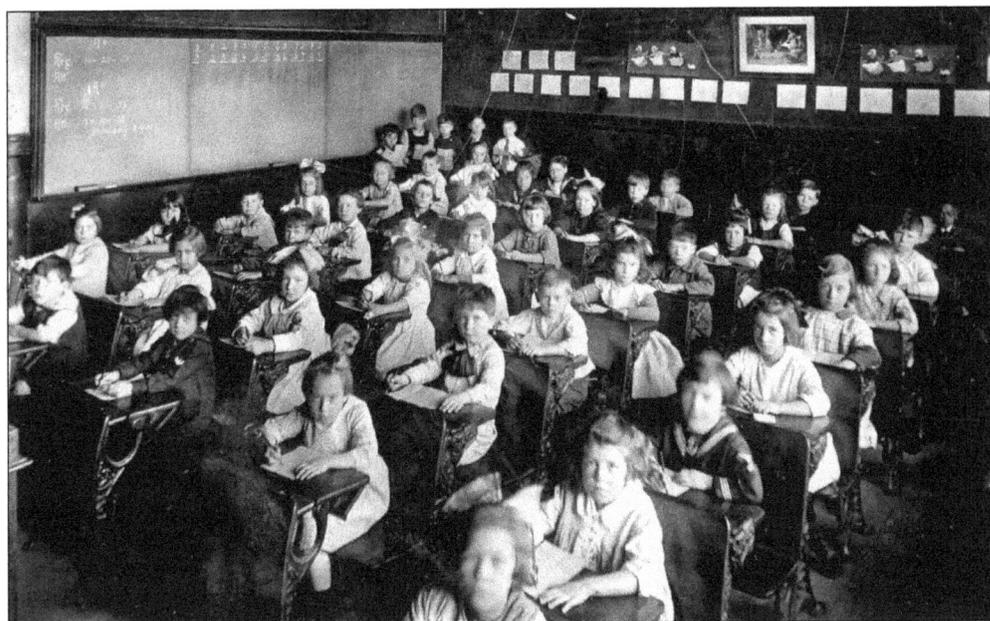

Although group photographs of students are common, it is unusual to see students actually in a classroom. The 1901 Public School No. 7, at 21st Street and 26th Road, had doubled its size by 1908. Coleman Buehler, age 6 3/4, was a student in class 1A in 1920. That year, the school had 1,757 students and 43 teachers under Mamie Fae, principal. (Courtesy GAHS.)

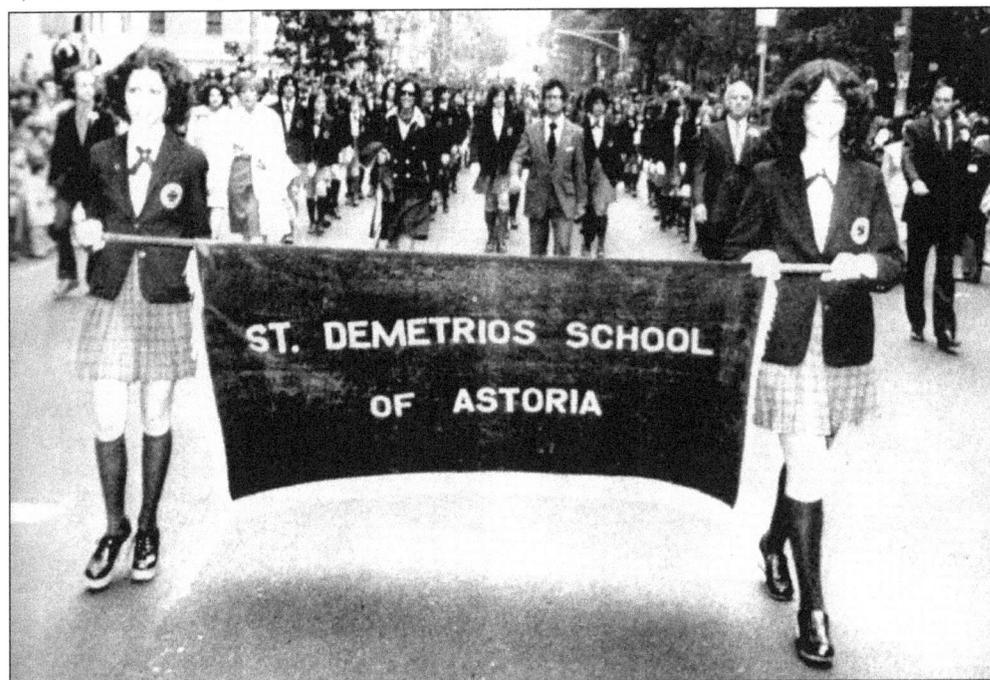

In 1927, the Afternoon Greek School was organized for the children of St. Demetrios Church. After World War II, the Greek community aimed to establish a school for its children offering education in academics and their Greek heritage. To get a loan for a school building, 50 members put their property up for collateral. The school opened in 1957. (Courtesy GAHS.)

These women, employees of Ronzoni, are enjoying a break in their lunchroom, eating pasta. Patriarch Emmanuel Ronzoni ran the company like a big family, and the employees were treated like members of the household. (Courtesy Al Ronzoni.)

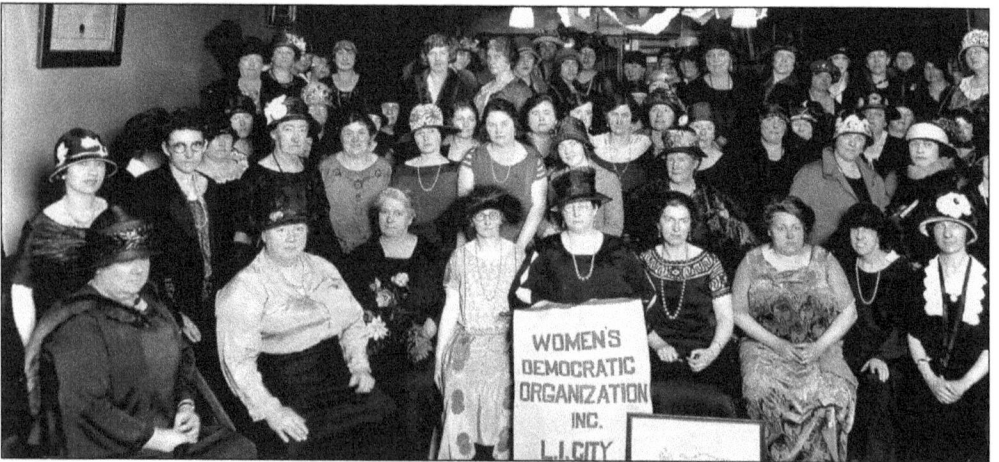

The barbershop and saloon setting of 19th-century political clubs excluded women from political party activities. After 1920, when women won the right to vote, they embraced political parties with a passion. The Woman's Democratic Organization, Long Island City, attracted women eager to join the political process c. 1930. (Courtesy Bob Ulino.)

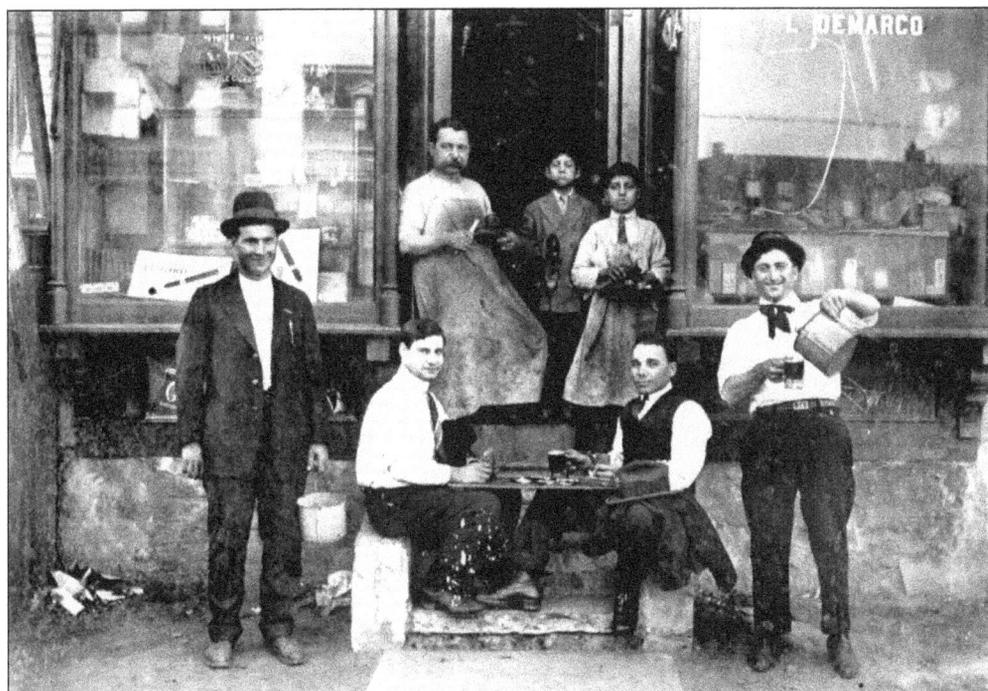

This store was owned by L. DeMarco. His son, Ralph (1908–1977), grew up to be a community and political leader in Queens County. Ralph was born in Calabria, Italy, and immigrated to Astoria with his family when he was three years old. A district leader from 1966 until his death, he served as deputy commissioner of the sanitation department and as an executive member of the Taminent Regular Democratic Club for 44 years. (Courtesy GAHS.)

On May 23, 1932, the Steinway Avenue Merchants Association held its dinner at Moose Temple on Broadway and 42nd Street. Honored that night were William Carey, president of the Madison Square Garden Corporation, and heavyweight boxers Jack Sharkey and Max Schmeling. These two athletes would face off the following month at Long Island City's Madison Square Garden Bowl to decide the world championship. (Courtesy GAHS.)

This is George Casey c. 1900, long retired as chief of the Long Island City Volunteer Fire Department. He founded the Veteran Firemen's Association and was its first president. He survived many of the spectacular fires at the numerous oil, gas, varnish, and chemical factories of Hunters Point. George Casey was the grandfather of William Casey, campaign advisor to presidents and director of the Central Intelligence Agency under Ronald Reagan. (Courtesy GAHS.)

Augustine "Gus" Kehoe (1864–1929) mugs for the camera in vaudeville costume as the consummate, stereotypical Irishman. Starting as a deckhand on the 34th Street ferry, he worked his way up to ferry pilot. Pres. Theodore Roosevelt, on his way home to Sagamore Hill, would go into the pilothouse and listen to Kehoe as he guided his ferry across the East River singing Irish ballads in his beautiful tenor's voice (see page 79). (Courtesy Tim Kehoe.)

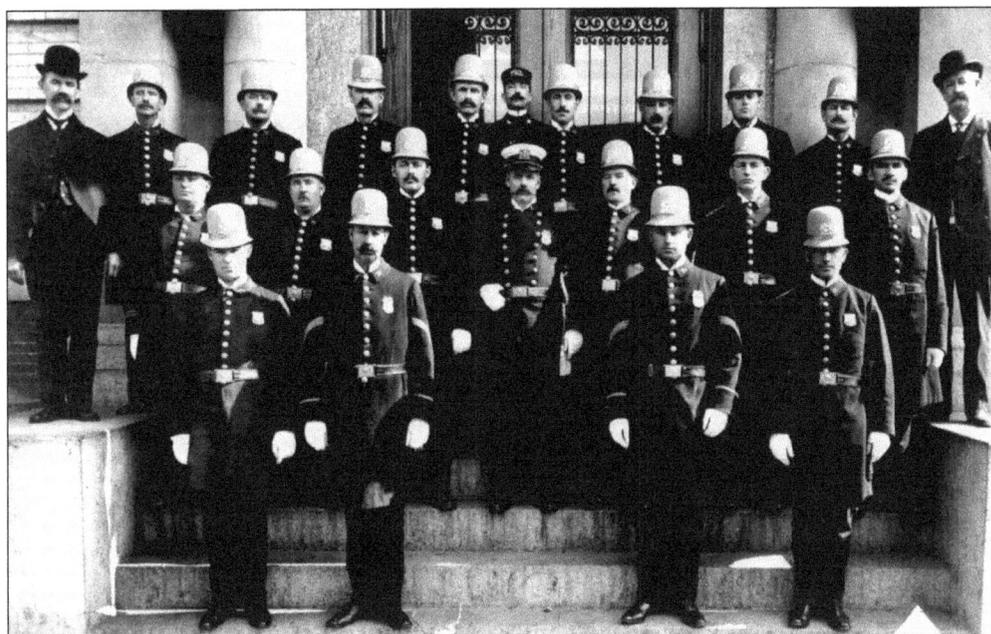

Sporting the spring and fall uniforms of 1908, before the time that old gray helmets were replaced by caps similar to those worn today, police officers line up before the 75th Precinct in Long Island City. Pot helmets were needed, as hoodlums would throw bricks off roofs during riots. (Courtesy Robert Singleton.)

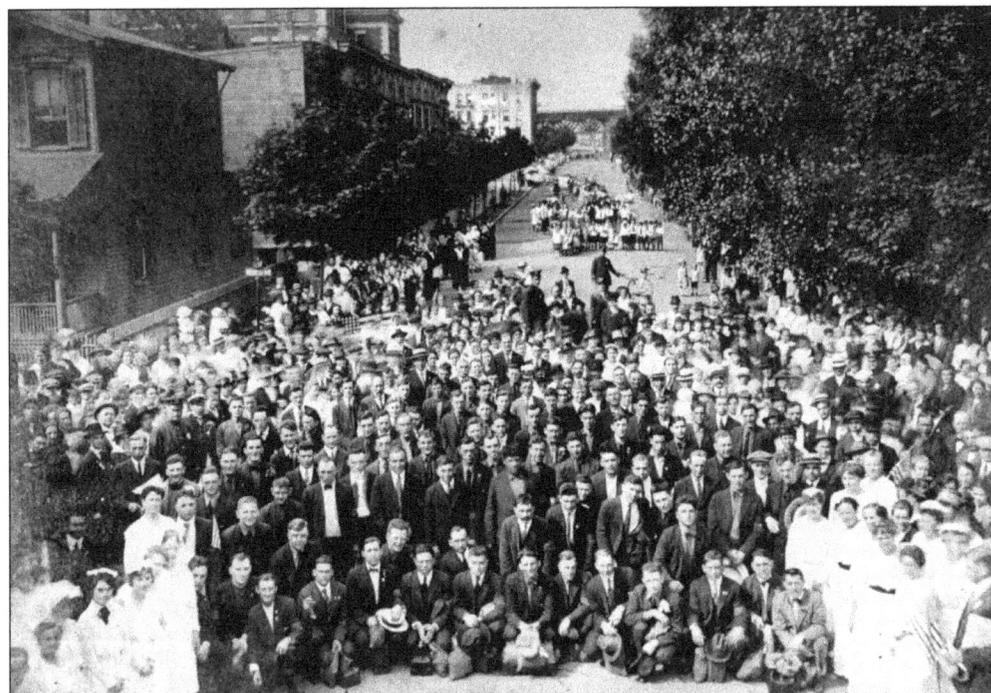

On May 28, 1918, these young men were going off to World War I to defend their country. Looking south along 41st Street from Ditmars Boulevard, it appears a crowd has gathered for a big sendoff. Mercifully, the Great War was over only six months later. (Courtesy GAHS.)

Patrick Jerome "Battle-Axe" Gleason (left, in a top hat), the last mayor of Long Island City (serving from 1886 to 1892 and from 1895 to 1898), is still vividly remembered after a century. Perhaps maligned, certainly misunderstood, and larger than life, he was a mayor for the common people. His biography is a great novel that awaits an author. This photograph is one of a mere few of Gleason to survive. (Courtesy GAHS.)

Although Gleason was despised by his political adversaries, he was just as fondly remembered by those he helped—the disadvantaged, notably children. A particular friend to the newsboys, he gave out scholarships and bought seats for the newsboys at public events. Public School No. 1 was his gift to the city's children. Here, at his funeral in 1901, his little friends paid tribute to their generous benefactor. (Courtesy Jack Conway.)

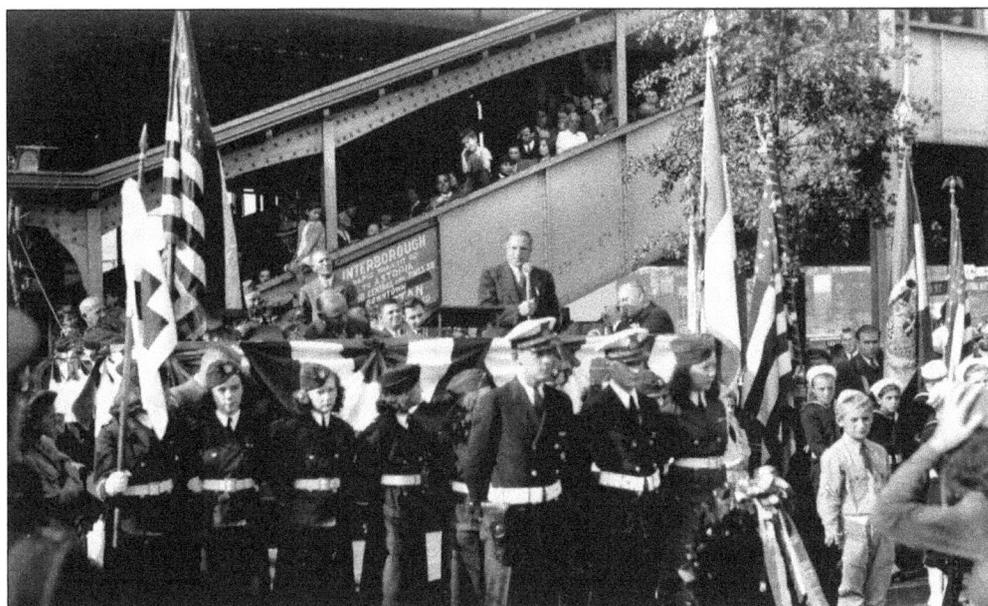

This is the 1940 Columbus Day observance held in Columbus Square and Astoria Park. A year later, in October 1941, Alexander Del Giorno, of the All-American Monument Committee, announced the unveiling of a statue of Christopher Columbus at Columbus Square, at Hoyt Avenue and Astoria Boulevard at 31st Street. Every Columbus Day, Italian-Americans, joined by other community groups, have held a parade celebrating Columbus. (Courtesy Bob Ulino.)

The Athens 2004 Olympic torch relay in New York City started in Athens Square, the center of the Greek-American community outside of Greece. Denis Syntilas proudly accepts the torch before it starts on its journey through the streets of New York City and eventually on to the summer Olympic games of 2004 in Athens, Greece. (Courtesy GAHS.)

Here, Queens district attorney Tom Cullen questions Willy "the Actor" Sutton. They have cuffs on Sutton, as he was on the lam from Sing Sing. In this 1950 photograph, Sutton is booked for robbing a bank at 47–11 Queens Boulevard after casing it from the elevated train platform. While at the Long Island City jail, he was asked why he robbed banks and replied, "Because that's where the money is," a statement he later denied. (Courtesy Sunnyside Chamber of Commerce.)

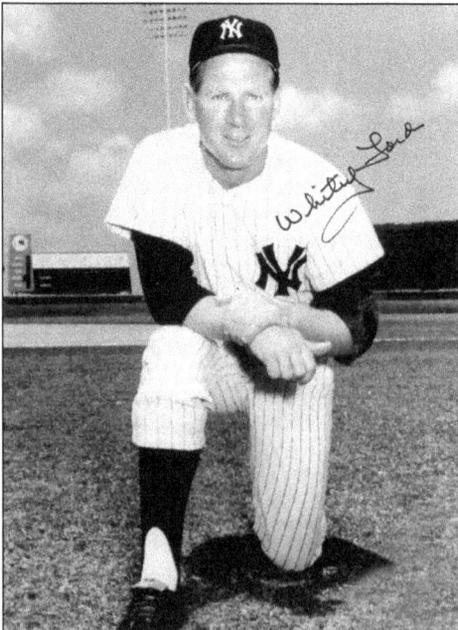

Edward "Whitey" Ford lived for a while at 34th Street and Broadway in Astoria. As a New York Yankees pitcher (1950–1967), the Hall of Famer compiled a record of 236 wins against 106 losses, the best lifetime winning percentage in modern baseball (.690). He owns numerous World Series records for wins, strikeouts, and innings pitched. When asked what was one of his biggest games, he replied, "pitching the Maspeth Ramblers to a 16-11 victory over the Astoria Indians." (Courtesy Whitey Ford.)

Isamu Noguchi (1904–1988), a man of many artistic disciplines, founded a studio here in 1961. He gained prominence and acclaim, leaving his large-scale works in many of the world's major cities. He created sculptures and gardens, designed stage sets for various Martha Graham productions, and designed mass-produced objects such as lamps and furniture (some are still manufactured and sold today). His work lives on around the world. (Courtesy Noguchi Foundation.)

Few images capture the future better than Socrates Sculpture Park in Ravenswood. A growing list of art studios, galleries, institutions, and cultural groups such as the Noguchi Museum, the Museum for African Art, P.S. 1 Contemporary Art Center, the Sculpture Center, Center for Holographic Art, the Museum of the Moving Image, and the Fisher Landau Center for Art now attract a growing flood of tourists. (Courtesy GAHS.)

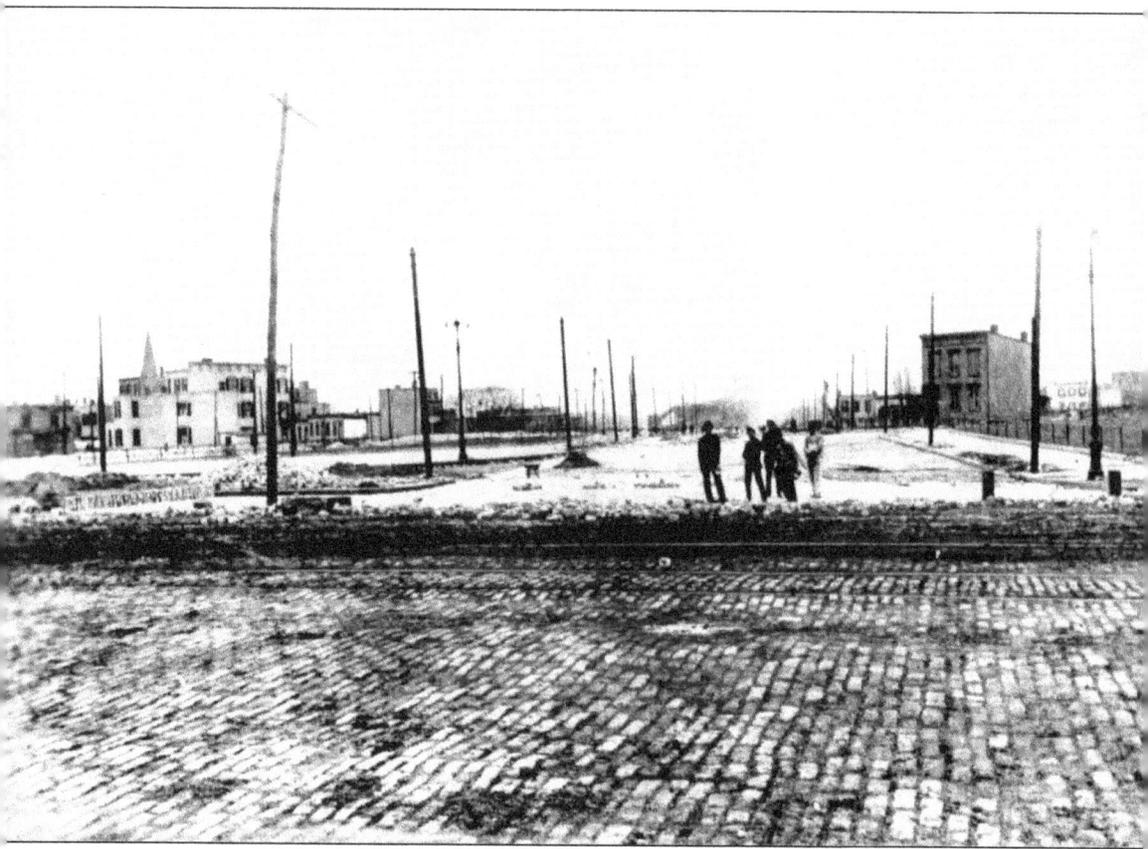

It is March 3, 1909, less than one month before the Queensboro Bridge opens. An empty, wide-open Queens Plaza looks to the past. The bridge, looming dimly in the distance, speaks of the future. Starting with the Brewster Building in 1910, both sides of the plaza would be solidly built up. The elevated trains came in 1915. Within a decade, this view was completely changed. The area was a backwater that was transformed into a bustling hub. (Courtesy Bob Stonehill.)

Seven

THE NEIGHBORHOODS

In 1898, a new municipality called New York City emerged from the consolidation of the city of New York, the city of Brooklyn, Long Island City, and tiny hamlets, villages, and townships over five counties. Long Island City disappeared as an independent entity but retained a permanent impression in its residents' hearts. Here we show what has happened in the century since consolidation, issues facing our community today, and some hints as to what is in the future.

For a description of Long Island City at the time of consolidation, we turn to Seyfried's *300 Years of Long Island City:*

> When Long Island City became a part of Greater New York on January 1, 1898, no dramatic event marked the transition in status. Whatever change there was took place on an official level; the average man in the street was dimly conscious that an era had closed but life went on unchanged and the working day seemed no different from the many that had passed.
>
> The whole population of Long Island City was only 48,272 and unevenly distributed. Old Astoria from the river to 21st Street was thickly settled; Steinway Street from 30th to 34th Avenues, the intersection of Steinway Street and Astoria Boulevard, and old Steinway around 21st Avenue were pockets of settlement. Hunters Point was filled with factories and frame houses and spilled out into Dutch Kills but by 35th Street the houses trailed off into emptiness. Ravenswood was a long ribbon of factories along the river's edge and with non-descript housing along Crescent St. but a gulf of emptiness lay in between. Blissville was densely settled along Greenpoint Avenue from Newtown Creek up to Hunters Point Avenue. And that was it!
>
> Vast tracts in the Ditmars section, all of eastern Astoria, Thomson Hill, Sunnyside and the whole of central Ravenswood lay undeveloped and only sparsely settled. There were farms and large estates that managed to survive intact into the new century, waiting for the expanding city and a surging tide of population to overrun the old boundaries and to absorb them into the greater city. The streets were primitive by modern standards; paving was an expensive luxury reserved for important well-traveled roads; all the side streets were dirt surface always tending to ruts, dusty in summer and muddy in winter; gas and water lines had come to most streets in the 1880s but the telephone was still a rarity and sewers a convenience to be found only in the older portions of town.
>
> Installing the amenities of life that we now take for granted, good streets, curbing, guttering, paving, sewers, better water, gas and telephone service, were all the work of years, but change came rapidly to Long Island City, too impatient to wait for an ideal environment.

Contrast Seyfried's profile of Long Island City of 100 years ago with the dynamic vision that planners have put together as a blueprint for the reinvention of Long Island City's downtown—essentially an extension of midtown Manhattan.

Planners talk about billions in investment for several office complexes, a waterside hotel and convention center, 15 residential buildings containing 6,000 apartments, and 20 acres of parkland. Other projects, in Dutch Kills and Queens Plaza, are looking to rezone dozens of blocks for office, retail, and residential development. The intention is to promote a vibrant mix of housing, light industry, commercial enterprises, and cultural activities, including stores, restaurants, artist studios, and small theaters. There is talk of an Olympic village for the 2012 games.

Every neighborhood has a unique history and distinct charm. Old Astoria Village, Steinway, Ravenswood, Hunters Point, Dutch Kills, Blissville, and Sunnyside may each be one facet, but as in a gem, they sparkle together. The neighborhoods of old Long Island City, in living together and acting collectively, have forged a shared relationship for solving problems and improving the community. Residents' investment in Long Island City is the foundation for our strong local bond.

Throughout these pages, people and communities evolve over time, but one theme endures. Neighborhood pride remains ever constant. Long Island City might have lost its sovereignty in 1898, but never its independence.

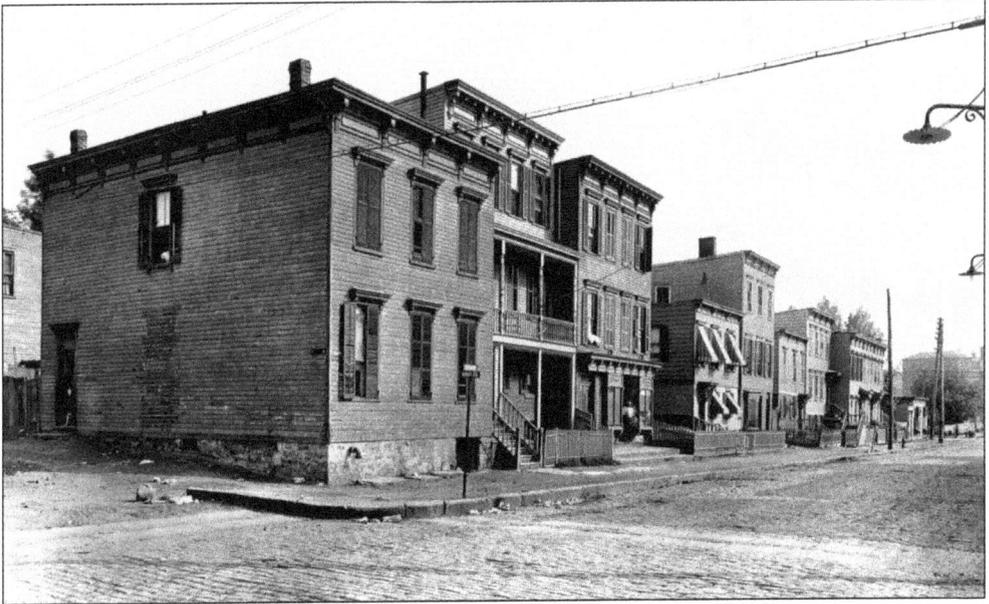

This view looks south, with St. John's Hospital in the distance. This block, framed by Crescent Street and 42nd Road near Queens Plaza, enjoys one of the last quiet days of its existence in 1914. Although the Queensboro Bridge was an unquestioned monument to progress, this block was soon swept away by the commercial whirlwind of Queens Plaza. (Courtesy Robert Singleton.)

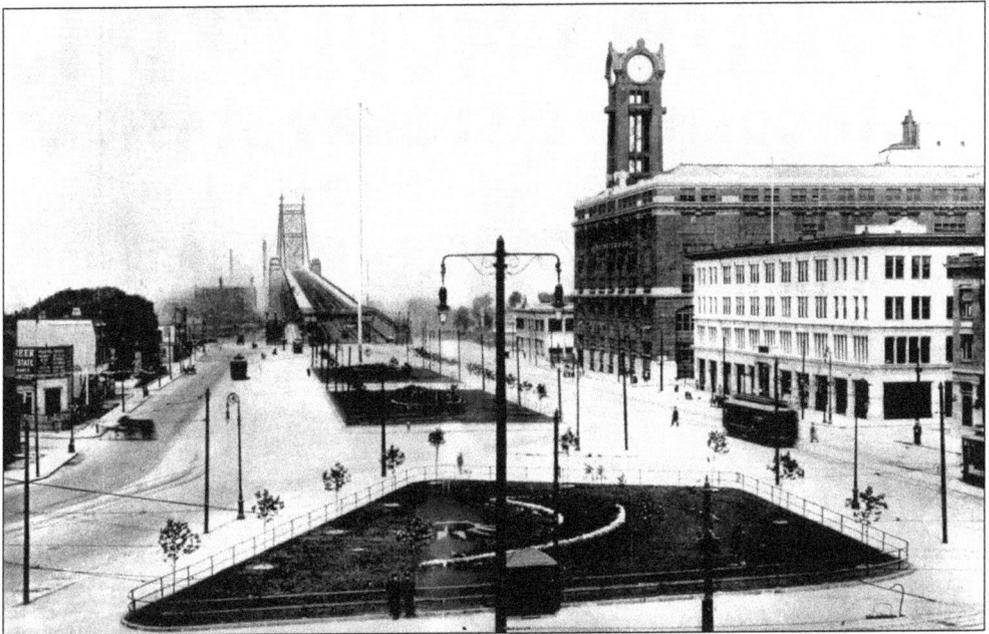

The newspapers boasted that Queens (or Bridge) Plaza, was "a thing of beauty," and "equal to the entrance to any park." Between 1912 and 1914, the square had the flagpole from Sir Thomas Lipton's yacht, while seasonal flowering plants and Japanese flowering cherry trees created a series of geometric patterns. The square was destroyed when the elevated station, Queensboro Plaza, arrived in 1915. (Courtesy GAHS.)

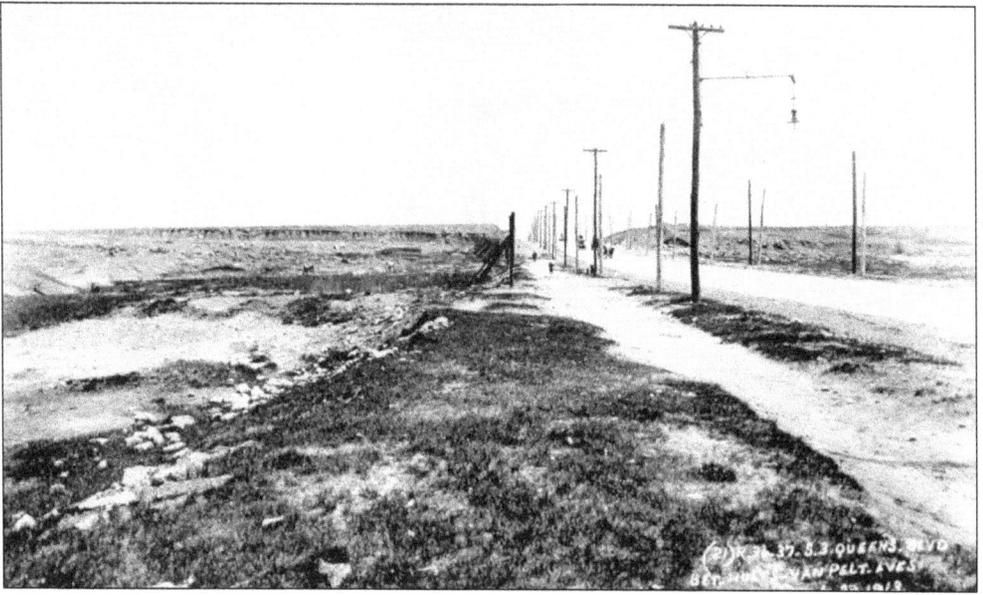

Seen are 37th and 38th Streets at Queens Boulevard in 1913. The neighborhood, although still empty and undeveloped, had infrastructure such as roads and utilities already in place. The elevated line was but a few years away. The sleepy setting, where time stood still, was at the cusp of the change and urbanization that created the modern world. (Courtesy GAHS.)

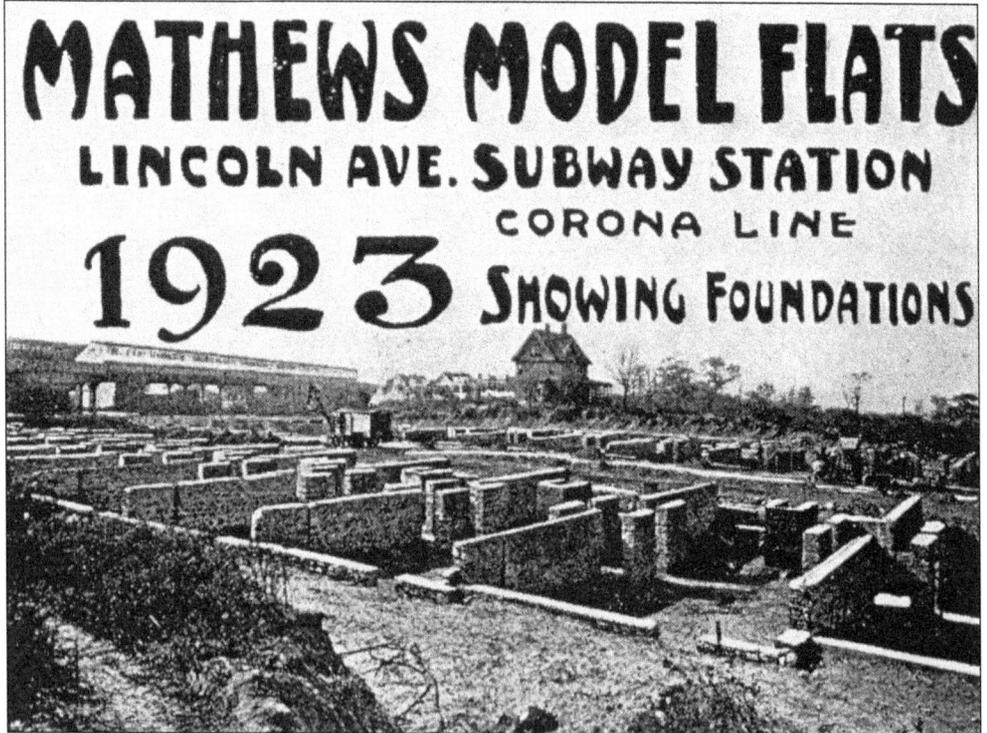

MATHEWS MODEL FLATS
LINCOLN AVE. SUBWAY STATION
CORONA LINE
1923 SHOWING FOUNDATIONS

With the laying of the building foundations, the old farmhouse in the background was shortly engulfed by an up-and-coming community. This was Lincoln Avenue (52nd Street) at the Woodside border in 1923. (Courtesy the Mathews family.)

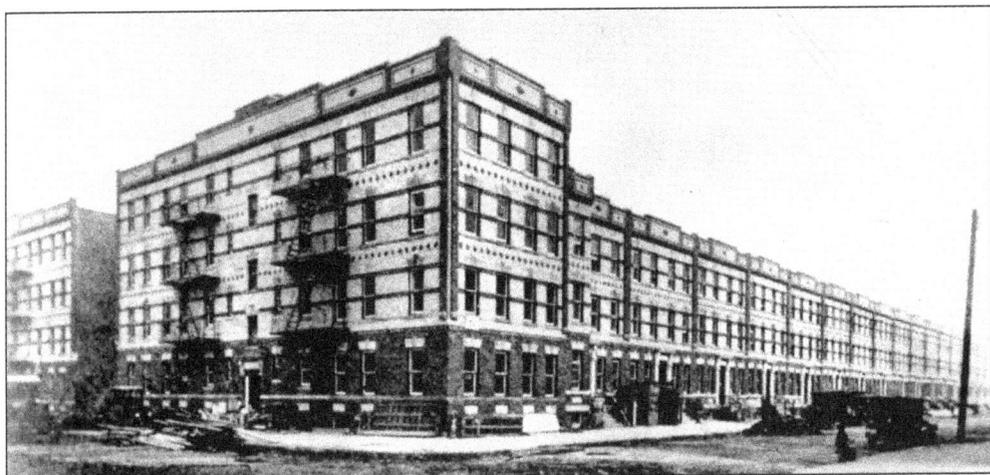

These homes at 42nd Street and 34th Avenue were built on the former site of Schuetzen Park. Julius Link, who was the last proprietor of the park before it closed in 1924, put up 42 apartment buildings in partnership with the Mathews family. (Courtesy the Mathews family.)

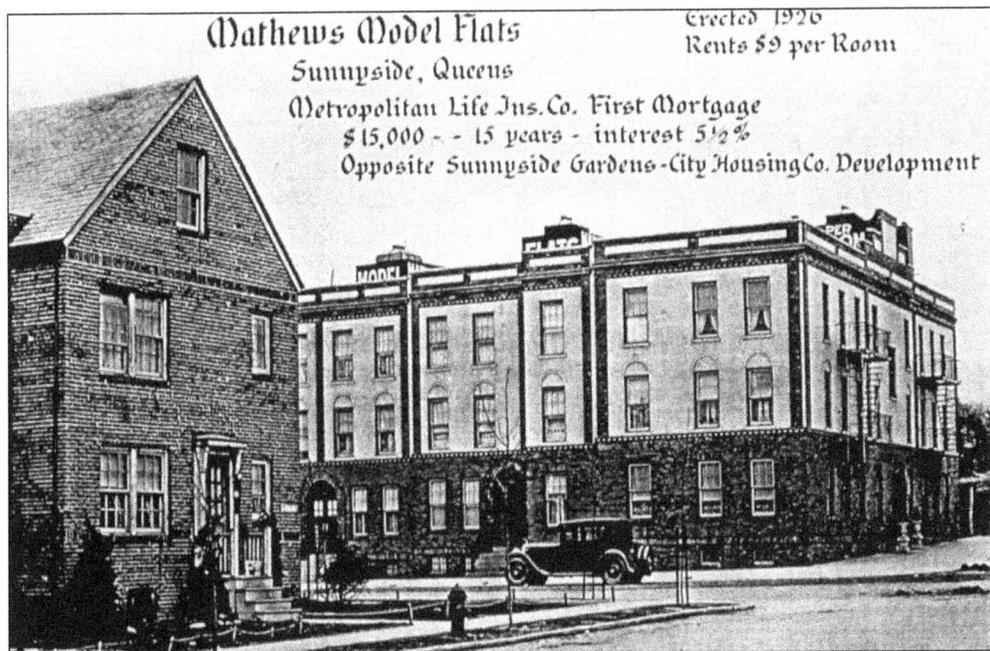

Mathews Model Flats
Sunnyside, Queens
Erected 1926
Rents $9 per Room
Metropolitan Life Ins. Co. First Mortgage
$15,000 - - 15 years - interest 5½%
Opposite Sunnyside Gardens - City Housing Co. Development

Sunnyside could boast some of the finest model apartments and planned communities ever built. This block of 48th Street showcases the fruit of early-20th-century innovative housing. Here, Mathews Model Flats and Sunnyside Gardens face each other. (Courtesy the Mathews family.)

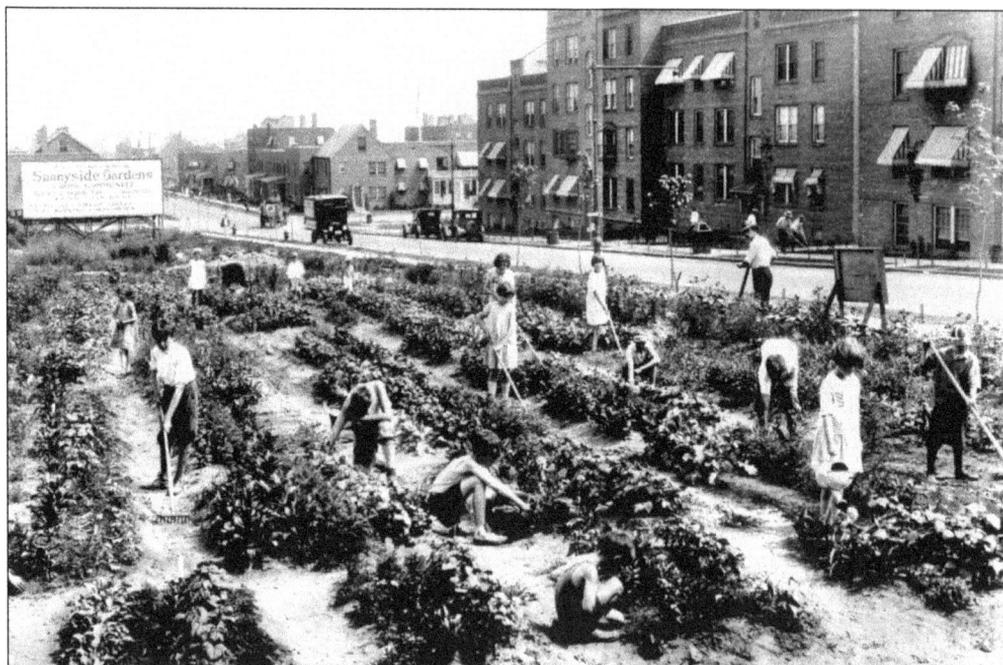

During the summer of 1926, children planted a community garden on the present site of the Wilson Court Apartments, at 47th Street north of Queens Boulevard. Across the street are the Carolin Gardens co-op apartments. Sunnyside Gardens was sold as the perfect antidote to urban congestion, as children could be safe in the fresh outdoor air here. (Courtesy Sunnyside Foundation.)

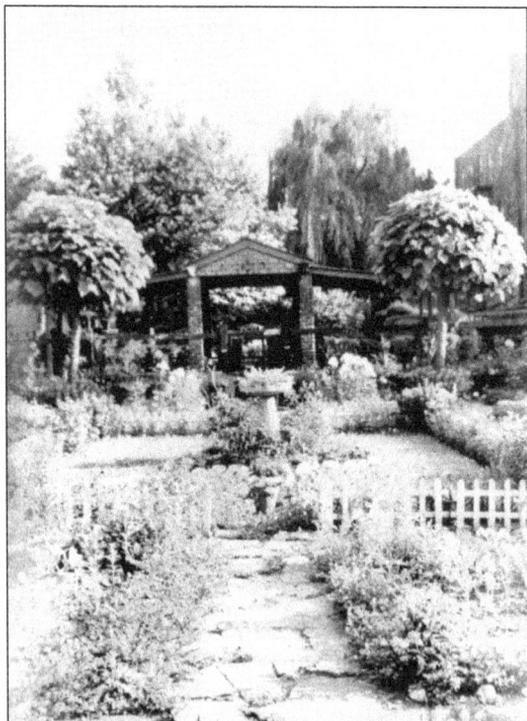

Colonial Court, built in 1924, was the first unit of Sunnyside Gardens. Houses enjoyed a front garden and private back garden that abutted the large central courts. Homeowner associations were created to manage and oversee the changes to the community. This image is from 1940. Colonial Court lies between Skillman and 43rd Avenues, spanning both sides of 47th Street and over to 48th Street. (Courtesy Sunnyside Chamber of Commerce.)

In the interior courtyard of Phipps Gardens is a lush and green landscaped oasis built between 1931 and 1935. All spaces were fully utilized, with fire escapes doubling as balconies. This city within a city is minutes from midtown, with meeting rooms, rooftop terraces, and day-care centers in the basement. (Courtesy Sherry Gamlin.)

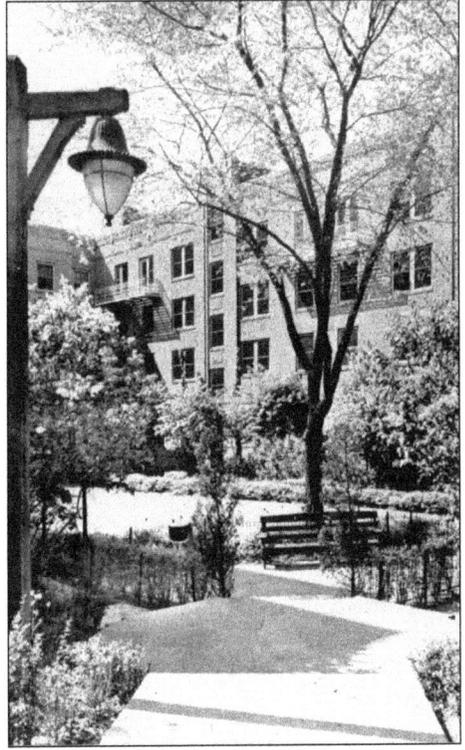

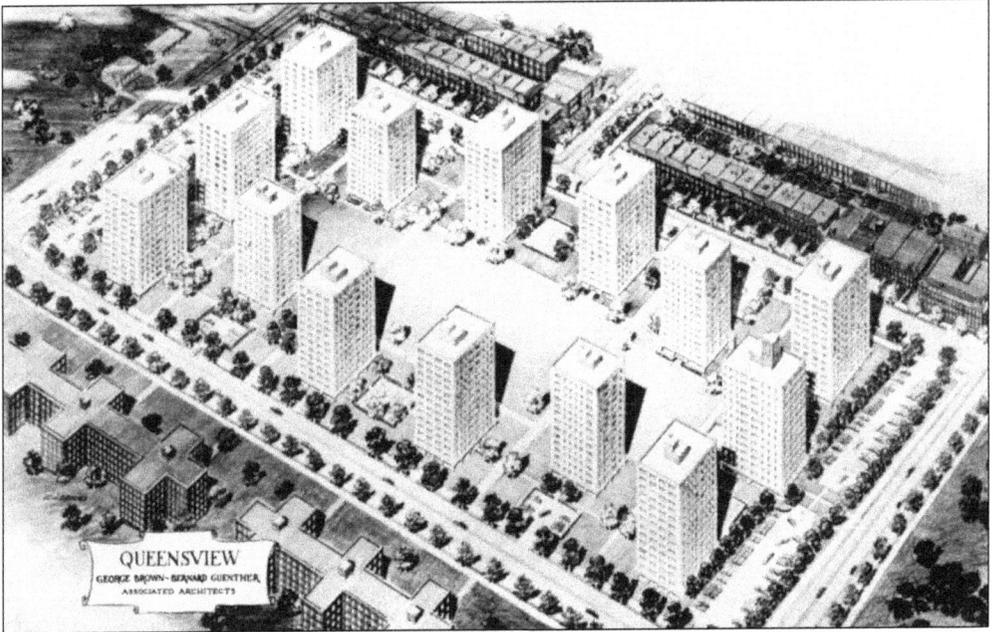

The postwar Queensview cooperative housing development at 34th Avenue and Crescent Street had a blue chip sponsoring group composed of Thomas Watson (IBM), Henry Morganthau (secretary of the treasury), David Sarnoff (RCA), and Gerard Swope (General Electric), among others. This proposed layout, taken from a brochure, showed 87 percent of the development set aside for gardens, grass, trees, recreational areas, and parking. (Courtesy GAHS.)

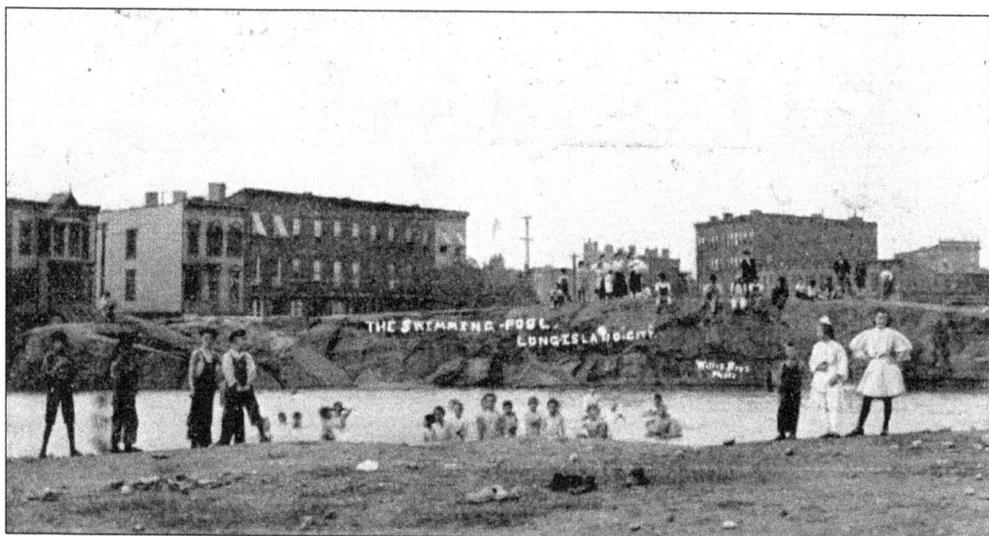

Swimming in Dutch Kills provided an afternoon of dangerous fun 100 years ago. Although the water was almost certainly polluted with industrial, animal, and human wastes, it seemed to be of little concern to those of humble means. Sickness and death were part of their everyday lives. A generation later, Robert Moses, parks commissioner, transformed the city with public amenities. (Courtesy Stephen Leone.)

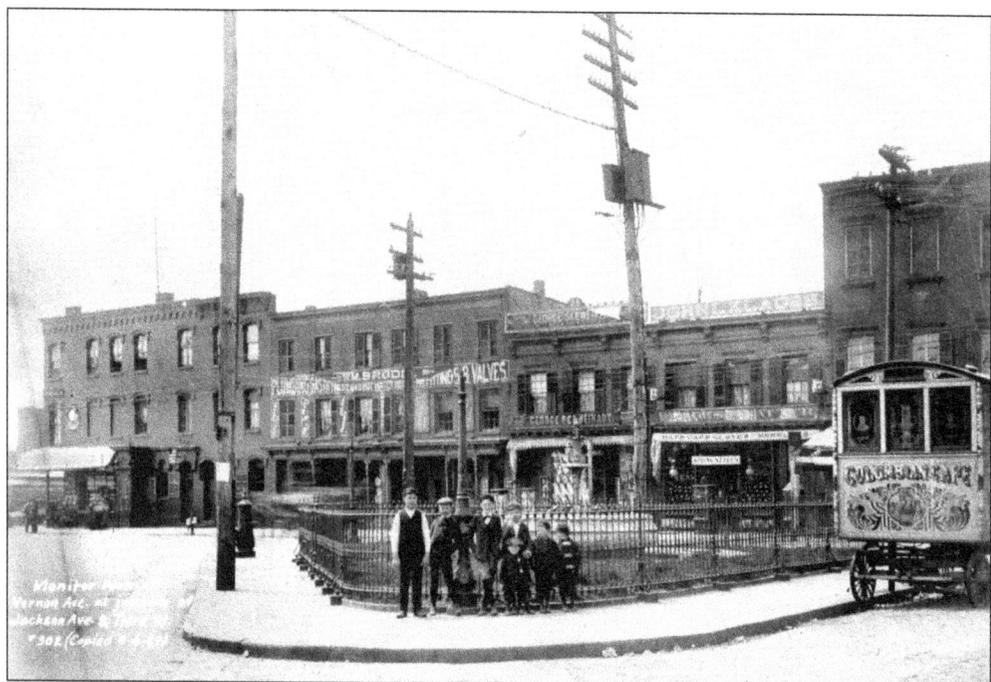

Hunters Point is unique in Queens for having begun almost immediately as a business center. Monitor Park was perhaps named for the Civil War ship *Monitor*, launched in neighboring Greenpoint, Brooklyn. Formerly located at the junction of Vernon Boulevard and Jackson Avenue, the park had a fountain at its center. The "Monitor seven" pose proudly for this photograph. (Courtesy GAHS.)

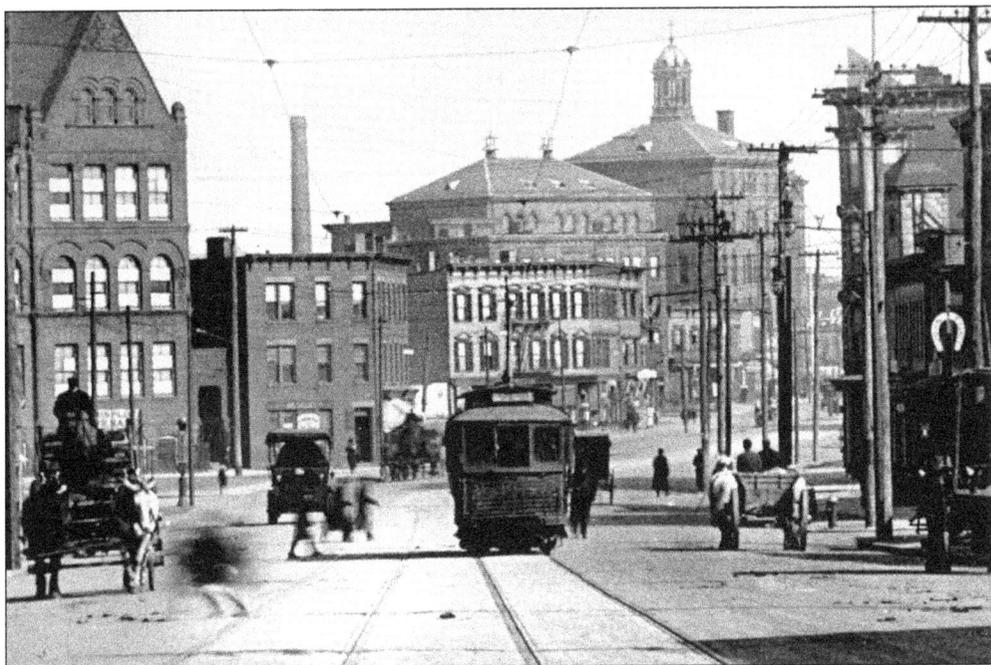

In this view, looking north on Jackson Avenue and 21st Street, is a thriving city c. 1910. On the left is Public School No. 1. In the distance are the buildings of St. John's Hospital. Established in 1861, it was the first hospital not only in Long Island City, but in Queens County as well. (Courtesy GAHS.)

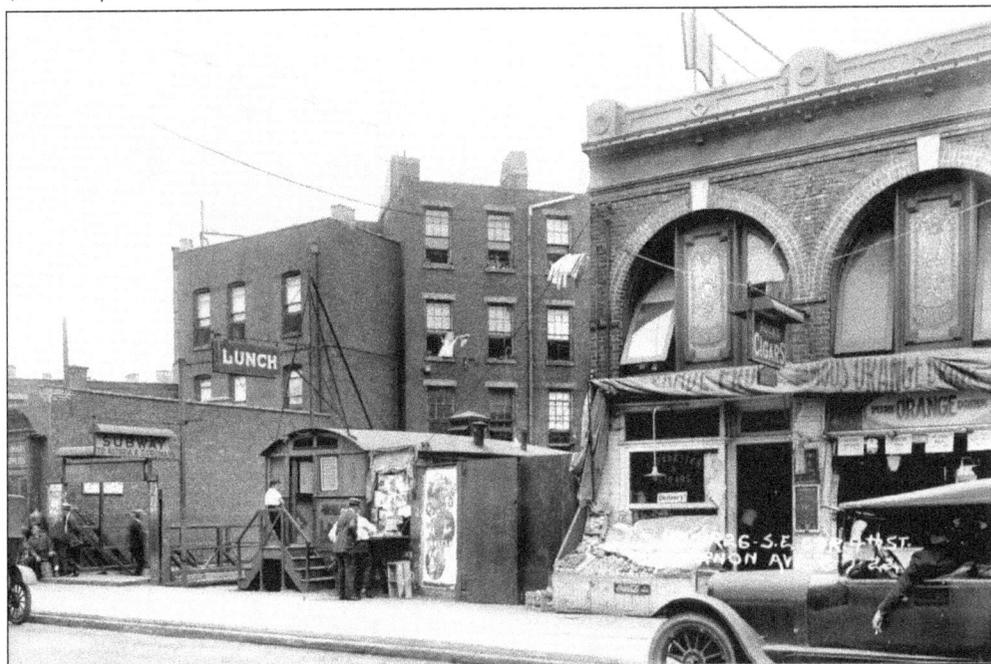

In Hunters Point, the Vernon-Jackson station on 50th Avenue opened in 1915. The building to the right, transformed into a few stores in this 1922 photograph, is the old Vernon Theater. Note in its upper windows are the words "comedy" and "music." (Courtesy GAHS.)

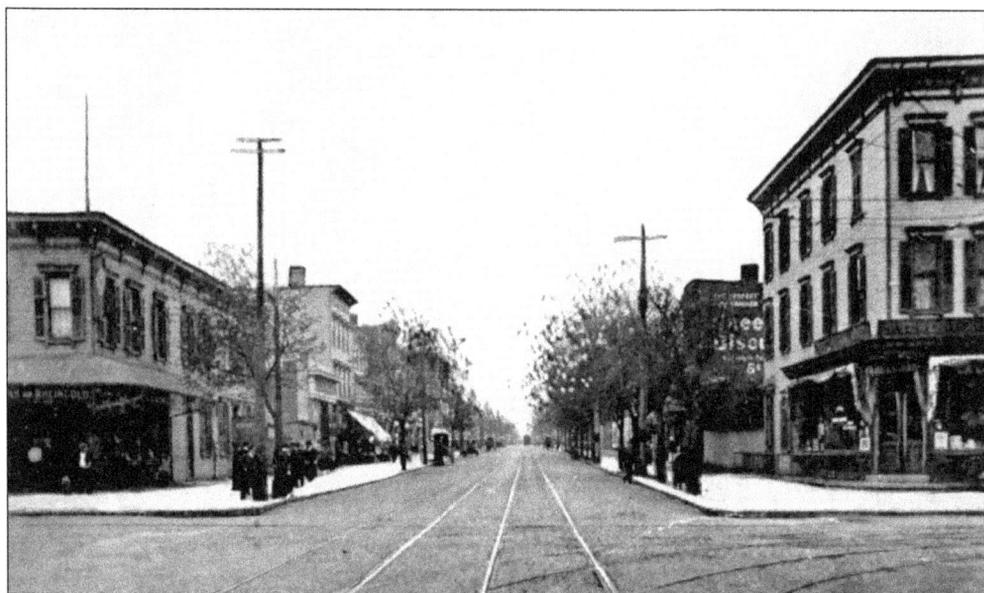

This is Steinway Street, looking north at Broadway in 1900. The street is 30 years old. (Courtesy Bob Stonehill.)

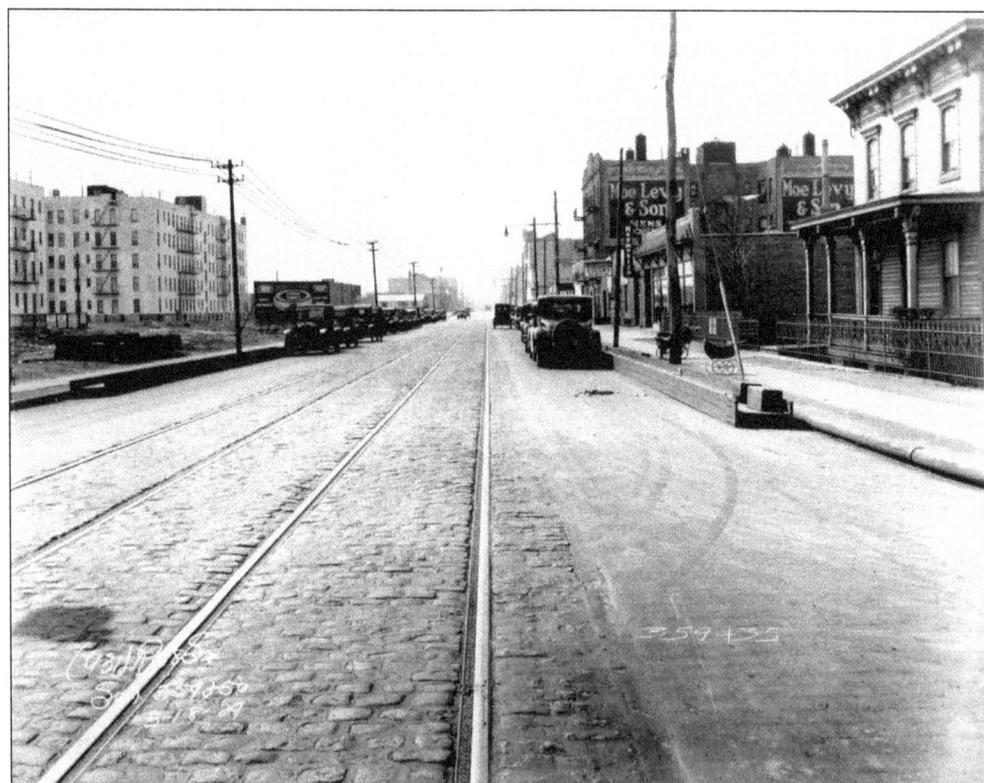

In this 1929 view, looking south toward 35th Avenue, is Steinway Street. The old house is a nice contrast to the apartment buildings. The street is 60 years old. (Courtesy GAHS.)

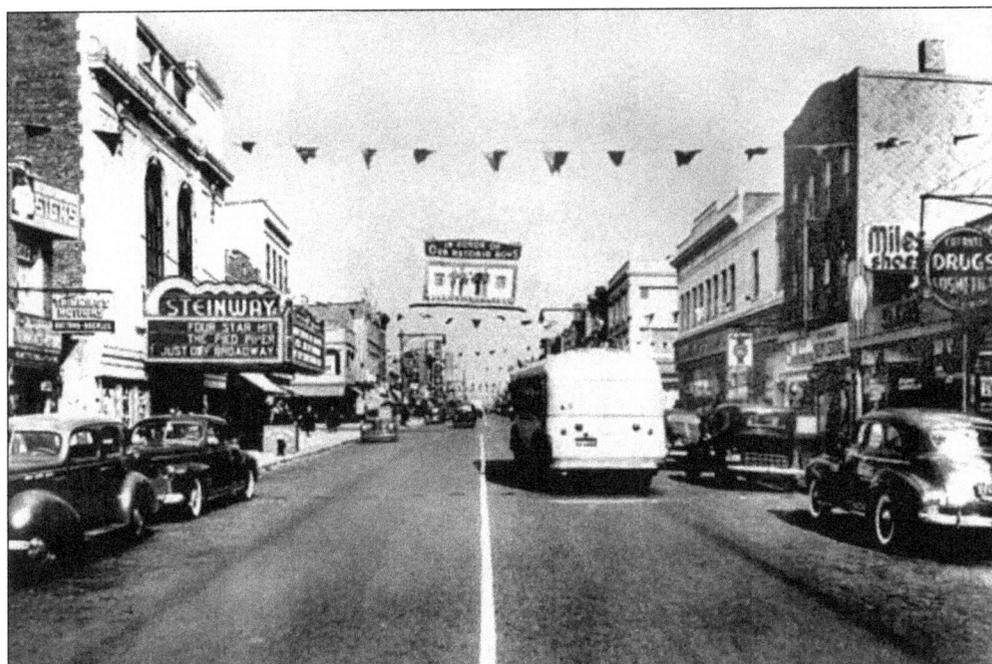

This photograph of Steinway Street, looking north toward 31st Avenue, was taken c. 1945. A World War II banner drapes the street. The street is 75 years old. (Courtesy GAHS.)

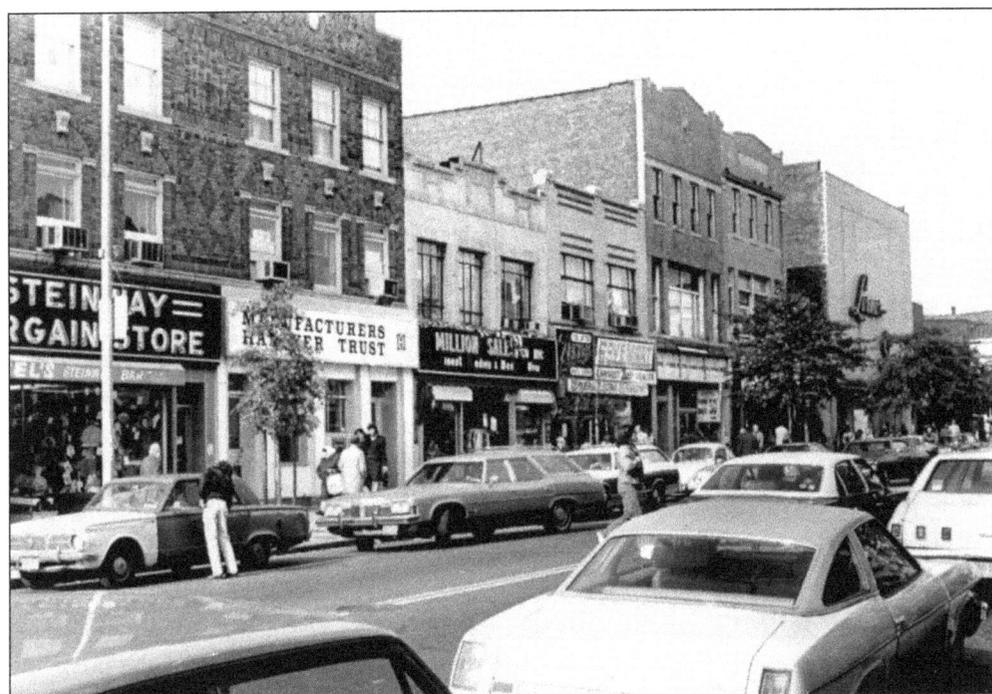

This c. 1975 view of Steinway Street looks north toward 31st Avenue. The street is more than 100 years old and is still going strong. (Courtesy GAHS.)

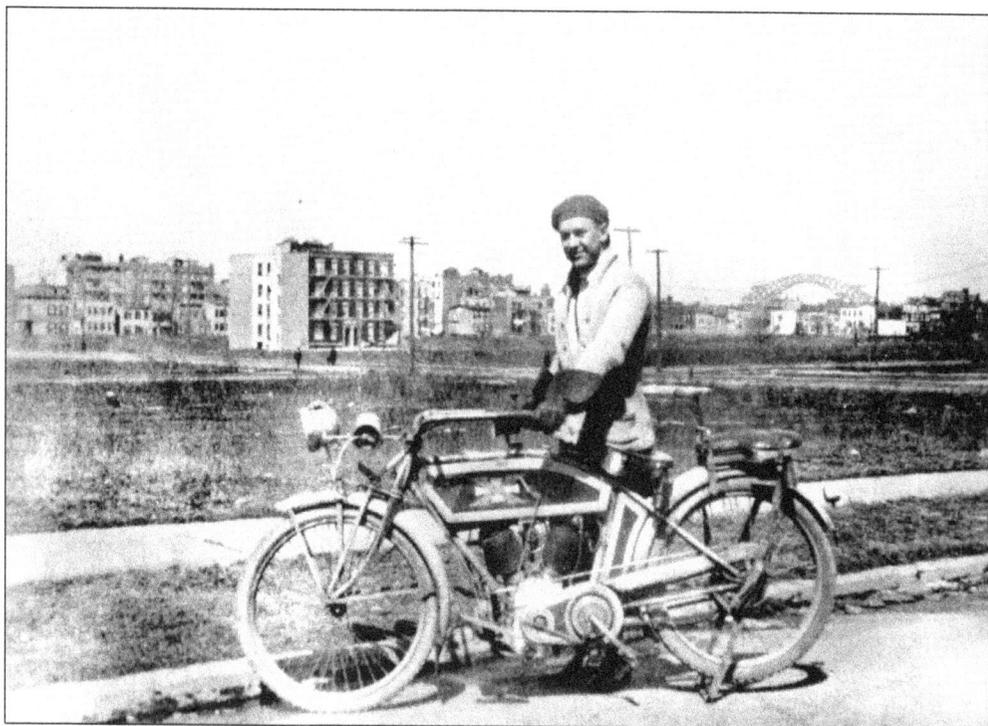

At the northwest corner of Broadway and 35th Street, a man pauses on his motorcycle. Empty lots with an occasional building stretch to the Hell Gate Bridge. This photograph was taken *c.* 1915, a few years before the elevated lines opened. (Courtesy Louis Mancuso.)

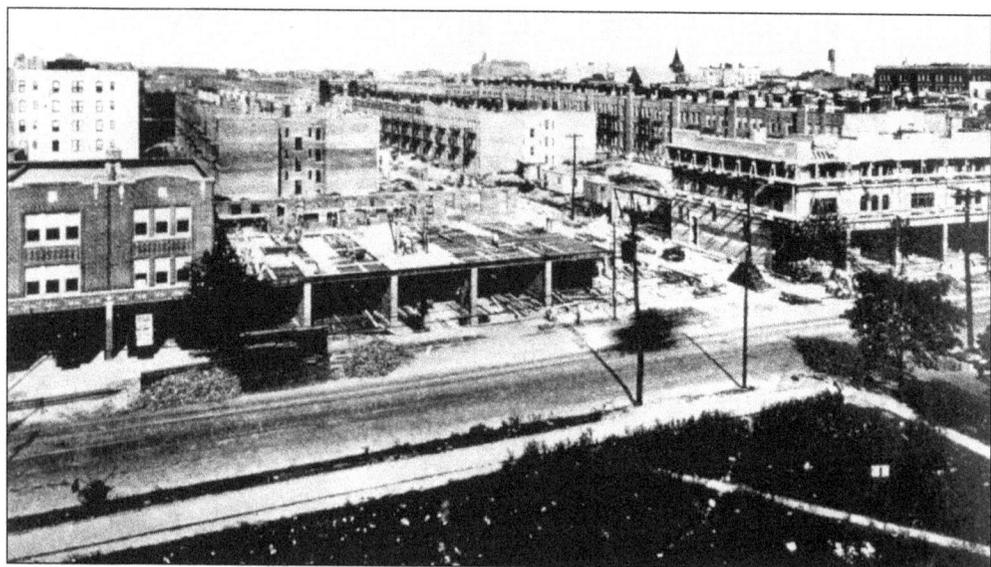

This photograph was taken two or three years after and a block away from the preceding picture. This view of 34th Street and Broadway shows frenzied building. The elevated line had just opened. Within a few years, the neighborhood would assume an appearance essentially unchanged from today. (Courtesy Louis Mancuso.)

During the early decades of the 20th century, Long Island City became part of the urban fabric of New York, as open lots were transformed into multidwelling housing units. The city seems to spring up around these people as they stand on a lot near the corner of 34th Street and 31st Avenue. They are, from left to right, Florence McGregor, Mary McGregor, William McGregor Sr., and Hilda Anderson. (Courtesy GAHS.)

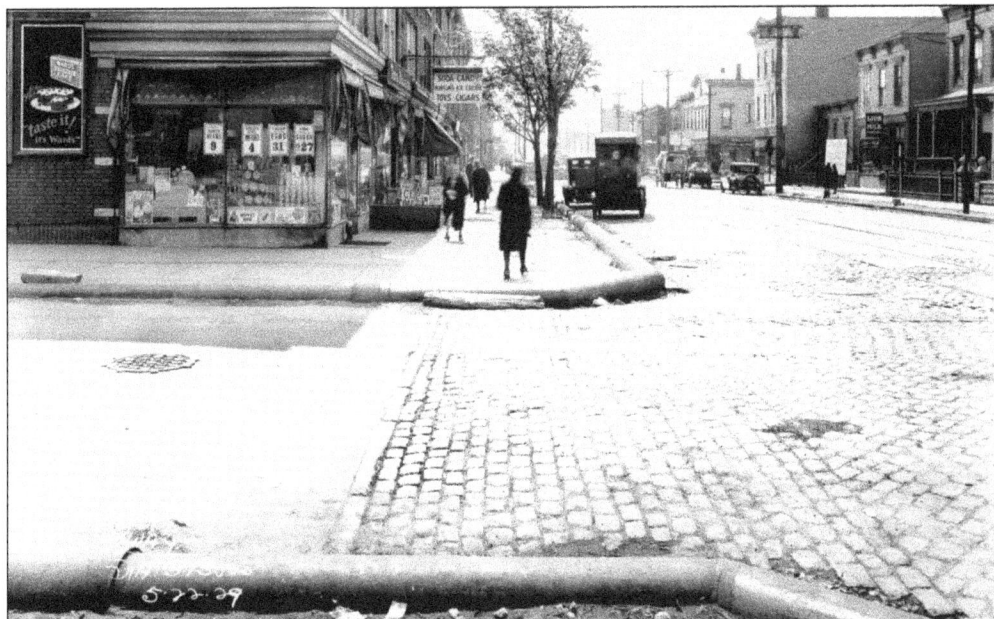

In 1929, the area of Broadway and 43rd Street was, as it is today, a mixture of commercial and residential buildings. Here, new water mains are being laid, perhaps in anticipation of the digging for the subway a few years later. (Courtesy GAHS.)

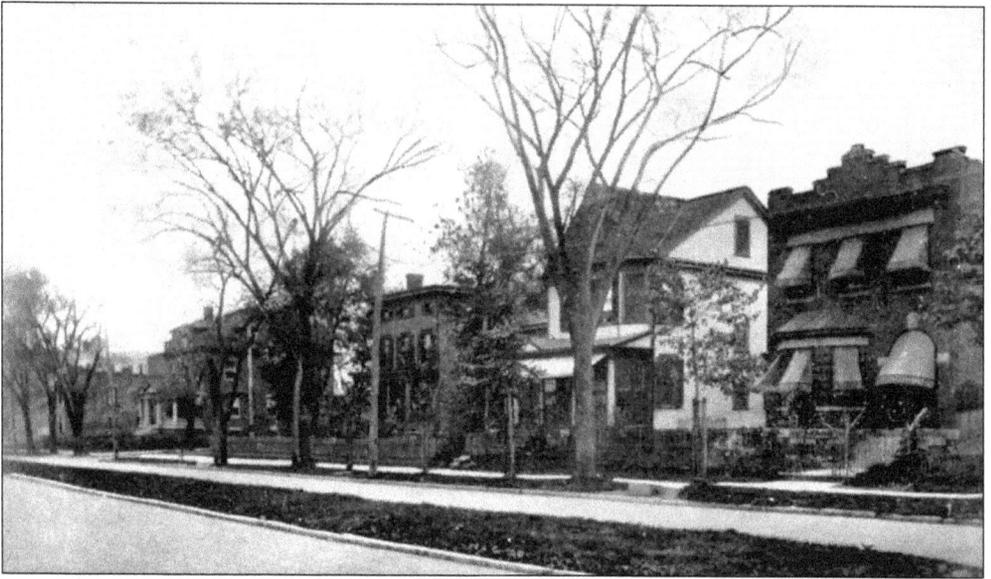

Jamaica Avenue (31st Avenue) was once a grand street with fine homes and a central median. After the elevated train was built, all the homes in this picture succumbed to the pressures of apartment development. Only one grand mansion remains today between 31st and 32nd Streets. (Courtesy Bob Stonehill.)

The building to the right is Astoria Hospital, today's Mount Sinai Hospital of Queens, which opened in the spring of 1896. This brick building is still standing today, at Crescent Street and Grand (30th) Avenue, although endangered. It stated, at opening, that it was intended for the treatment of all patients without regard to gender, creed, or nationality. The great home, tree, and urns on the stone fence were long replaced by the hospital. (Courtesy GAHS.)

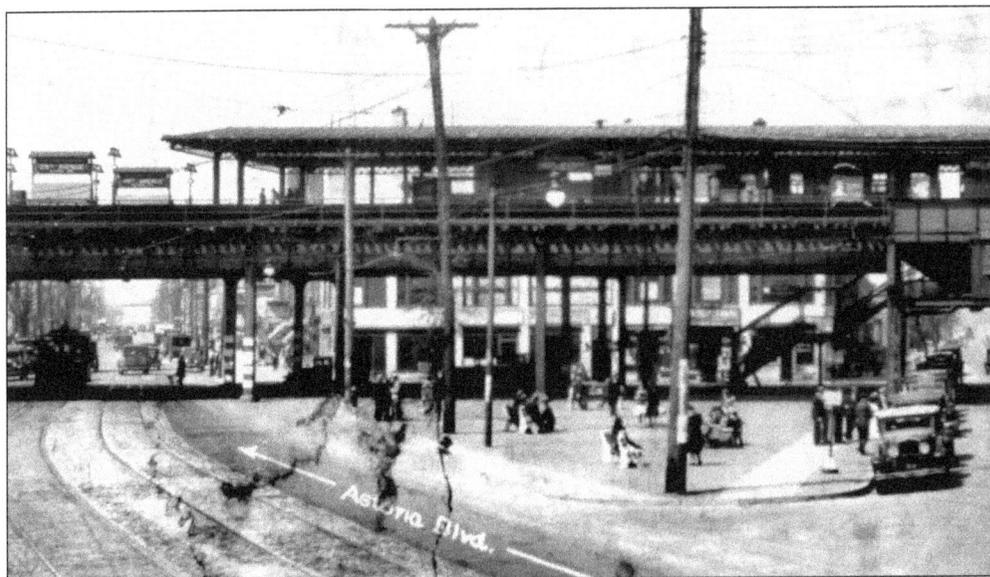

The Astoria Boulevard–Hoyt Avenue subway station changed in 1936, when the Grand Central Parkway was built. The neighborhood to the right of this station was lost to the creation of the sunken roadway. (Courtesy GAHS.)

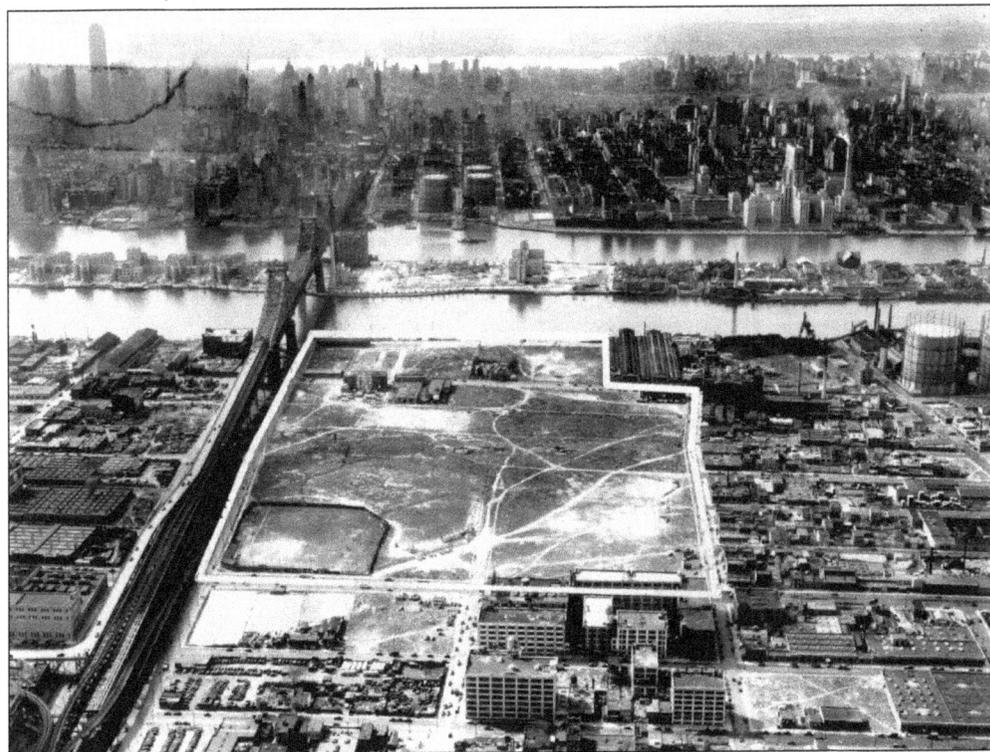

In 1939, we gained the neighborhood of the Queensbridge Houses. Once the largest housing project in the country, it had 3,142 units. In the center is an octagonal plaza with shops and a community center offering a small-town feeling. Note the old ball field in the corner. (Courtesy GAHS.)

If you walk down 33rd Street between 34th Avenue and Broadway there is a house out of line with the rest of the block. Although some may think it an architect's whimsy, it is actually situated perfectly in line with an old road that no longer exists, Ridge Road. (Courtesy GAHS.)

The early-18th-century hamlet of Middletown still exists in a cluster of old homes on Newtown Road and 46th Street. One of these precious gems remains hidden under a new façade of Mediterranean green stucco. (Courtesy Steven Melnick.)

Even 20 years ago one could walk down 12th Street and experience the 19th-century village of Astoria. Sadly, as older residents move out, eager developers move in and leave an incompatible street scene. As of this writing, only one building remains. (See page 38 for an earlier view.) (Courtesy GAHS.)

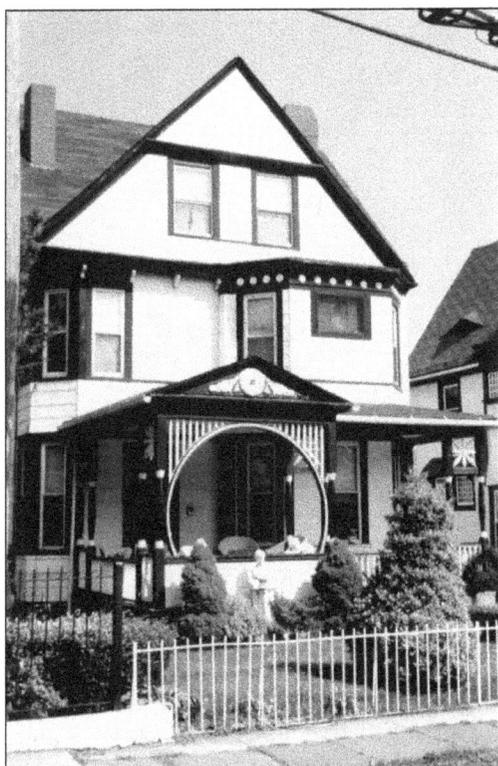

Many residents resent the destruction of the historic fabric of Old Astoria Village. This house on 14th Street is standing today, but without New York City landmark designation will it be standing tomorrow? (Courtesy GAHS.)

Welling Street is at least 300 years old. It wound around the home, barn, orchard, and garden of William Hallett's 1652 plantation. Maps show houses on this location 200 years ago. The ages of these dwellings are unknown. (Courtesy GAHS.)

This small row of cottages on Welling Street (c. the 1840s) was built for working people. To the right is the former Hallett Burial Ground. As late as the 1960s, bodies were accidentally disinterred at the former 1840s Methodist churchyard, also off to the right. (Courtesy GAHS.)

It is often easy to miss the best while rushing down the street. This wooden Dutch Kills house, built *c.* 1860, sits nestled between two brick buildings on 29th Street and 38th Avenue. A recent development study of the area suggested that lots like these are underutilized. (Courtesy GAHS.)

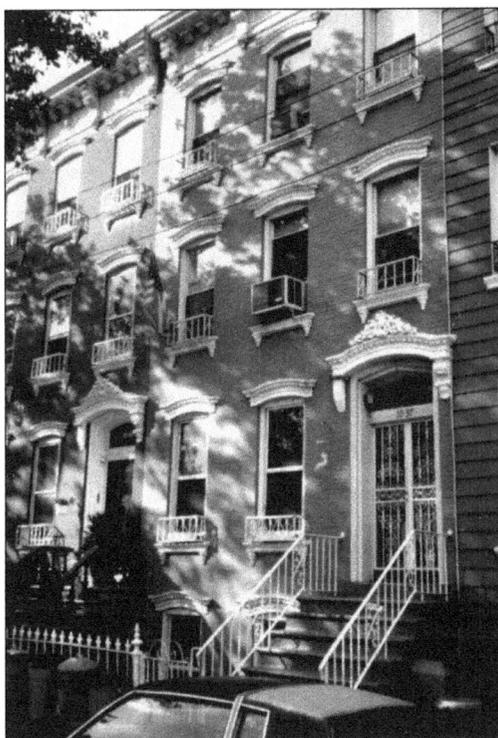

This image of a quiet, treelined, Civil War–era street can be quite deceiving. The other half of the block opens on to the noise from the toll plaza of the Queens-Midtown Tunnel. (Courtesy GAHS.)

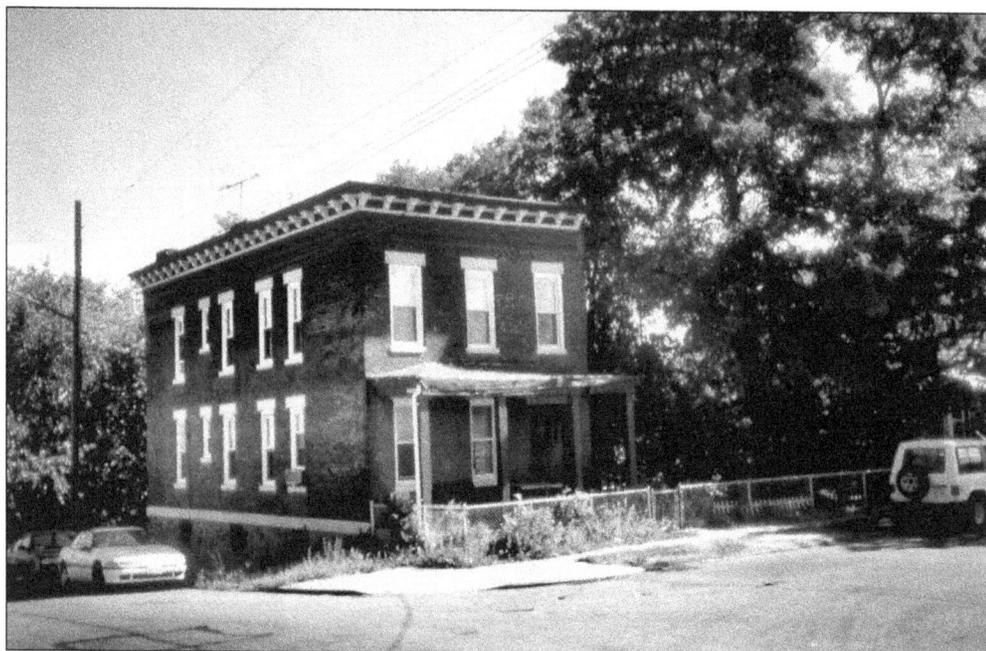

Not only has the name Blissville disappeared, but the small hamlet itself has been all but obliterated by later development. If you look closely in the area, a hint of the original character can still be seen. (Courtesy GAHS.)

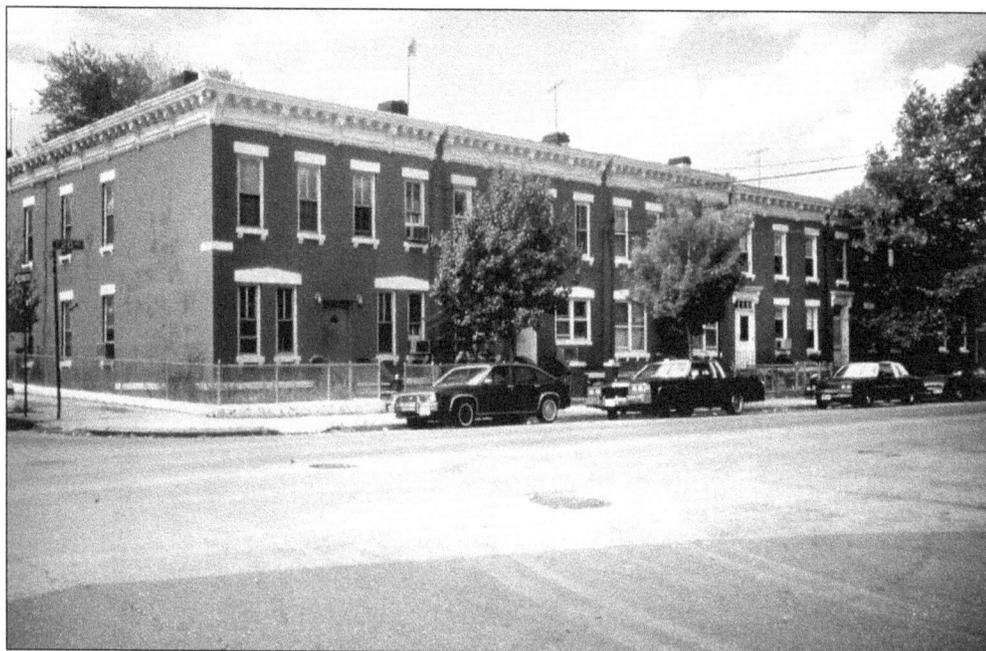

The Steinway workers' housing is on 20th Avenue, from Steinway Street to 42nd Street, and dates from the 1870s and 1880s. The New York City Landmark Preservation Commission designated this district in 1974, but it was overturned by the Board of Estimate in 1975. Since then, some of these homes have been altered beyond recognition. Without the protection of the Landmarks Law, these buildings can be lost. (Courtesy GAHS.)

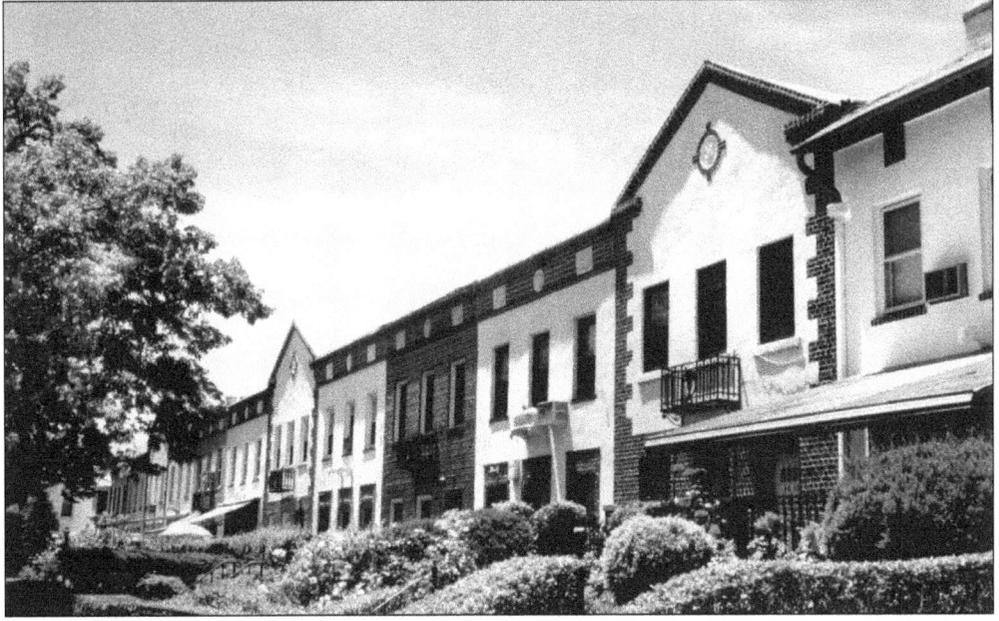

Norwood Gardens was once called "doctor's row" because of the number of doctors who lived and practiced there. An intrusive four-story structure, permitted by zoning regulations, allowed a serious compromise of this block's picturesque ambiance. The residents protested "as of right" development. (Courtesy GAHS.)

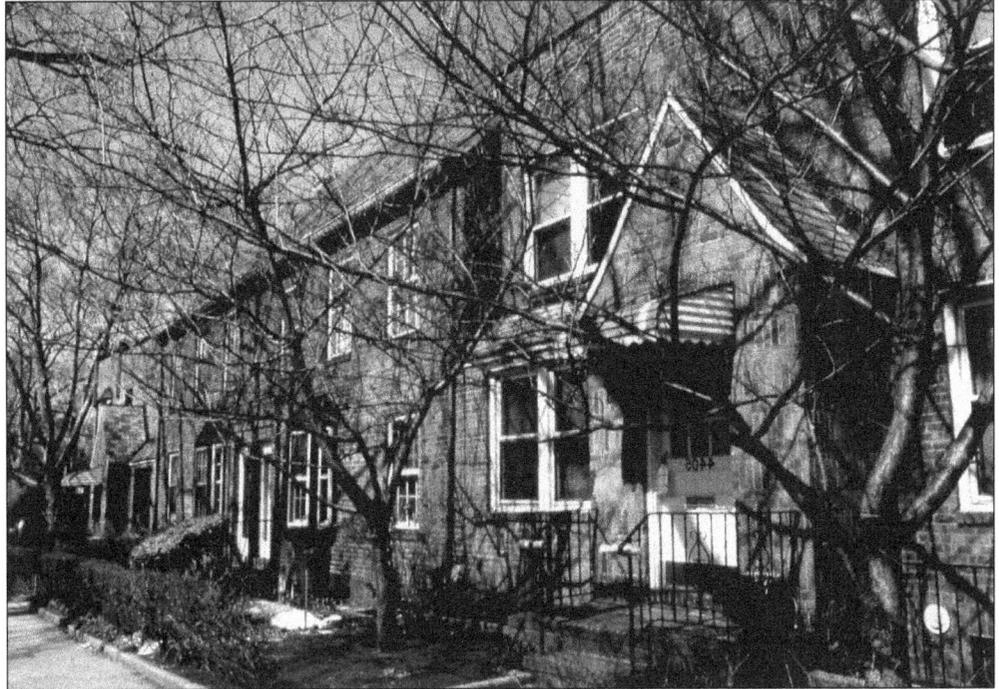

As in the 1920s, Sunnyside Gardens, a landmark-worthy district, is being rediscovered by the influx of younger couples looking for a fine place to raise a family. History does repeat itself. (Courtesy Sunnyside Gardens Preservation Alliance.)

The Hunters Point Historic District, located on 45th Avenue between 21st and 23rd Streets, was the first historic district in Queens. The residents of this block realized that without the protection of the New York City Landmarks Law their beloved 1870s row houses could be lost. Designated in 1968, this block has been a highly sought after street to live on. (Courtesy Steven Melnick.)

Anable Basin is near where our story began, but certainly not where our story ends. Long Island City will inevitably change once again, for such is the kinetic nature of communities. The flow of a new generation brings in a new tide of creative and imaginative people in search of a better life. But that is another story. (Courtesy Steven Melnick.)

www.ingramcontent.com/pod-product-compliance
Lightning Source LLC
Chambersburg PA
CBHW050649110426

42813CB00007B/1961